AFRICA
Women's Art, Women's Lives

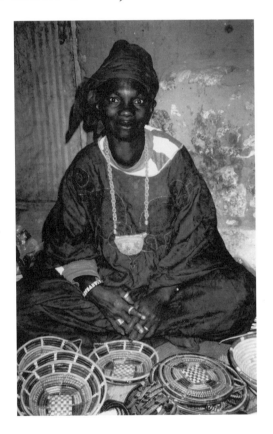

BETTY LADUKE

Preface by Dr. Mikelle Omari–Obayemi

Africa World Press, Inc.

P.O. Box 1892
Trenton, NJ 08607

P.O. Box 48
Asmara, ERITREA

Africa World Press, Inc.

P.O. Box 1892 — Trenton, NJ 08607 P.O. Box 48 — Asmara, ERITREA

Book design and layout : Jason Westgard
Cover design: Jonathan Gullery

Library of Congress Cataloging-in-Publication Data
LaDuke, Betty.
 Africa : women's art, women's lives / Betty LaDuke.
 p. cm.
 Includes bibliographical references.
 ISBN 0-86543-434-4 (cloth). -- ISBN 0-86543-435-2 (paper)
 1. Women artists, Black--Africa, Sub-Saharan--Biography.
I. Title.
N7391.65.L34 1996
709'.2'2--dc20 96-41841
[B] CIP

Dedicated to my children and their children:
Winona LaDuke, **Waseyabin** and **Ajuawak**
and
Jason Westigard and **Samuel**

"If you assume that there's no hope, you guarantee that there will be no hope. If you assume that there is an instinct for freedom, there are opportunities to change things, there's a chance you may contribute to making a better world.
That's your choice."

– **Noam Chomsky,** *On Human Freedom*

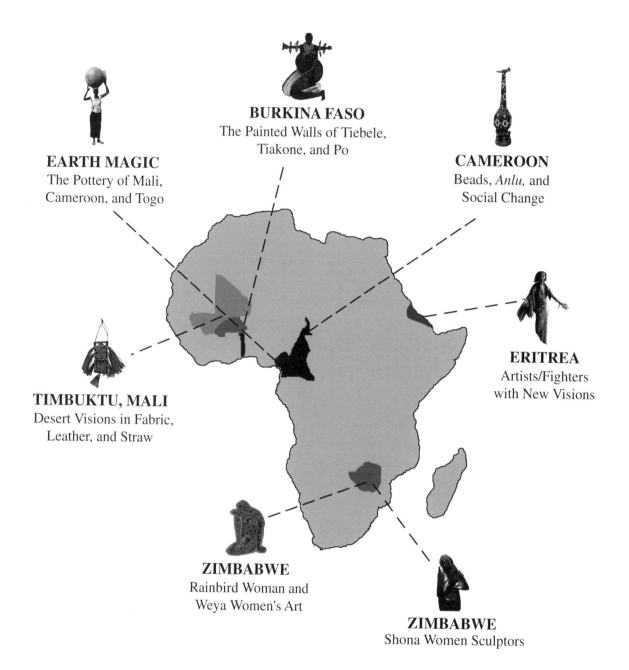

BURKINA FASO
The Painted Walls of Tiebele,
Tiakone, and Po

EARTH MAGIC
The Pottery of Mali,
Cameroon, and Togo

CAMEROON
Beads, *Anlu,* and
Social Change

ERITREA
Artists/Fighters
with New Visions

TIMBUKTU, MALI
Desert Visions in Fabric,
Leather, and Straw

ZIMBABWE
Rainbird Woman and
Weya Women's Art

ZIMBABWE
Shona Women Sculptors

CONTENTS

DEDICATION ..III

PREFACE: By Dr. Mikelle S. Omari-ObayemiVI

ACKNOWLEDGEMENTSVIII

INTRODUCTION ... IX

BURKINA FASO 1

The Painted Walls of Tiebele, Tiakane, and Po

TIMBUKTU, MALI 23

Desert Visions in Fabric, Straw, and Leather

EARTH MAGIC 41

The Pottery of Mali, Cameroon, and Togo

CAMEROON 63

Beads, *Anlu,* and Social Change

ZIMBABWE 85

Shona Women Sculptors

ZIMBABWE 117

Rainbird Woman and Weya Women's Art

ERITREA 147

Artists/Fighters with New Visions

Dr. Mikelle S. Omari–Obayemi

PREFACE

Africa: Women's Art, Women's Lives is an important continuation of artist/ scholar Betty LaDuke's pioneering efforts to document the art of non-European women. LaDuke's *Compañeras: Women, Art, and Social Change in Latin America* (1985), *Africa Through the Eyes of Women Artists* (1990), and *Women Artists: Multi-Cultural Visions* (1992) were the first serious publications that foregrounded the art of women of color. *Africa: Women's Art, Women's Lives* is a compelling sequel to these earlier works. Based on annual visits to diverse African regions since 1986, LaDuke's germinal research on African women's creativity was largely financed from her personal resources.

This broadly conceived and geographically far-ranging reconnaissance effort will prove invaluable for scholars desiring to accomplish more particularistic studies of African women and their arts in the future. LaDuke has located for us named, independent women artists as well as art collectives as geographically disparate as Mali, Cameroon, Burkina Faso, Togo, Zimbabwe, and Eritrea. The categories of art-making LaDuke documents are equally broad-ranging: from pottery, basket manufacture, house painting, and leather decoration (conventionally classified as "crafts") to paintings, sculpture, and political art. Strengthened by her warm, personal encounters with these artists, LaDuke has sensitively provided (perhaps for the first time) a view of the women artists' consciousness of their own agency and sense of themselves as contributing to social/political change and the dismantling of old boundaries and stereotypes. Her sketchbook was more often than not the bridge that established rapport and transcended the boundaries between Western culture and the cultures of the African women artists with whom she interacted.

To Betty LaDuke, whose great courage and devotion produced this exciting work, we owe heartfelt gratitude. She has affirmed the primacy of African women's creativity and its relationship to their personal lives. In addition to situating these artists squarely within the emerging discipline of Modern/ Contemporary African art-making, LaDuke's lyrical and readable writing style exuberantly carries the reader along with her and facilitates an all-too-fleeting entry into the hopes, fears, thoughts, and other aspects of the African women artists' lives. Thus, LaDuke compellingly highlights the connections between African women's art-making and their communal and individual experiences. As we accompany LaDuke on her enchanted journey, we the readers feel that we personally know the African women artists about whom she writes. *Africa: Women's Art, Women's Lives* is a significant contribution to the field.

Dr. Mikelle Omari-Obayemi
Professor, African Art History
Director, African-American Studies Program
University of Arizona, Tucson

ACKNOWLEDGEMENTS

I am grateful for the nurturing from my friends and my family in Oregon: Chela Tapp Kocks, Professor of Romance Languages, Southern Oregon State College, who consistently journeys with me through the written and visual interpretations; Lois Wright and Mary Burgess for the transformation of my original scrawls into a legible format; Florence Schneider, Olive Streit, Grace Henson, and Vincent Crowell, who always listen and look at the work in progress; Rod Fowler and Becki Brown who process my many photographs with patience and skill; and my husband, Peter Westigard, who worries but always supports my creative venturing near and far.

I am also fortunate to have the support of other colleagues and the administration at Southern Oregon State College, who consider my art and non–Western research perspective relevant to teaching drawing, painting, and lecture classes: Women and Art and Art in the Third World.

Dr. Janet Stanley, librarian at the Smithsonian's African Art Museum, has been an invaluable guide to people and books before and after each journey. I have also benefitted from telephone conversations with distant scholars who generously shared their research experiences to facilitate my own: Dr. Christaud Geary, National Museum of African Art, and Dr. Eugenia Shanklin, Trenton State College, on Cameroon beadwork; Dr. Raymond Silverman, Michigan State University, and Dr. Elizabeth Biaso, Volkerkundermuseum der Universitat Zurich, on Ethiopian painting (I visited Ethiopia briefly before continuing on to Eritrea); Dr. Fred Smith, Kent State University, on the painted walls of Ghana and Burkina Faso; Jonathan Zillberg, Shona sculpture historian, from Zimbabwe; and Dr. Hans-Joachim Koloss, who provided the photograph of the Kom.

Sometimes detours are useful. I appreciated the invitation from the Director, Christopher Dunford, to visit Freedom From Hunger's "Credit with Education" programs in Ghana and Burkina Faso. As a result, I gained valuable insight about village life, women's solidarity, and creative survival activities. En route from Ghana to Burkina Faso, I discovered "The Painted Walls of Tiebele, Tiakone, and Po" (Chapter 1).

In each country, the woman artists I interviewed respected my interest in their art and their lives and genuinely gave of themselves. Along the way there were others whose friendships or language skills proved invaluable for my research, especially Cecilia Winter–Irving of the National Art Gallery in Zimbabwe; Dr. Tom Killion, University of Asmara, Eritrea; Mikael Adonais, Ministry of Information and Culture, Eritrea; Berhane Adonais, Director, Asmara Fine Arts School, Eritrea; and Danny Dafla of the National Art Museum, Eritrea.

Ultimately, I am grateful for the encouragement provided by Kassahun Checole, my publisher, and Pamela Sims, his assistant. Sims sent me the 1991 catalog, "An Exhibition of Art Works by Eritrean Fighters," that piqued my curiosity, and Checole and Angela Winn facilitated my meeting with Eritrea's women artists–fighters, related in "Eritrea, New Visions," (Chapter 7). I am also grateful to Patricia Allen for her sensitive editing and to Jason Westigard for his innovative graphic design of *Africa: Women's Art, Women's Lives.*

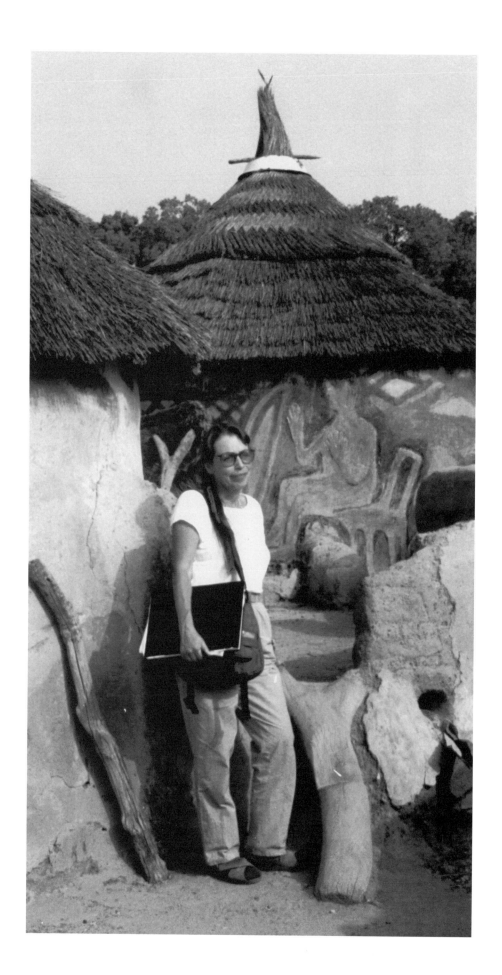

(Fig.1) Betty LaDuke
at Tiakane, Burkina
Faso, 1993.

Introduction
Women's Art, Women's Lives

Art and life are inseparable in Africa. So I discovered in my journeys there from 1986 to 1994 (Fig. 1). For African women, their passion to create images that reveal their personal thoughts about social and political issues is manifested in unique art forms little known in the West. This passion is much in evidence, no matter the circumstances, in times of peace and in times of war, under favorable conditions and under the most difficult and dangerous circumstances imaginable.

Decoration is one of the most vividly expressed forms of the women's art: from the smallest clay bowls to the sturdy walls of their homes, where the women give birth and see life pass away. Decorative motifs are frequently symbolic and reinforce shared community values.

Across the African continent from Timbuktu in Mali to Asmara in Eritrea, women work creatively—weaving; working with leather, straw, beads, or clay; painting with mud, *sadza*, oil, or acrylic; sewing fabric appliqué; or sculpting monumental stone. Their art incorporates myth and reality as expressions of their joy, frustration, humor, and hope.

Africa: Women's Art, Women's Lives reflects my interaction with the artists and enjoyment of their work. This book evolved from 1990 to 1994 and is almost a continuation of my first book, *Africa Through the Eyes of Women Artists.*[1] The work in hand is the result of travel and research in Burkina Faso, Mali, Togo, Cameroon, Zimbabwe, and Eritrea. In each nation, I become immersed in a different

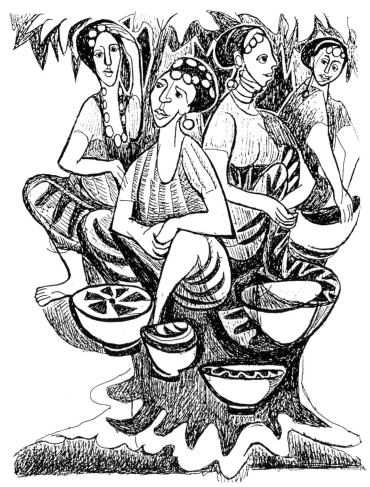

(Fig. 2) *Market Day*, **by Betty LaDuke, Pen Drawing, 14 x 11", Burkina Faso, 1993.**

cultural and historical perspective that related to an artist or group of artists, be they traditional or modern. Since my research procedure depends on establishing relationships, my sketchbook was a useful means of recording and communicating. Unwittingly, I frequently provided community entertainment, as people enjoyed observing my interpretations of them. The sketches (Figs. 2–5) also serve as a useful reference for my own acrylic paintings and etchings at journey's end (Fig. 6–8).

The process of "discovering" African women's art would occasionally begin with a casual observation, followed by a willingness to detour from a journey's projected itinerary in search of adventure; my first views of the painted houses in Burkina Faso, and pottery in Togo, were all the result of serendipitous sightings from the windows of a bus or a local bush taxi. On discovering that each of these enticing forms was created by a woman, I redirected my tour to the specific village or home of the artist.

Books can also inspire a journey.[2-7] Reading about Eritrea's long war of liberation (1961–1991), where combatants sometimes carried paintbrushes as well as guns, provoked my curiosity. Since the books revealed that a large percentage of women participated in

the war, I then wondered if women combatants also painted. Subsequently, I went to Eritrea to find the artists-warriors.

It is important to transcend stereotypes in order to understand the changing roles of women in African society today. If, in the past, women did not create stone carvings, sculptural beadwork, or acrylic paintings on canvas, it does not mean they are not doing so now. Historians still overlook women artists, as is evident in Susan Vogel's recent publication, *Africa Explores.*

> *The problem of equal representation of women artists remains regrettably unsolved here. For a variety of familiar social and economic reasons, Africa claims only a fraction as many professional women artists as men. In many places there are literally none. The number grows, however, with each generation, and there are more women artists at the beginnings of their careers today than there are in their maturity.*[8]

Many of the artists I have chosen to interview are young and are, indeed, at the beginning of their careers. Nevertheless, I feel it is valid to document their work, because they represent the current and future directions in African art.

(Fig. 3) *Women*, **by Betty LaDuke, 14 x 11", Barantu, Eritrea, 1994.**

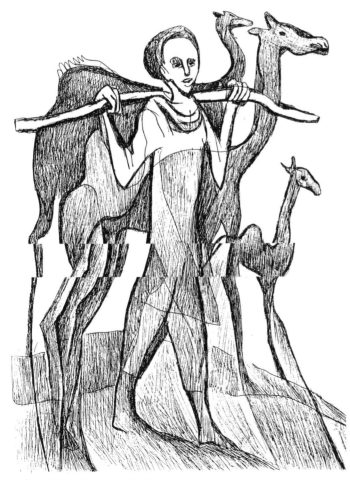

(Fig. 4) *Camels*, **by Betty LaDuke, 14 x 11", Barantu, Eritrea, 1994.**

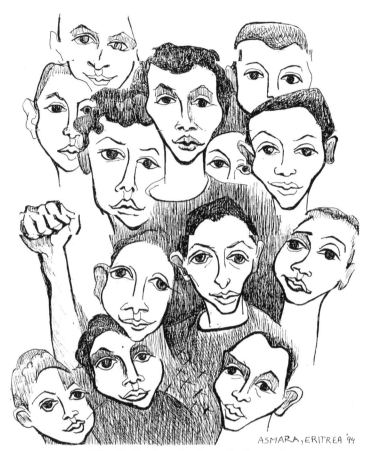

(Fig. 5) *Children*, by Betty LaDuke, Pen
Drawing, 14 x 11", Asmara, Eritrea, 1994.

OVERVIEW OF *AFRICA: WOMEN'S ART, WOMEN'S LIVES*

Chapter 1, "Burkina Faso: The Painted Walls of Tiebele, Tiakone, and Po," is a discussion of the collective pride and self-esteem manifested during their traditional painting process. There is also a description of my encounter with Kavouri, an independent painter/story-teller.

Chapter 2, "Timbuktu, Mali: Desert Visions in Fabric, Straw, and Leather," tells of the women in a geographically isolated and predominantly Moslem community who take Bible lessons in conjunction with sewing lessons, using foot-pedaled Singer sewing machines. There is also a report on the desolate environment of the semi-nomadic Tuareg women, who are able to contribute to their families by making traditional leather work for the local inhabitants as well as for tourists; and the president of the Tombouctou Artisan Association, sustaining herself by networking with other artisans and traders to sell her straw baskets, mats, and jewelry, which are also available at New York City's African Art Museum.

Chapter 3, "Earth Magic: The Pottery of Mali, Cameroon, and Togo," presents examples of utilitarian and ceremonial pottery—

e.g., the mimbo pot, used for ritual sharing of palm wine in Cameroon; the monumental water storage jars in Togo; and the painted pottery in Mali. In Africa, pottery forms are diverse, beautiful, and basic to survival.

Chapter 4, "Cameroon: Beads, *Anlu,* and Social Change," reveals the social significance of beaded sculptures that were formally relegated to the great palaces, fons, and chiefs. Today, women produce these sculptures for anyone who can afford to buy them. There is also an account of *anlu*, a women's society formed for protection as well as for social action. Many forms of *anlu* exist, but the news media seldom report stories about African women's creative resilience.

Chapter 5, "Zimbabwe: Shona Women Sculptors," in addition to providing an historical context for appreciating Shona sculpture, discusses the specific problems that women have encountered as they create their own sculptures, rather than polish the works their fathers, husbands, or brothers created. There is also a discussion of how the women's monumental figurative images relate to their own personal experiences.

Chapter 6, "Zimbabwe: Rainbird Women and Weya Women's Art," finds that weaving, painting, and fabric appliqué were a significant means of generating income and raising consciousness. Art, for these women, varies thematically from mythical legends to poignant stories about family relationships, family planning, and AIDS. Their work is also represented in Zimbabwe's prestigious National Art Gallery.

Chapter 7, "Eritrea: Artists/Fighters with New Visions," shows how women's artistry developed during the war years, when they were also combatants. Their realistic drawings and paintings document their responses to war from their perspective as women artist-warriors. They painted women as heroes and martyrs. When looking at contemporary African art, these images may not be what one expects to find. They are not intended for tourist consumption. Rather, they are designed to promote national unity.

Elisabeth Biasio has documented the emergence of modern and abstract artists in Ethiopia in contrast to Russian-influenced social realism. She discusses some of the issues involved when artists deviate from the expected norm.

> *The works of modern artists from the Third World are quickly dismissed as "third rate" . . . for a lack of their own characteristics. Most Western-oriented people want Africa to remain a museum, i.e., they would like to see Africa play tom-toms, because for them Africa means tom-toms, snakes, and monkeys [masks, fertility figures, and tourist art] that's the point. But they think we can't play electronic music [create modern art]. I think it is most important for people to understand that there is an "electric Africa."9*

I am also aware that some women artists are painting in an abstract expressionist style, as exemplified by Meo Matone from Botswana

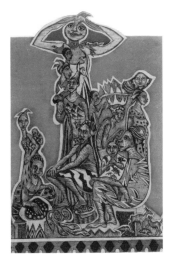

(Fig.6)

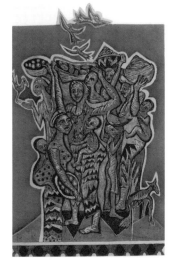

(Fig.7)

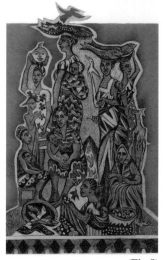

(Fig.8)

(Figs. 6-8) *Africa: Women on the Move,* by Betty LaDuke, Etching (Tryptich), 1994.

(Fig. 9). Her aesthetic direction is influenced by one of several workshops recently held in southern African nations that promote media explorations. However, while I chose not to pursue this research direction at this time, this information adds to our awareness of the diversity of women's art and, at least, should be mentioned.

IMAGES OF WOMEN: COMPARISONS AND CONTRASTS

For most women artists, the female figure is a dominant theme, but their portrayal varies not only in media but in thematic context. New role models are evolving.

In Zimbabwe, Grace Chigumira's paintings on wood illustrate her experiences in the communal lands. In addition to school teachers, nurses are important role models, as they explain and demonstrate family planning methods, infant diarrhea control, or inoculation of children against communicable diseases (Fig. 10).

In Eritrea, a significant role model is the *Woman Hero* (Fig. 11), a painting and popular poster by Elsa Jacob, which portrays a

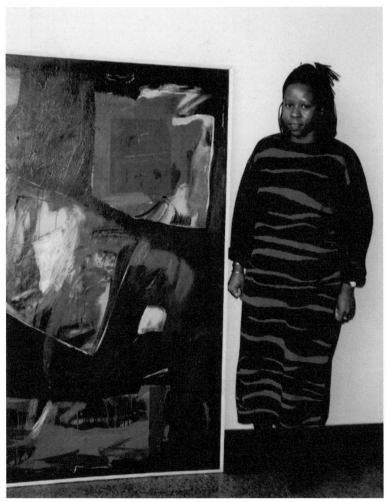

(Fig. 9) Meo Matone and Her Abstract Painting, National Art Gallery of Zimbabwe, Harare, Zimbabwe, 1993.

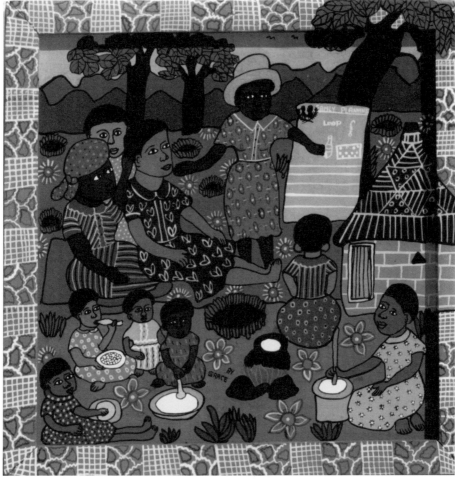

(Fig. 10) *Family Planning,* by Grace Chigumira, Acrylic on Wood, Harare, Zimbabwe, 1994.

woman dressed in khaki shorts and shirt, carrying a Kalashnikov rifle in one hand and a grenade in the other, with the slain enemy beneath her feet. This new Eritrean role model emerged after their thirty-year liberation struggle which ended in 1991. Now their challenge is to create new role models of women during peace. Will they revert to traditional images, or will there be an amalgamation?

In Zimbabwe, women produced many stone sculptures honoring their strong maternal and domestic roles. In contrast, Mavis Mabwe's work suggests other possibilities. *Proud Lady* (Fig. 12) could be considered a self-portrait, honoring women's emerging creativity and their success as sculptors in a profession dominated by men.

Sometimes the continuity of traditional art forms is considered a radical act: the wall painting in Burkina Faso; the persistence of pottery-making in Togo, Cameroon, or Mali despite the plastic imports; and the imposition of new commercial values through the mass media, etc. Traditional means of expression reinforce the community's cultural roots despite strong pressure to change, modernize, and westernize. However, there is often some modification, such as incorporating crosses as part of the wall designs, or creating clay ashtrays and other purely decorative items.

An important aspect of the creative process is the sense of community experienced by the artists through the formation of collective organizations or cooperatives that represent their interests. Women's earnings also modify family relationships as women prioritize their incomes. Frequently their children's education comes first.

Art can also upset negative stereotypes and racial relationships. In Zimbabwe, there was little internal support for the Shona sculptors initially, but as the work began to receive international acclaim, it was reconsidered by the public and by the national press. More recently, this change has occurred for Weya women's appliqué art, which is visually appealing and penetrating in a candid presentation of personal and social themes. However, it was disappointing to learn that images expressing racial tension or relating to their war of independence from white Rhodesian oppression were not encouraged as topics of exploration. The exact opposite occurred in Eritrea, where women produced art about their fighting experiences. Ilse Noy, In her book *Weya Women's Art,* explains:

> *If the women illustrate the different lives white and black Zimbabweans live, the paintings are excluded from art exhibits and not taken for sale by market outlets. Paintings about the Chimurenga (or liberation struggle) are hardly accepted in the official glorious version, not to mention the horrible personal experiences the women endured during the war. Not one of them has ever tried to show her experiences during the war in her work.*[10]

NETWORKING

It has been a wonderful experience to make the results of my African journeys available in various formats. There are currently two traveling exhibits: *Africa Through the Eyes of Women Artists* based on the book published in 1990; and *Africa Between Myth and Reality*, my impressions of Africa as revealed in my prints and paintings. Both exhibits are sponsored by the non-profit Exhibit Touring Services of Eastern Washington University.[11] The response to the first exhibit, consisting of fifty-two poster-size photographs and ten select examples of women's art, has been gratifying. Shelley L. Brooks of the Portsmouth Museum in Virginia states:

> *One of the best things I can see about this exhibition is the way it affects families. I see people paying close attention to the photos and art works and discussing it among themselves. It has spawned a lot of inquiry between parents and their children, and . . . it will again stir a lot of conversation and thought.*[12]

However, the need to make my own identity as an artist visible is not always so acceptable. For example, in the Women's Art Journal, Pamela H. Simpson reviews *Africa Through the Eyes of Women Artists* and concludes:

> *A bit self-serving are her use of her own drawings to illustrate the books and the inclusion of a chapter on her own*

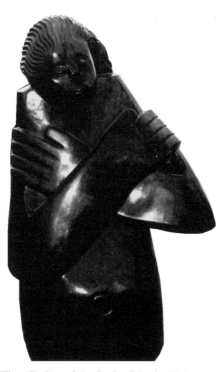

(Fig. 12) *Proud Lady*, by Mavis Mabwe, Stone Sculpture, Chitungwiza, Harare, Zimbabwe, 1993.

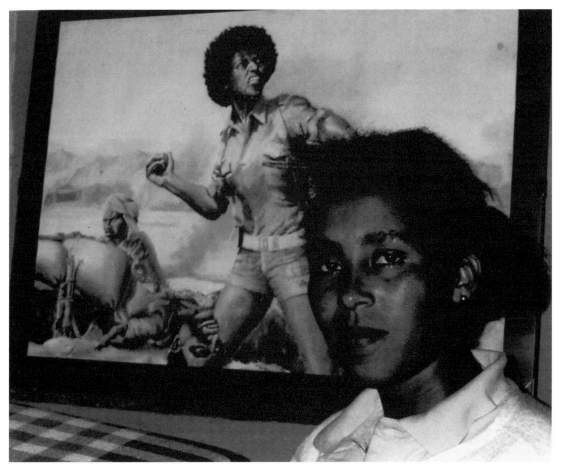

(Fig. 11) *Woman Hero*, by Elsa Jacob, Asmara, Eritrea, 1994.

*work, but these are done within the context of her very
personal presentation of the women she has interviewed
and whose work she admires.[13]*

On one occasion, when the two exhibits were simultaneously fea-
tured at the African-American Caribbean Culture Center in Fort
Lauderdale, Florida, there was an affirmative response from Aina
Olmo, the Center's director:

*It's fresh that Betty is a white woman with something good
to say. . . . That says not all whites see us in a negative
light or stereotypically. She does a very positive repre-
sentation of African images. . . . A lot of black institu-
tions are leery as to how their constituency will take to
LaDuke's representing black images. They schedule her,
but when they discover she's Caucasian, they put her back
on the waiting list. . . . But it's important to share some
positive African images by a white artist for a change.[14]*

Not being shy about sharing or showing my art to others has re-
sulted in a wonderful exchange with the Cold Comfort Farm Weav-
ing Collective in Zimbabwe. The women weavers had a very posi-
tive response to my painting *Africa: Bird Women, Keepers of the
Peace,* which has also been reproduced in *Multi-Cultural Celebra-
tions, Betty LaDuke Paintings 1972-1992* and as a poster.[15] Using this

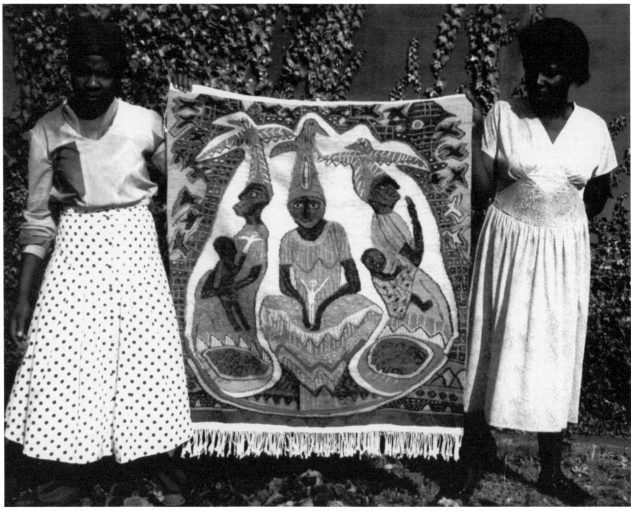

(Fig. 13) *Rainbird Women*, Design by Betty LaDuke, Weaving by Juliet Makombe and Leocadia Masango, Harare, Zimbabwe.

poster as a guide, they are interpreting this image as a tapestry (Fig. 13). I felt honored to have had my work accepted by African women, and I describe this experience in Chapter 6, "Zimbabwe: Rainbird Women and Weya Women's Art."

African women's art has been the focus of my research and explorations for only nine years, and I feel that I have only touched the surface. The significance of African women's art and the process of social change are under-explored historically and contemporarily. The examples presented here are evidence of what African women have been, showing unequivocally the integral contributions they have made to African aesthetics. Their vision, however, needs to be and should be further explored, recognized, and honored.

Endnotes

1. Betty LaDuke, *Africa Through the Eyes of Women Artists* (Trenton, N.J.: Africa World Press, 1990).

2. Dan Connell, *Against All Odd: A Chronicle of the Eritrean Revolution* (Trenton, N.J.: Red Sea Press, 1993).

3. Robert Papstein, *Eritrea, Revolution at Dusk* (Trenton, N.J.: Red Sea Press, 1991).

4. Amrit Wilson, *The Challenge Road: Women & the Eritrea Revolution* (Trenton, N.J.: Red Sea Press, 1991).

5. Thomas Keneally, *To Asmara, a Novel of Africa* (New York: Warner Books, 1989).

6. Abeba Tesfagiorgis, *A Painful Season & A Stubborn Hope* (Trenton, N.J.: Red Sea Press, 1991).

7. Catalogue, *An Exhibition of Art Works by Eritrean Fighters*, prepared by the National Guidance Department, Eritrean People's Liberation Front, Asmara, Eritrea, 1990.

8. Susan Vogel, *Africa Explores* (New York: The Center for African Art, 1991), p. 12.

9. Elisabeth Biasio, *The Hidden Reality: Three Contemporary Ethiopian Artists* (Volkerkundemuseum der Universitat Zurich, 1989), p. 184.

10. Ilse Noy, *The Art of the Weya Women* (Harare, Zimbabwe: Baobab Books, 1992).

11. Jim Rosengren, Director, Exhibit Touring Services, Eastern Washington University, Cheney, WA 99004, 1-800-356-1256.

12. Shelley L. Brooks, "The Art of Betty LaDuke," *The Currents* (Sept. 16/17, 1993), pp. 10-11.

13. Pamela H. Simpson, review of *Africa Through the Eyes of Women Artists*, in *Women's Art Journal* (Fall, 1993), p. 62.

14. Aina Olmo, Director, African American Caribbean Culture Center, Fort Lauderdale, Florida, from Deborah P. Work, "Drawing on Africa's Spirit," Sun-Sentinel, Fort Lauderdale, Florida (March 21, 1993).

15. Gloria Orenstein, *Multi-Cultural Celebrations, Betty LaDuke Paintings* 1972-1992 (Petaluma, California: Pomegranate Books, 1993).

Burkina Faso

THE PAINTED WALLS OF
TIEBELE, TIAKANE, AND PO

Little did I realize that window-gazing during a twenty-six-hour bus journey from Accra, Ghana, to Ouagadougou, Burkina Faso, would lead to an adventure. When my journey first began in Accra, it was fortunate that the bus driver's assistant insisted I sit up front for a good, scenic view. Between dozing and talking, I enjoyed the unfolding brown landscape, especially the large patches of shimmering green millet. It was a verdant period, and everywhere the rounded backs of women and men were silhouetted above the millet stalks as hands rhythmically worked with small machetes to clear the threatening weeds, encouraged by recent rains (Fig. 1).

Dispersed over the landscape were small, round, mud-walled houses and granaries with pointed, thatched roofs perched above them like little hats. They were grouped together in walled compounds sporadically comforted by the deeper green tones of tall trees that cast welcoming shadows over the hot, humid land. As we came closer to the border region between Ghana and Burkina Faso, I was startled to see that the mud-walled houses that emerged from the millet fields were dressed in geometric designs, painted in muted earth tones of black, brown, and white. These patterns reached up from the earth, covering the walls of both circular and rectangular homes in a variety of designs that seemed to echo the rhythmic growth of the surrounding millet (Figs. 2–3). Who had created these wall patterns? And why? But the bus driver's knowledge was sparse. He was surprised by my interest, and soon after we left this border region, the houses became

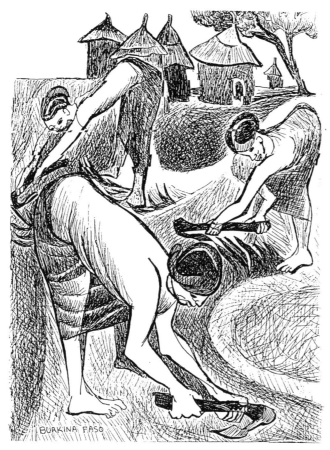

(Fig. 1) *On the Farm*, **by Betty LaDuke, Pen Drawing, 11 x 14",**
Burkina Faso, 1993.

ordinary again with distance. I then began to wonder if I had dreamed these magical designs.

In the days that followed, I forgot about the painted houses as I was busy with sketchpad and camera documenting the Freedom From Hunger (FFH) projects in the villages surrounding Sabou, Kienfangie, and Zenaire. There was so much to see and learn, especially about the women's cooperation within polygamous households. Fortunately, my FFH host, Ayeli Foli, had planned some "sight-seeing" days before I returned to Ghana. Our driver, Sarfo Tico, was free to take me in his small Mazda to the border region between Burkina Faso and Ghana. I would be able to see those painted walls again—this time up close! Tico then drove us back to the main town of Po. From there we took a thirty-one-kilometer detour along an unpaved road to the village of Tiebele. En route, Tico indulged me many times as I stopped to admire each painted house (Fig. 4). I had to touch every wall, tracing design patterns with my fingers, then find the best camera angles to capture these images. After all, I was never sure how many more painted houses there were, and I could not chance missing one. The household inhabitants were somewhat amused by my enthusiasm for their walls, revealed more by my gestures and facial expressions than by words. My French is minimal, and I could only repeat, "*Trés joli, trés joli*," or "very nice," which Tico translated into the local dialect.

Finally, we reached Tiebele, and Tico made it clear to me that the chief's palace would be the culminating site. He was right (Figs. 5-8). During this two-day venture, in addition to the chief's compound at Tiebele, there would be two more extraordinary sites: the chief's palace at the village of Tiakane and the Nanoui family home near Po. These July photographs would then sustain me over the next few months, proof that the experience was real.

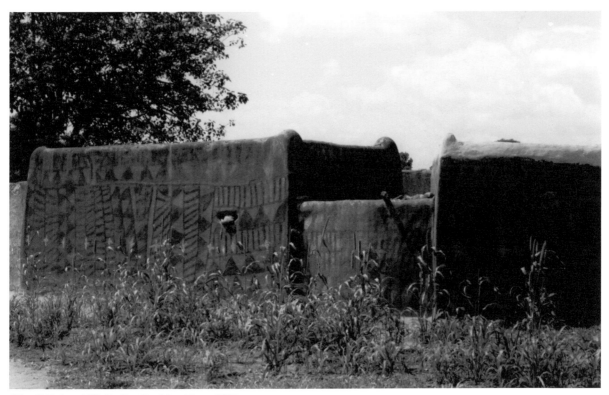

(Fig. 2) Painted Walls, Po, Burkina Faso, 1993.

(Fig. 3) Millet Storage Hut, Po, Burkina Faso, 1993.

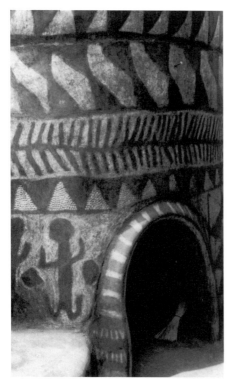

(Fig. 5) The Chief's Compound,
Tiebele, 1993

(Fig. 4) Painted House
En Route to Tiebele,
1993.

However, I felt I had to venture out once again to Tiebele, Tiakane, and Po to gain insights beyond the photo facades . I wanted to see the women actually paint these walls and to understand how and why they nurtured them into being. I wanted to witness this process of enriching their lives and their environment with *bambolse* (beauty). I was told that the women painted after the harvest, during the *harmattan* season from December to Màrch and before the rains. Therefore, I would have to return to this region to discover the human component in the painted walls.

When the harvest season came, I set off for Tiebele. The painted walls would become more than façades. I would begin to see and to understand them as living sculptures with specially shaped interior and exterior spaces that bore witness to rites of passage, birth, marriage, and death. These were communally shared traditions, uniquely enhanced by the hands of women who, for centuries, had painted these walls each year, developing a sense of pride in their own work as they created their own form of *bambolse*.

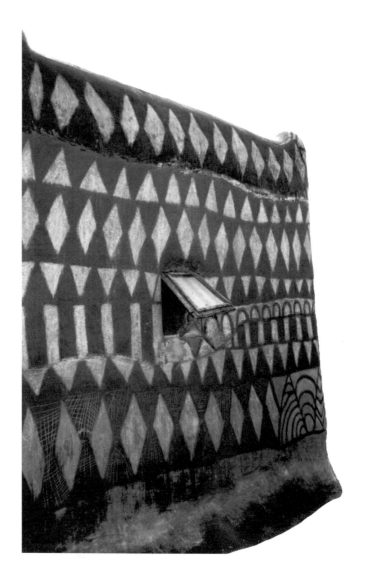

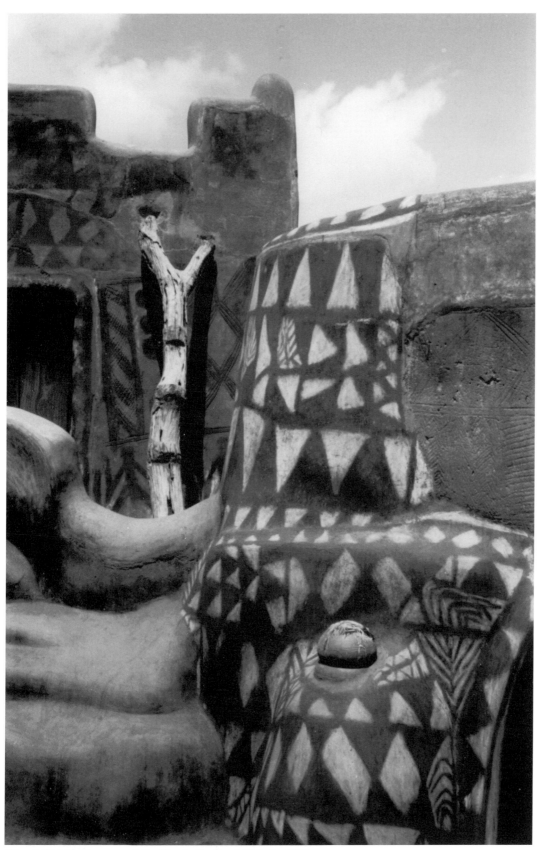

(Fig. 6) Chief's Compound, Ladder to the Roof, Tiebele, 1993.

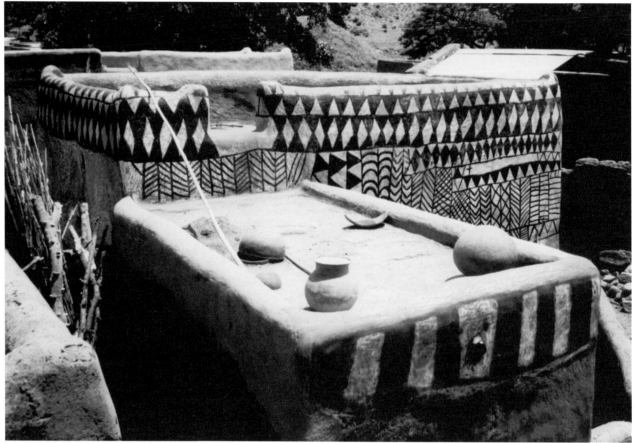

(Fig. 7) Rooftops, Chief's Compound, Tiebele, 1993.

In Fred Smith's 1977 article, "Gurensi Wall Painting," he refers to the concept of *bambolse* as something that means "embellished, decorated, or made more attractive, but the term is almost exclusively restricted to wall decoration. . . . The intention of that action must have been primarily to increase the aesthetic merit of the form if the decoration is to be *bambolse*."[1]

TIEBELE

When I first arrived at Tiebele, the palace chief Aneya Dubadie was not available, but his son (who spoke English) and several friends insisted on escorting me around the compound (after a modest fee was agreed upon). I would not be hurried. Each curved, painted wall that we passed seemed harmoniously aligned with other walls that unexpectedly intersected at different heights, angles, and curves. It was like a sculptural labyrinth that never repeated itself; I was continually startled by small, round doorways each resembling the opening of a hearth (Fig. 5), or by curved walls with protruding rounded shelves in which were embedded clay pots with feathers of a recently slaughtered chicken still clinging to the surface (Fig. 6).

Propped up along the sides of the houses, there were notched tree trunks that served as ladders to the flat rooftops (Fig. 6). We climbed up (it was awkward for me, as my feet seemed too big for

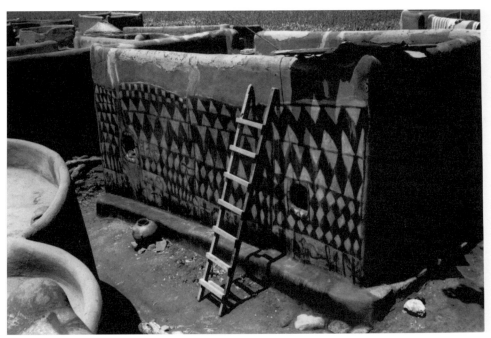

(Fig. 8) Burial Chamber, Chief's compound, Tiebele, 1993.

the shallow notched steps), and from the rooftops I could see the overall complex of the compound design that had been mushrooming for over a century to contain an ever-expanding family (Fig. 7).

Chief Aneya had sixteen wives. (His father, I was told, had twenty-four.) Each wife had a separate, usually round hut or room for herself and her young children. Of course, there were houses for the chief's brothers and for their wives and children, etc. Some structures were seriously crumbling like aged parents, while sturdy new mud wall structures were built around them.

(Fig. 9) Kitchen, Tiebele, 1993.

There was a room with the roof shaped like a figure eight where, I was told, a corpse would be prepared for burial (Fig. 8). Burial grounds were everywhere, at the entryway to the palace and in the courtyards beside each hut. It was as if the living and the dead were part of an ongoing partnership, with new life constantly emerging from sunken earthen chambers where the women gave birth. In the courtyards there were large, round water storage pots that mirrored the shape of the curved walls, along with an assortment of smaller cooking pots and calabashes (Fig. 9).

Katiana, one of Aneya's wives, was considered "the master painter" by all. She allowed me to photograph her as she proudly stood before her doorway holding white and black rocks in each

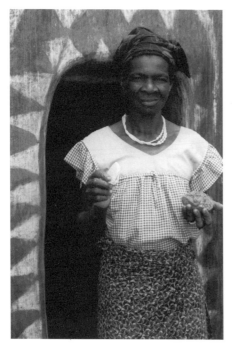

(Fig. 10) Katiana, The Master Painter, Holding Rock Pigments, Tiebele, 1993.

hand (Fig. 10). The rocks, she explained, were the source for the pigment for the wall painting. She told me that each design was symbolic: the dominant zigzag pyramid shapes represented each "half a calabash." When two pyramid shapes were assembled with their narrow points joined together like an hourglass, the design symbolized a *tabour* or small drum. Figures with extended arms were a welcoming handshake motif.

Many designs were conceived as linear patterns, contained within long, narrow strips bordered by thick, black lines. Their proportions are similar to the West African strip-cloth weavings that men produce: V-shaped lines symbolized birds' wings; X's represented fish nets; short, straight, horizontal lines represented garden plots; while a long line with short, wavy ones projected from either side represented a millet stalk. There were also thick lines with little, round coils above them that symbolized the pestle for pounding millet.

From his extensive research, Smith identifies approximately seventeen common motifs that the Gurensi women of northern Ghana used in their house painting. The Gurensi culture also extended into Burkina Faso. (The process of dividing a people into political nations was for the benefit of European colonial expansion, completely ignoring the cultural cohesion of the inhabitants.)

As I was guided around the compound, I saw one wall distinguished by the pattern of a dominant female form. She had only one large, centered eye and one arm pointed to a special brew (Fig. 11) prepared on a small stove. The hand of a male figure reached toward this brew. My guides (the chief's son and his friends) described this dramatic scene as "the picture of a magic woman. This man wants medicine from her."

In considering the unique aspect of this wall painting, I refer to Smith's comment:

> *Individual creativity and interpretation does exist for Gurensi wall decoration, and this is an aspect of the concept of bambolse. . . . Gurensi wall decoration directly reflects on a woman's ability, her interest in the appearance of the compound and on the prestige of her husband.*[2]

In this case, perhaps it was the artist's own importance in the community that was reflected in the painting. Was she the "magic woman or a healer?"

After the initial excitement of seeing the painted walls of Tiebele in July, it was good to be able to return some months later (in December), after the harvest, with the hope of seeing the women actually in the act of painting. Smith states that the conditions related to "whether or not a particular compound is decorated depends on the interplay of environment and social variables . . . and depends in good measure on the women being sufficiently motivated."[3]

In her book *African Canvas*, Margaret Courtney-Clarke writes enthusiastically about the women's motivation, the interrelatedness of pottery production, cloth dyeing, and wall painting. She states:

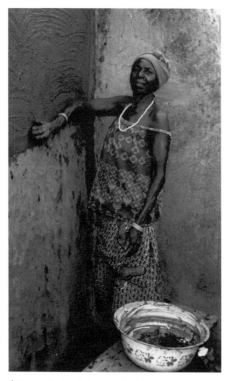

(Fig. 12) Applying a Red Earth Mixture, Tiebele, 1993.

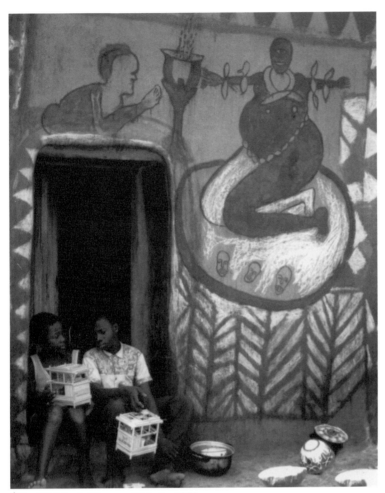

(Fig. 11) Magic Woman, Tiebele, 1993.

Wall painting is an accepted activity, a way of life, a joy of life. For women, the art is a natural gesture, as necessary and as incorporated in the lifestyle of these people as is walking, eating, sleeping. Foremost, the art form is a means of beautifying the space in which they and their families spend a great deal of time, enhancing an otherwise harsh environment. It is also a magical form of creativity, the magic coming not from its meaning or intent but from the actual act of applying paint to the wall.[4]

When I returned to Tiebele, I brought with me photographs taken in July to give to Aneya's son, to Katiana the "master painter," and to the mother of the children playing with cricket cages beneath the room of the "magic woman." These photographs were warmly received and very much appreciated. Several women then agreed to paint a section of a wall for me so that I could understand more about their collective work process and photograph them. The chief's older wives, Akounké, Tiana, Ayiguàdé, Bapayinko, Katiga, Jeniho, and Kaye, all participated. As they always worked together, their routine seemed natural, each taking her part of the process. They were a joy to observe, like old friends repeating a familiar activity, but still needing to tease, analyze, and debate one another.

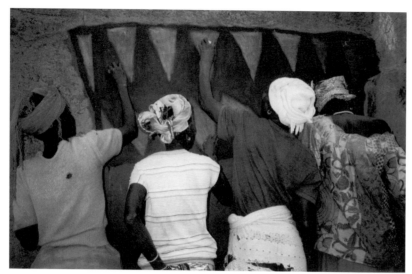

(Fig. 13) **Painting a Wall in the Chief's Compound with Chicken Feather Brushes, Tiebele, 1993.**

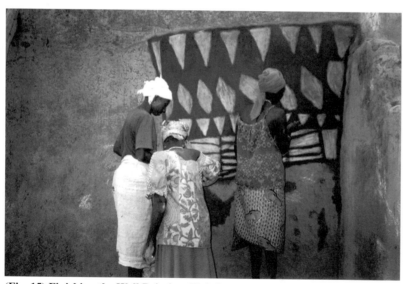

(Fig. 15) **Finishing the Wall Painting, Tiebele, 1993.**

Painting began after a section of the old, cracked mud wall was scraped smooth with a garden hoe. Meanwhile, the basic color palette was being prepared, as well as a large pail of cow dung mixed with water and earth to be applied with the hands, as a gesso or first undercoat. Several women worked together, standing on a bench, their stretched arms working rhythmically as they applied cow dung into all the crevices. Eventually, they began to smooth the surface of this section of the wall, approximately six feet wide and four feet tall, with flat rocks. Meanwhile, other preparations were being made. Another woman, working with a sleeping baby tied to her back, was pulverizing hard red rock and soil in a wood mortar until it became a fine, red sand that she then sifted through a strainer. This red sand was added to a large calabash filled with water and stirred into a thick, creamy consistency. Several women applied this mixture over the thicker, darker brown cow dung (Fig. 12). Then they smoothed the mixture with flat river stones and allowed it to dry for a short time. Normally, the drying period for each stage of the painting would take several hours before the actual design painting began.

During this entire procedure, another woman prepared a large calabash with black pigment, also made from a pulverized rock. A different woman made paintbrushes for the group by catching a small chicken and plucking several of its feathers, which were then tied together at one end with a piece of straw. The women consulted each other about the design process and then decided to start from the top down with the broken calabash motif. They outlined the top row first, then filled in the forms, and began another row below, utilizing the drum motif. A much smaller version of the broken cala-

bash pattern was then repeated before creating the last pattern, which consisted of horizontal lines symbolizing garden plots (Fig. 13). Then, as some women continued to paint with black pigment, others reached around them with palm-size, flat white stones that they rubbed over the red sand area (Fig. 14). Gradually, a glowing white patina began to cover the undercoat of red sand. They repeatedly polished the surface with short, circular strokes in order to highlight the contrast in the design (Fig. 15). Another woman showed me a handful of locust bean pods from the dawa tree, and the chief's son explained how they would be boiled for several hours, resulting in a clear, glutinous liquid that would then be washed over the surface of the entire painting. Three applications of this solution would then protect the wall and the painting from the heavy rains,

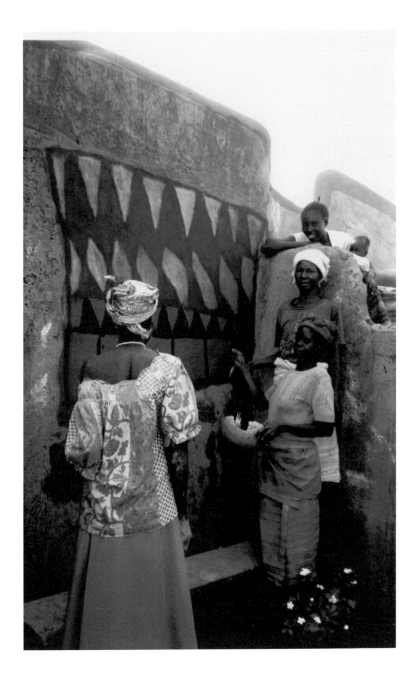

(Fig. 14) Painting with Black and White Pigments, Tiebele, 1993.

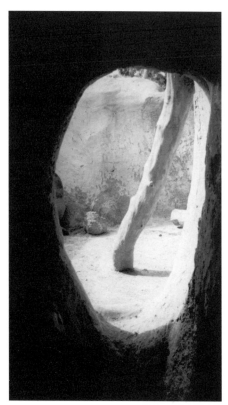

(Fig. 17) Entry Way to a Birthing Room, Tiakane, 1993.

ensuring that it would last for approximately four years before needing to be repainted.

It was fascinating to observe these women painting as they physically seemed to enjoy each stage of the process, from the preparation of the pigments and the wall surface, to the actual painting process, whether with bold strokes of the hand, with the delicate tip of their guinea fowl brushes, or with flat white rocks burnishing around each shape between the black forms.

The history of wall painting is vague, and Courtney-Clarke offers only general insights about the tradition as being "handed down from mother to daughter from generation to generation."[5] She also adds:

> *Despite overwhelming odds, what has survived though sporadically is the belief in community. Social interaction among the women, especially between co-wives in a polygamous society, and their need for self-expression as well as their desire to please their husband are reasons for the art which survives today."[6]*

TIAKANE

From the Po market, the road to Tiakane was approximately twelve kilometers of narrow turns, filled with deep holes and treacherous rocks. But, by December, the road seemed more easily negotiable since this was the dry season, while in July unexpected rivers of

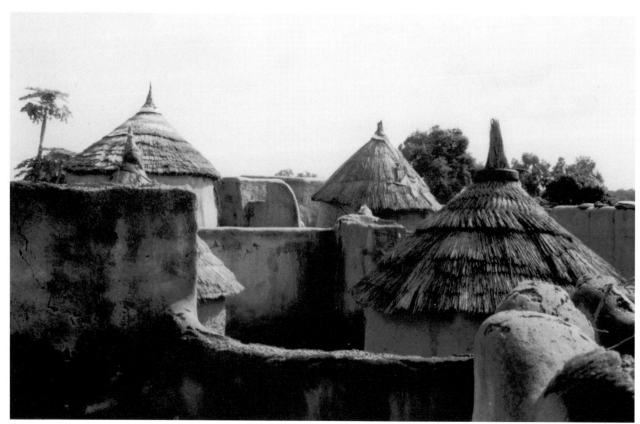

(Fig.16) The Chief's Compound, Tiakane, 1993.

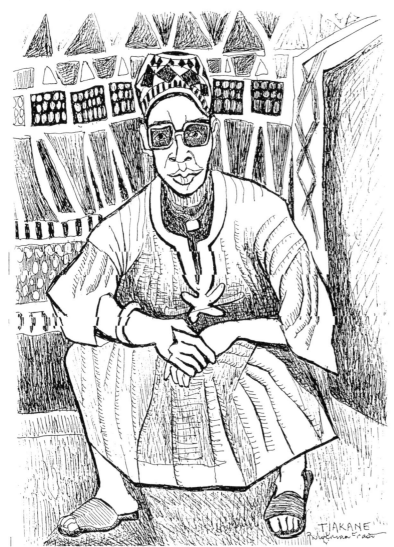

(Fig. 18) Chief Bouilou Apiou Douliguiou, by Betty LaDuke, Drawing, 11 x 14'', Tiakane, 1993.

water also submerged parts of the road, making driving even more hazardous. However, there was much to see along the way, as tall trees provided some shade and there were many homes on either side of the road. Women returning from the Po market were carrying huge enamel pans, calabashes, and baskets filled with produce on their heads. But Tico knew that the Tiakane chief's compound was at the very end of this long road, and I felt privileged for the car ride.

When we first arrived, the compound façade at Tiakane seemed less interesting than the one at Tiebele (Fig. 16) as there was very little painting on the outer walls, but, on entering the compound, this feeling changed immediately. The mud wall structures were built on several levels. Some were dug out partially below the ground, so that one had to bow down very low to enter the oval, womb-like openings. These were birthing rooms, where mothers temporarily resided with their newborn infants for quiet seclusion (Fig. 17). There were also elevated rooms that could be reached

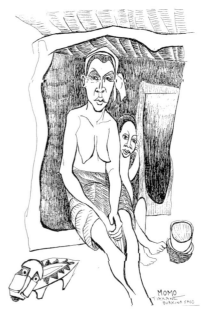

(Fig. 19) Momo, the Master Painter, by Betty LaDuke, Drawing, 11 x 14'', Tiakane, 1993.

13

only with notched ladders. Each alcove revealed a personal vignette of women cooking or children playing.

Before the chief's son, Balliou Baki Pregnon, led me through this maze, I was able to greet the chief himself. He was dressed in a traditional hand-loomed blue and white tunic, wearing the same orange and brown diamond-patterned hat and sunglasses that I remembered from July. Since I had come with photographs from our previous meeting that featured the chief with one of his fourteen wives, he was very pleased to see me. The chief then invited me into his special chamber.

What made this room so extraordinary was the traditional painting that covered one wall. It glowed with the warmth of the earth

(Fig. 20) Binger's Room, Tiakane, 1993.

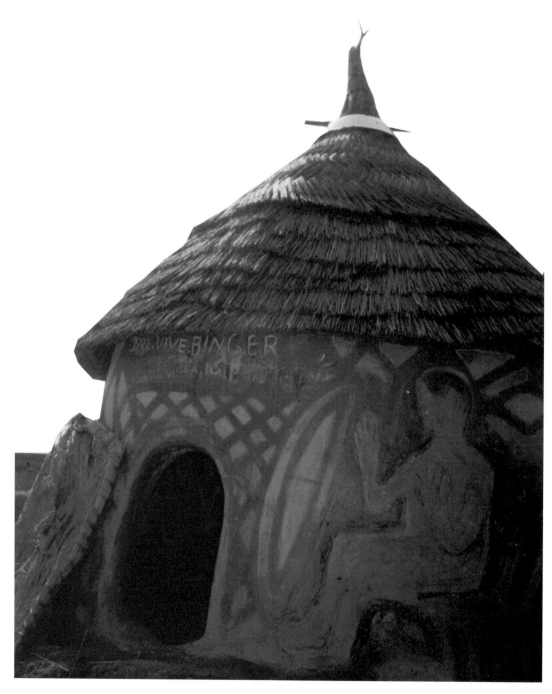

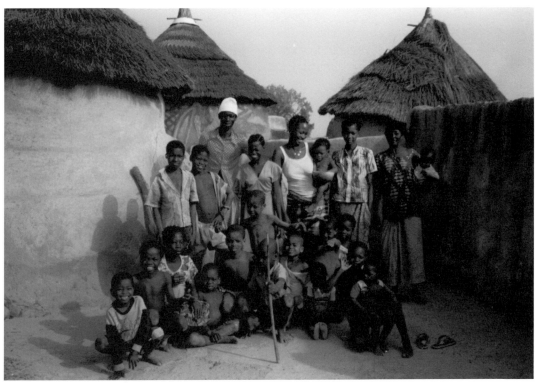

(Fig. 21) Tiakane Family Compound, Tiakane, 1993.

colors and the shiny application of the locust bean pod solution. Raised shelves along the edges of the room served as seats or beds. I asked Chief Bouliou Apiou Douliguiou, age eighty-four and seemingly in good health, if I could draw him, and he agreed (Fig. 18). This proved to be a more interactive process than mere photo taking, as many of the chief's twenty-four younger children and grandchildren came to see the drawing evolve. But Pregnon, the oldest son and my designated guide, kept them at a distance. Ultimately, the chief seemed to approve of my drawing.

As my tour continued through the labyrinth of rooms and compartments, I was fortunate enough to meet the chief's first wife, Momo, age 70. I was especially interested in Momo, as I was told she was one of three women who did most of the painting in the compound. Oddly enough, her room was bare of any painting, but a large drum was suspended along the wall, and there were several small stools carved in the shape of little animals, such as a cat and a tortoise near her cooking fire. She did not mind my drawing her (Fig. 19) but said photographs were prohibited because of a special sacrifice and promise she had made many years ago.

What I found most interesting at Tiakane was a circular room raised high, at the very center or apex of the compound (Fig. 20). The exterior painting created by Momo featured a seated figure with a hunter's bow. Pregnon said, "The bow is to get rid of all evil spirits." Printed on the wall above the small arched doorway was the date, "1882," followed by "Vive Binger." Pregnon then told

me, "Binger was a French explorer who lived here in this room for one month in 1882, and this room is dedicated to him." Currently Pregnon sleeps in this room, but it also serves as a "marriage chamber." The current chief's father, "Nigoue, knew Binger, the French explorer." When everyone was present, Pregnon also told me the household numbered approximately sixty. Before departing, I took a photo of as many of the wives and children who were available to gather together below Binger's room, though Momo was not present (Fig. 21).

PO

En route from Tiakane to Po again, where I had one more special compound to visit, a woman asked if we would give her a ride. It turned out she would be extraordinarily helpful, since she was originally from Ghana and spoke English.

When we arrived at the compound, situated on a small hillside overlooking millet fields, two brothers greeted us. This compound had first attracted my attention in July, as one exterior corner was painted in an unusual style, its vibrant figurative paintings visible from the road. The brothers had invited me to see their house close up, as well as the new addition of three rooms that were also painted in this personal-story style. But, since they only spoke French and their local dialect, I had been limited primarily to the visual enjoyment of this unusual environment. Now, with my bilingual Ghanian acquaintance, I had the opportunity to ask questions, hoping to learn the history and meaning of these paintings.

During this second visit, I was once again welcomed by the brothers of the Aliroc Zahereen Manorie family and their mother who was holding a grandchild on her lap (Fig.22). They were very pleased that I had sent them photographs of my July visit. Seeing these painted rooms again gave me a much clearer understanding of their prestigious function. The rooms were kept locked and were set aside for visitors or to commemorate special occasions rather than for everyday use. In one corner, a table was filled with a large collection of painted enamel pots for cooking (a prestige item). At the time, a large sack of grain was also stored in this main room. There was an adjoining bedroom and a smaller room for taking a bath. But what made these three rooms extraordinary is that one continuous painting, filled with active, whimsical figures and decorative patterns, evolved from floor to ceiling in a unified flow of movement (Fig. 23).

The brothers told us that Kavari, a woman artist, had been hired to do this special painting. Since she lived way out in the bush, if we returned the following morning, they could bring her to the house for me to meet. Sure enough, at 8:00 a.m. the next morning Kavari was there, and she seemed delighted that I was interested in her work (Fig. 24). We laughed as we discussed the meaning of the many adventures she had playfully portrayed on those walls. One central image featured a celebration with men in

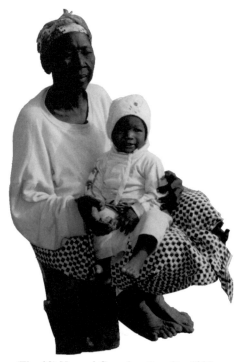

(Fig. 22) Nanoui Grandmother, Po, 1993.

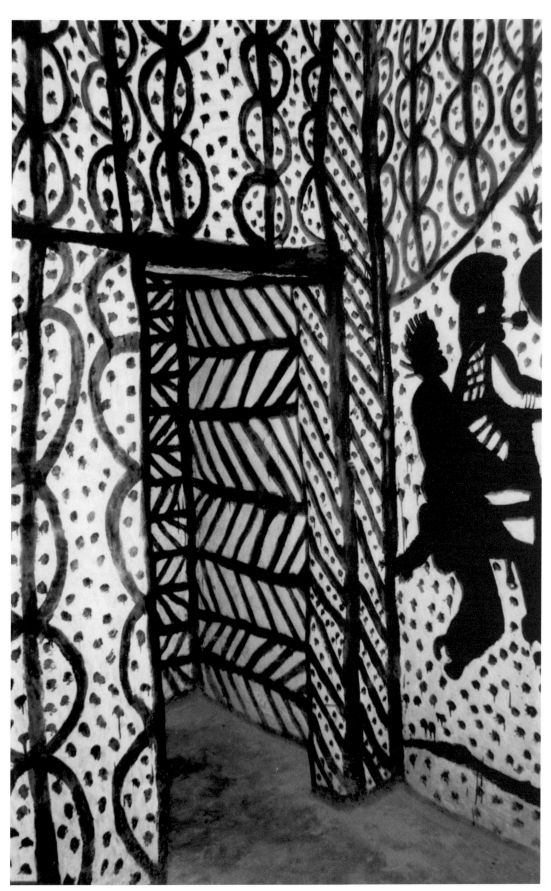

(Fig. 23) Nanoui Family Home Painted by Kavari, Po, 1993.

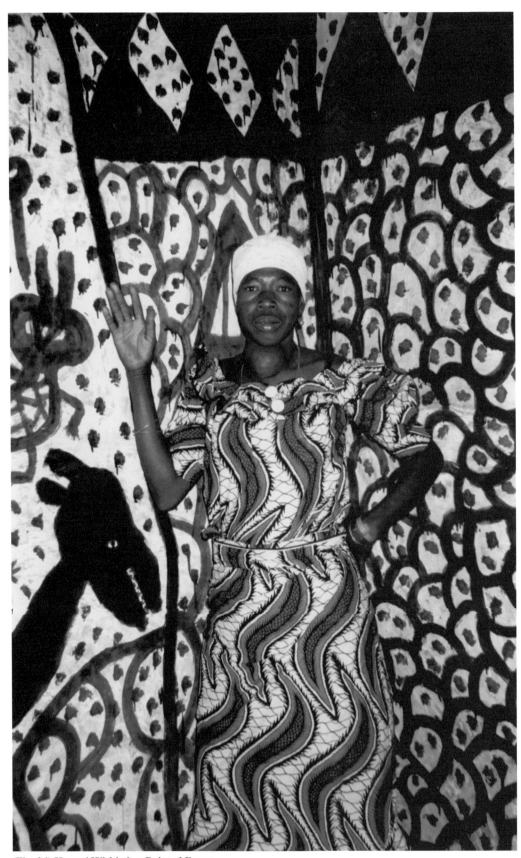

(Fig. 24) Kavari Within her Painted Room.

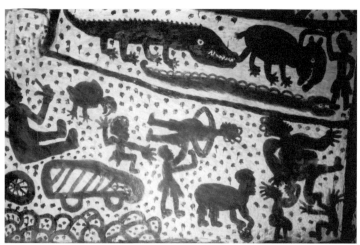

(Fig. 26) Crocodile Biting a Cow, by Kavari, Po, 1993.

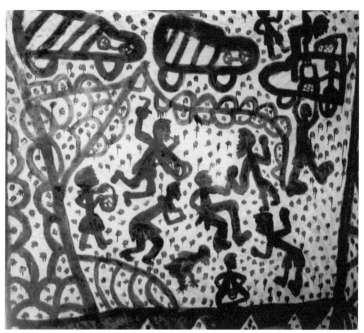

(Fig. 25) Men Celebrating, Drumming, and Dancing, by Kavari, Po, 1993.

a circle drumming, and three cars parked nearby (Fig. 25). On another wall, at the very top, a huge crocodile was biting a cow, while a large serpent attacked a man. Below, from left to right, a man was smoking a pipe as he entered the compound (Fig. 26). Nearby, a healer sat, giving advice to two people attending a sick person. At the bottom, two people were attending a woman who was in the process of giving birth. Another story unfolded along the wall partially covered by the table and enamel pots. A hunter with a bow seemed to be chasing away animals that might attack his cow and sheep. Above, a chicken seemed to be pecking at a huge serpent. Birds appeared in all of the scenes, whimsically overlooking these activities (Fig. 27).

The Nanoui brothers told Kavari that she could do as she pleased. They provided the paint, consisting of a commercial white enamel for the underlying coat and black to delineate the images. It took Kavari about five days to complete those walls. She seemed to enjoy telling me about the images, but insisted, "I can paint more beautiful than this, and in many more styles."

Kavari told us she was born on the Gold Coast in Ghana in 1948 but was brought to Burkina Faso as a small child. Therefore,

(Fig. 27) Chasing Evil Away, by Kavari, Po, 1993.

she does not speak English, but, through our Ghanian interpreter, she told me: "I learned to paint from one woman when I was about 20 years old, and I have painted many houses." Kavari has three children. She said, "They don't paint, but now I will teach my youngest daughter, who is 13 years old, to paint." Since Kavari's commissions for painting houses are sporadic, she also depends on her garden for growing millet and vegetables (pumpkins and tomatoes) to eat and sell.

The Nanoui family (Fig. 28) are very proud of their ample compound overlooking their millet fields. In addition to rectangular rooms at one end of the compound, a wall enclosed four circular huts for their wives and children and their mother. There were also two smaller huts for cooking and others for storing grain. I tried to imagine what it would be like to be in the compound during a rite of passage, a birth or marriage celebration. How were the painted rooms utilized—for spiritual protection or a healing ritual? These seemed to be some of what Kavari had shared with them or similarly experienced, and then utilized as the subject of her paintings.

I was sorry that time limitations did not allow me to visit more of Kavari's delightful paintings at other compounds. After meeting with the women painters—that is, the wives of chiefs in polygamous households of Tiebele and Tiakane—I realized Kavari's position as a freelance independent artist was unique. She was self-

supporting, depending on her own initiative to create images that were personally satisfying as well as pleasing to her clients. She had earned a positive reputation and a position of status and respect within the Po community. However, since she worked alone it was easier to use commercial pigments. The bold contrast and gloss of her work was less subtle than the warm earth tones the women achieved from local sources as they collectively applied their mixture over prepared and smoothed surfaces with their rhythmic hand motions, while Kavari relied on a commercial brush.

I also wondered if there was a parallel between Kavari and the painter of the one-eyed magic woman in the Tiebele compound? Did their paintings reflect each woman's personal capacity for promoting magic activity or their own healing powers? Would Kavari be a role model for other women who, with or without healing powers, wanted to paint outside of a collective or communal situation?

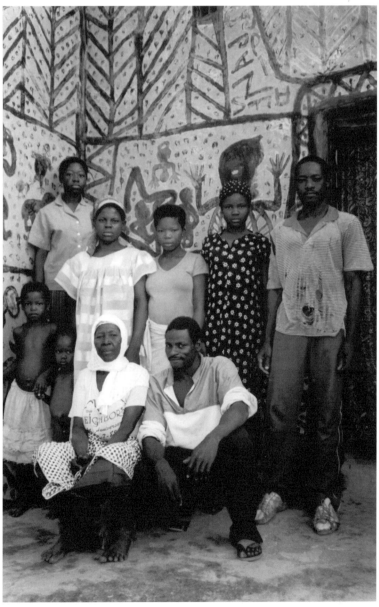

(Fig. 28) Nanoui Family, Three Generations, Po, 1993.

Endnotes

1. Fred T. Smith, "Gurensi Wall Painting," *African Arts* Vol.2, No.4, July 1977-78, p.36.
2. *Ibid.*, p. 40.
3. *Ibid.*
4. Margaret Courtney-Clarke, *African Canvas, the Art of West African Women* (New York: Rizzoli Int. Pub., 1990), p. 70.
5. *Ibid.*, p. 70
6. *Ibid*

Though I left with many unanswered questions, I really appreciated this opportunity for a brief glimpse into a cultural community that encouraged women to paint and to fulfill a deep human need, to create and to live in a harmonious environment surrounded with *bambolse*.

Timbuktu, Mali

DESERT VISIONS IN FABRIC, STRAW, AND LEATHER

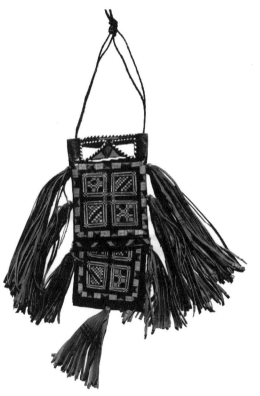

Timbuktu is inaccessible by road for most of the year, and reaching this remote but renowned ancient Islamic spiritual center required a precarious four-day boat journey up the Niger River or a short plane trip. With the realization that it would be five days before I could leave Timbuktu, I decided to fly from Bamako, Mali's capital.

Arriving in the mythical city in December 1993, I initially was struck by a dismal sense of endless space. There was sand everywhere, augmented by an eternal sand-colored horizon that merged earth and sky. Few people were visible, and Timbuktu truly seemed utterly isolated. Morosely, I began to wonder about my emotional survival in such a forlorn environment (Fig. 1).

The name Timbuktu (or Tombouctu as it is written locally) is credited to a woman. Around A.D. 1100, a tribe of nomadic Tuaregs was herding its livestock near the banks of the Niger River and accidentally came upon an oasis. The Tuaregs established a permanent settlement there, and when they decamped (as part of their annual cycle) to seek new pasture for their large herds of goats and camels, an old woman was left in charge. Her name was Tombouctou, which means "the mother with a large navel."[1] Gradually, a market developed in this area, and it became a meeting place for people traveling by canoe or camel. Through the centuries, Timbuktu thrived as the commercial crossroads between the desert and the Niger River, and Tuaregs still carve and wear protective wood amulets dedicated to the "mother of Tombouctu."

Until the recent period of drought (1980) and the desert's rapid and persistent annual encroachment upon grazing lands (1950), Timbuktu and the surrounding region have experienced few ecological changes. As a result, the current social and geological changes visited upon the nomadic Tuaregs have been devastating. In the past, they were the proud guardians of the desert camel routes linking Mali, Mauritania, Algeria, Morocco, and Egypt. In the nineteenth century, Tuareg warriors were "a familiar menace to Europeans who attempted to conquer Saharan territories," but their swords and shields were no match for machine guns. While the Tuaregs "have never been completely out of contact with the West . . . or isolated from urban society . . . they take pride in remaining apart and distinct. The desert is clean and wholesome, they say, while the city is filthy and full of evil."[2] Although Tuareg culture had survived bullets and attempted colonialization, I now wondered

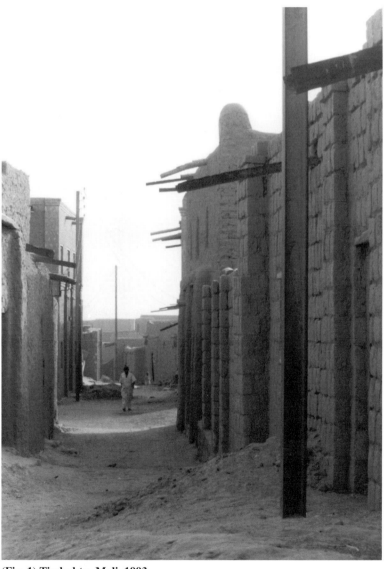

(Fig. 1) Timbuktu, Mali, 1993.

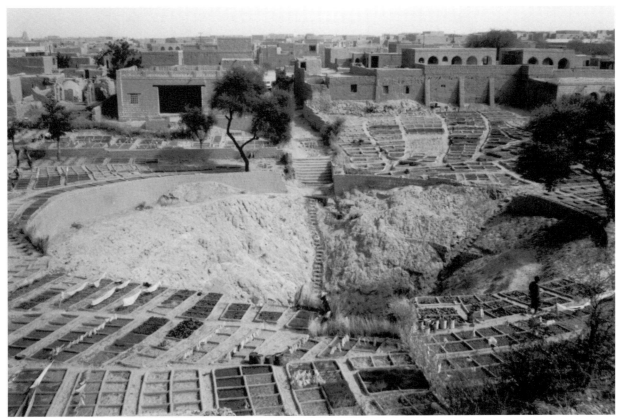

(Fig. 2) Collective Garden Around a Dried Lake, Timbuktu, Mali, 1993.

what lasting impact desert encroachment on their grazing lands, Western technology, materialism, and the Bible would have upon their way of life and their Islamic beliefs. Would their creativity give them a stronger role in that society? How would women creatively respond to this current crisis and struggle for survival?

Fortunately for me, Mohammed Hamzata, a lean young man of Tuareg heritage, wearing jeans and a tee-shirt and speaking some English, offered to be my guide. Before we started out, he told me that he frequently accompanied his father's camel caravan on 800-kilometer desert treks to collect salt, just as in biblical times. For these occasions, he would, of course, be appropriately attired in traditional garments and veiled. With Mohammed's help I gradually began to explore some of the unique layers of Tuareg history, culture, and contemporary life that co-exist somewhat incongruously in Timbuktu, a city that advertises itself on a local billboard as "Mysterious" and "City of 333 Saints."

I was curious to see a World Vision project site, as several years ago I had read about this Christian organization that promoted a women artisan's collective in Timbuktu to increase the women's subsistence income. When I met Timbuktu's Minister for World Vision, Dan Halley from the United States, we spoke first about the environment. I was shocked when Halley informed me that "Only forty years ago, around Timbuktu there were flocks of birds, forests of trees, crocodiles in the rivers and many lakes that provided water

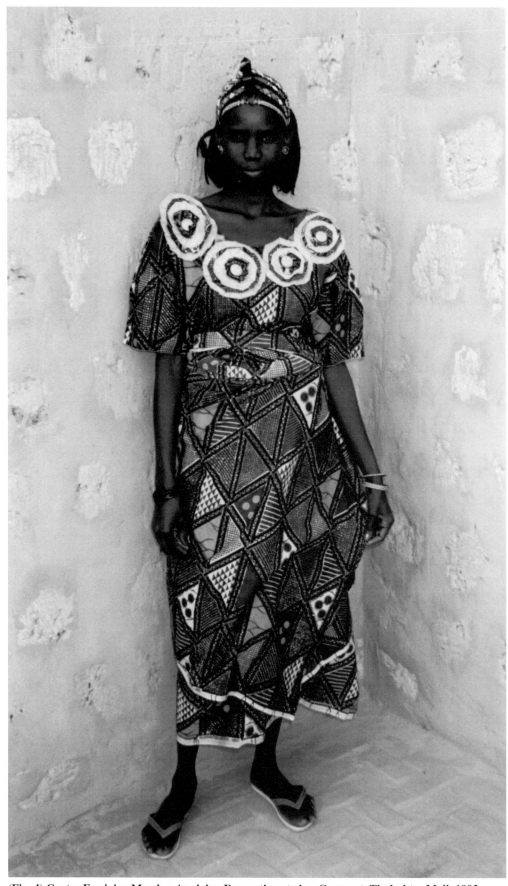

(Fig. 4) Centre Feminine Member Applying Decorations to her Garment, Timbuktu, Mali, 1993.

for hundreds of acres of irrigation, and the sustaining of goats, camels and horses." This was difficult to imagine because, since then, rainfall has been minimal, and the Sahara has insidiously encroached upon daily life, creeping into towns and covering everything with sand. Timbuktu has been steadily crumbling, and houses were in disrepair. Tents were cast where buildings should be, as many wealthy Tuareg's have lost most of their goat and camel herds because of the drought, and in desperation, settled in or around Timbuktu.

A recent two-year war (1990–1992) between the nomadic Tuaregs and the commercial and farming peoples around Timbuktu added to the current difficulties, which were compounded by a lack of water and food. But when I arrived there was peace and life stubbornly persisted. On the outskirts of Timbuktu, site of the government hotel, there is, surrounding the rim of a former lake, a huge collective garden with steeply carved steps leading down to the lake bottom, where the Tuaregs retrieve the remaining water (Fig. 2). Gradually I began to see beyond the bleak sand-covered horizon to discover traditional and innovative projects related to women's creativity and economic survival which I spent the next five days exploring.

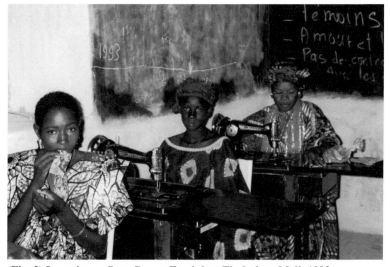

(Fig. 3) Learning to Sew, Centre Feminine, Timbuktu, Mali, 1993.

World Vision and Sewing Machines

Since 1953, there have been missionaries in Timbuktu. But in 1990, World Vision established a new focus that attended to the physical and the perceived spiritual needs of the people. A small, rectangular building had been constructed that served as both a Centre Feminine (Women's Center) and an Eglise Mission Evangelique (Evangelical Church) for Sunday sermons. Pasteur Nok Yatara, born in Timbuktu of Tuareg and Moslem heritage, was their only African Christian minister convert, and he worked closely with Dan Halley.

Pasteur Nok (as he is called) had been preaching the gospel since 1967, but in recent years he became involved with survival projects such as well drilling, gardening, and tree planting. He was particularly proud of his work with two women's associations in Timbuktu, which brought together women of different tribes—Tuareg, Songhai, and Bambara—while promoting new or traditional craft skills, alphabetization, and Bible lessons.

The work of Timbuktu's Christian missionaries progressed with difficulty, as this predominantly Moslem population was under the supervision of *marabouts,* or Moslem spiritual leaders and teachers. Christians were in awe of certain marabouts, Dan Halley explained, because "they had powers to enter your courtyard, go through walls, or use black magic to put curses on people, or white magic to provide good results." It was fascinating to hear about the evil power of witches, appearing as birdlike creatures, who had the power to "convert a man into a hyena or the reverse." Though I was interested, I did not have time to explore these mysterious happenings.

Halley also wondered about the "marabouts who treat us with respect, but what do they say behind our backs?" He was concerned that there is an attraction to Christian missionaries, because they are perceived as "having access to wealth, and unlimited resources."

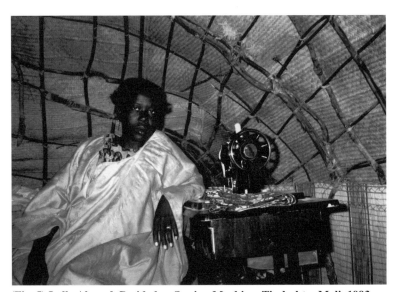

(Fig. 5) Lalla Ahmad, Beside her Sewing Machine, Timbuktu, Mali, 1993.

Indeed, the Women's Centre promoted this image of Christian prosperity in making over a dozen foot-pedal Singer sewing machines accessible to two women's groups (of forty each) that met there for two hours each day, four days a week. Their sewing teacher was a World Vision convert from Ghana. She directed their learning activities, which included using the sewing machines, as well as creating various forms of hand-stitched, intricate embroidery and

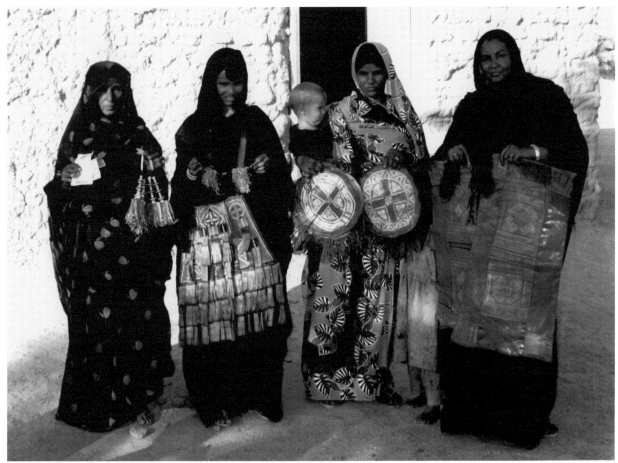

(Fig. 6) Members of the Villageoise de Bariz Women's Collective, (left to right): Arawdat Walat Mohamed, Ashtiku Walat Hadini, Tehake Walat Mohamedali, and Wartim Walat Amala, Mali, 1993.

appliqué-embellish garments (Figs. 3 & 4). Women of mixed heritage comprised one group. They were from fifteen to thirty-five years of age; they were unmarried. The second group varied from eighteen to forty-seven years of age, and they were all married. During my two-hour visit to the Centre, the women seemed happy to be there, especially to learn how to sew by machine, usually a business activity performed by men in commercial shops or in market stalls. The goal of the program, in addition to Pasteur Nok's Friday Bible studies (the lessons were evident on the blackboard), was to give each woman graduate of the nine-month program a sewing machine. The first year the course concluded, I was told that approximately twenty women received sewing machines donated by the Netherlands Embassy. Last year twenty-five women completed the course, but no sewing machines were available.

I asked to meet a sewing machine recipient, and early one morning Pasteur Nok brought me to the tent of Lalla Ahmad. I had to stoop very low to enter, as the tent was shaped like a shallow half moon. It was composed of several layers of large straw mats stitched together over a frame made from curved tree branches anchored into the sand. The foot-powered sewing machine was

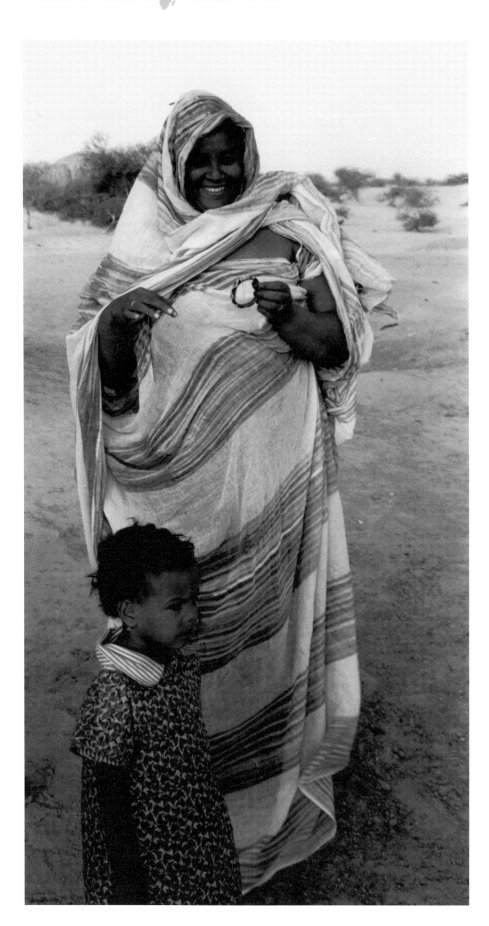

(Fig. 7) Wartim Walat
Amala Beading a Bracelet,
Villageoise de Bariz, Mali.

near the doorway, the only source of light (Fig. 5). Lalla sat beside her machine wearing one of her own creations, a bright pink *bou bou*. She told me that before she attended the Centre Feminine, she had no skills or employment possibilities. Now she could earn some money, especially around the Moslem holiday season, when she receives sewing commissions for *bou bous,* "which are two and one-half meters wide and completely envelope and conceal the body of its owner in folds of cloth, proudly proclaiming his membership within the community of the faithful."[3]

Lalla is approximately twenty-seven years old. She was not married but has had three children, one of whom died. She is happy to have her own home and to be able to work there, but every two years she must buy new mats for her tent roof. Lalla told me she does not earn enough money to pay for more than millet grain, their year-round food staple. However, she is in a better position than she was earlier in her life. Pasteur Nok translated her comments: "With the gospel, she sees sin in things she did before. Now she must not repeat these sins. Now she has a good spirit to find work. With the gospel she sees the importance of helping her family."

(Fig. 8) Bracelets by Wartim Walat Amala

Tuareg Leather and Bead Work

Another day I accompanied Pasteur Nok to a Tuareg settlement only about two kilometers from Timbuktu. But because we were walking through ankle-deep sand, the distance seemed interminable. En route, there was nothing to see except an occasional Tuareg tent and one precious water pump where young people congregated to wait their turn to fill the clay pots they carried to their respective but much dispersed tents. Finally, on the distant horizon, I spotted a tall, two-room adobe structure, the meeting center for the Villageoise de Bariz women's collective (Fig. 6). With Pasteur Nok's assistance, this collective was constructed and began to function in 1984. At the time of my visit, it numbered approximately fifty members. The president, Wartim Walat Amala, was a tall, smiling woman, and she, along with ten other women and their children, had come from the surrounding Tuareg settlements to greet me and show me their bead and leather projects (Fig. 7). Production time for Amala was not wasted, since she continued to attach decorative beads around the outer edge of a leather bracelet as we spoke. The bead designs were complex and involved several colors, but it only took her one day to complete a bracelet while simultaneously attending to many other mundane chores.

As the women gradually assembled, they seemed, dressed in their colorful garments, like an oasis of brightly painted flowers in the otherwise colorless setting. When they opened the association door, I saw two tables crowded with an assortment of leather work, mostly red-patterned cushion covers, large and small; ornately designed shoulder bags and key rings arrayed with lots of tassels; and baskets filled with beaded bracelets. The technical quality of these pieces, along with their aesthetic appeal, was irresistible, and the women seemed overjoyed to sell me several leather items and beaded

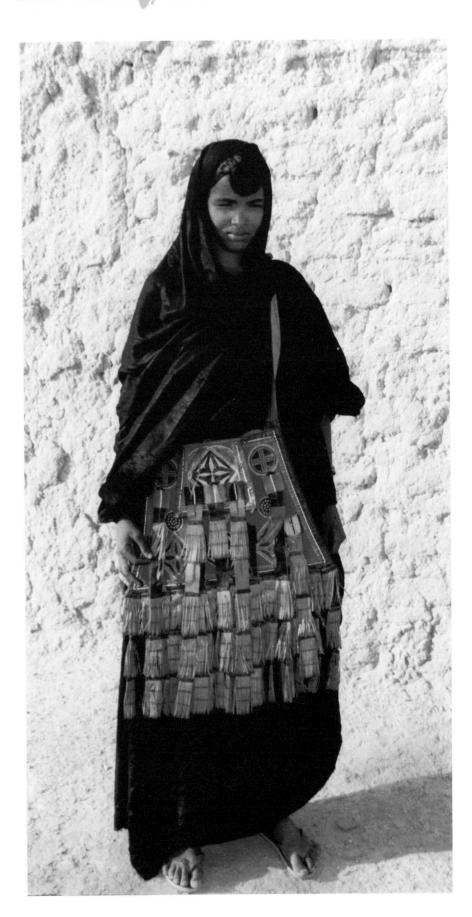

(Fig. 9) Ashtiku Walat Hadini Wearing her Leather Shoulder Bag, Villageoise de Bariz, Mali, 1993.

bracelets (Fig. 8). Few tourists ventured to this distant workshop, although traders and merchants did stop by. The adjoining work-shop room contained a blackboard and functioned mainly as a class-room for Bible and literacy studies and for group meetings, all pre-sided over by Pasteur Nok.

Pasteur Nok told me that when the French colonized the re-gion, they referred to this then-thriving and fertile land as "little Paris." The Tuaregs pronounced Paris as Bariz, and since then their settlement of about three hundred people is known as Villageoise Bariz. Within Tuareg society, there is a class hierarchy that consists of nobles, vassals, holy men, and slaves. The slaughter of animals and the tanning of hides is by custom the work of metal forgers or smiths, whose social status in Tuareg society "is between holy men and slaves."[4] While the men create the basic forms of the sandals and camel saddles, women cut and shape leather bags, wallets, and smaller items and embellish them with distinctively detailed de-signs. René Bravmann enthusiastically describes Muslim creativity as applied to items of everyday life as a "passionate pursuit of el-egant shapes, complex geometric patterns, sumptuous colors, and exquisite textures. To look at such objects is to confront a world of forms marked by a special beauty and purity of design that cannot fail to please the beholder."[5]

In this regard, Ashtiku Walat Hadini's work is particularly impressive. She wore a large triangular shoulder bag made from goatskin (Fig. 9). Applied to the tan surface were intricately cut and stitched green and black circular and rectangular leather patterns, which revealed a layer of red cloth beneath the cut sections. Long tassels were suspended from the bottom, and there was also white lace stitching coordinated with the geometric designs. It took Hadini one month to complete this elaborate bag, which in the past would have been filled with her personal possessions during the family's cyclical desert treks searching for pasture for their animals.

Maude Wahlman, in her 1974 publication *Contemporary Afri-can Arts*, offers the following insight: "Elaborate geometric designs are a trademark of Islam and their use in Tuareg culture is natural for the Tuareg[s] are Moslem, even if only nominally so." She adds that while some Tuareg artisans have recently used felt-tipped pens to augment their designs, overall in their leather work, "there has been little change in the past fifty years in spite of other profound cultural changes."[6] In twenty years since Wahlman's book, I could see no major changes in the quality of the leather work.

Since many of the Villageoise Bariz residents had lost their livestock, securing leather was difficult. Many Tuaregs remained close to Timbuktu, and many of the items formerly made for per-sonal use were now created for tourist sale. Pasteur Nok explained that when there are sales, the association keeps a small percentage of the income so that group members can borrow money for per-sonal needs. They were required to repay the loan with interest. But while their decorative leather work was appealing to tourists, the recent war was devastating for sales.

**(Fig. 10) Resting Camel, by Betty LaDuke, Pen Drawing, 11 x 14",
Timbuktu, Mali, 1993.**

Before returning to Timbuktu proper, I was taken on a tour of the local collective garden and of several family compounds. Each compound was fenced in with old straw mats and thorny brush to prevent the remaining animals from eating the garden produce and to protect the family privacy and the compound from desert winds and encroaching sand. The Tuareg diet consisted primarily of millet, which in previous years had been supplemented with goat's milk and meat.

In the Tuareg's matrilineal society, the position of women is strong, as "the rights to chieftainship and other ranks and privileges are inherited through the women . . . and property is inherited from both parents."[7] It is significant that the guardian of Timbuktu is a woman. "Mothers have special knowledge of Tuareg cultural practices, herbal medicine, and history and, as a result, are public persons who are sought out for their counsel."[8]

Another unique aspect of Tuareg culture is that assertiveness is valued as a desirable feminine trait. In contrast to other Moslem societies, where women are veiled, in Tuareg society "the men wear the veils." In her article "Where All the Women Are Strong," Barbara A. Worley states, "Tuareg women wouldn't consider veiling their faces, and they continue to assert their right to a public presence and to voice their opinions openly."[9] However, there are variations in the manifestation of these traditions among the Tuaregs, as they are organized in confederations, tribes, and clans and geographically span a large desert area within several nations.

Since the war, tourists have gradually returned. One morning I agreed to take a short tourist-promoted camel ride (Fig. 10) to a nearby encampment that included a visit with a Tuareg family and a ceremony that consisted of drinking three small glasses of strong peppermint tea heavily sweetened with sugar. As I sat with the

family, slowly sipping the tea, I made sketches of them (Fig. 11). The husband, Bouiliou Apiou Douliguiou, was veiled, and while he was intent on showing me his elaborately curved knives that he said he made, as well as an assortment of small, ornate teapots and amulets, I found myself more attracted to the leather wallets that his wife produced. They were approximately six by four inches and adorned with many tassels (Fig. 12). Their surface pattern was vividly detailed with contrasting strips of interwoven leather. I was surprised that three successively smaller wallets used for holding coins, amulets, needles, or other small items were contained within the outer one. They were designed with a bottom tassel so that the inner wallets could easily be pulled down or made to retreat with a quick tug on the neck string.

Though it is unlikely that many Tuareg women of Villageoise Bariz and the Timbuktu region would have the opportunity to travel beyond their desert environment, examples of their traditional artistry are becoming more accessible in Bamako and as far away as New York City. Timbuktu amulets, leather wallets, and beaded bracelets are often on display at New York's African Art Museum

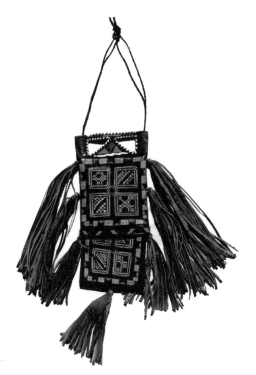

(Fig. 12) Tuareg Leather Wallet, Timbuktu, Mali, 1993.

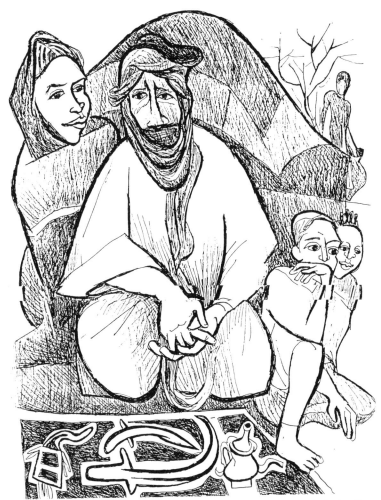

(Fig. 11) Bouiliou Apiou Douliguiou and His Family, by Betty LaDuke, Pen Drawing, 11 x 14", Timbuktu, Mali, 1993.

gift shop, brought there, I was told, by tourist guides and traders.

Bravmann points out that the decorative urge not only reflects the Moslem fascination with mathematics and geometry, pattern and design, but serves as "a mirror for deeper realities . . . to remind man of his deeper and more enduring relationship to the cosmos."[10] There is also a relationship "between the desire for abstract patterning and ideas concerning personal privacy and the ways in which Moslems present themselves and interact with one another."[11] Bravmann distinguishes African-Christian communities from Moslem communities and notes the architectural differences as well as "the subdued quality of personal interactions, the stateliness and dignity with which individuals carry themselves and a strong desire for privacy." He goes on to say, "Decorative patterns like formal gestures and manners occur on the surface, revealing little while concealing a great deal."[12]

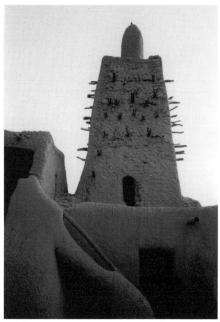

(Fig. 13) Sankore Mosque, Timbuktu, Mali, 1993.

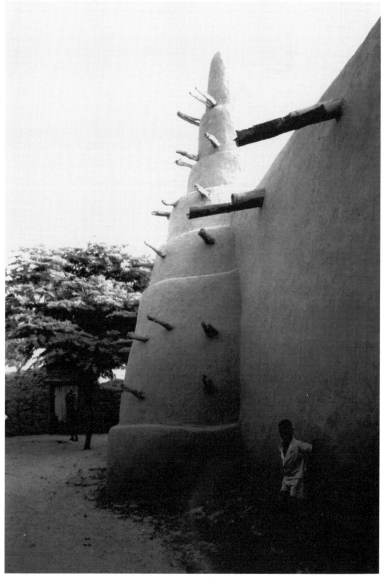

(Fig. 14) Sankore Mosque, Timbuktu, Mali, 1993.

(Fig. 16) Timbuktu Carved Window Shutters, Timbuktu, Mali, 1993.

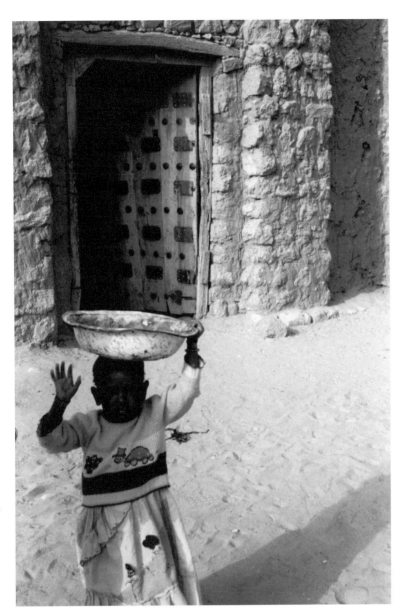

(Fig. 15) Traditional Timbuktu Door and Child-Helper, Timbuktu, Mali, 1993.

Straw Projects

In Timbuktu, the old and the new co-exist. The city continues to be an important Islamic spiritual and learning center; every year throngs of Moslem pilgrims, students, and tourists visit its three illustrious, ancient mosques (Figs. 13 & 14). Other distinguishing Timbuktu architectural characteristics are the traditional elaborate doorways with finely forged geometric iron shapes attached to the wood surface, as well as wooden window shutters with their lattice-like wood frames and cuthole openings (Figs. 15 & 16). While some wives of upper class merchants and marabouts are still confined to interior courtyards behind closed doors and view street life through their keyhole opening, many young women are now seen on the streets carrying books, en route to secondary schools and to colleges.

As Mohammed and I walked along a narrow street of modest homes and undecorated doorways, we saw a woman baking bread

(Fig. 17) **Al Madane Handedeou with her Straw Projects, Timbuktu, Mali, 1993.**

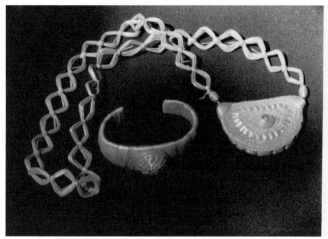

(Fig. 18) "Timbuktu Gold," Timbuktu, Mali, 1993.

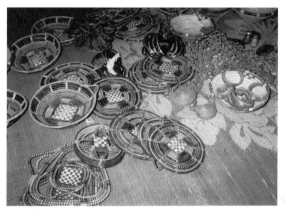

(Fig. 19) "Timbuktu Gold," Timbuktu, Mali, 1993.

in a tall, adobe outdoor oven, another common sight in Timbuktu. Mohammed recognized the woman, Al Madane Handedeou (Fig.17), as she is "very famous for her straw work." Handedeou invited us in and, as we sat on a straw mat opposite her, she gradually pulled out, from various plastic bags, an assortment of her colorful projects (Figs. 18 & 19). They consisted of vivid, multi-colored baskets and placemats with complex woven designs, and elaborate straw jewelry in the form of gold-colored bracelets and pendants.

Al Madane Handedeou explained that she learned to do straw work from her mother and grandmother, and that for the past five years she has been president of the Women's Federation of Artisans of Timbuktu. This group organized and regulated commercial displays of work in Timbuktu and facilitated participation in national artisan festivals. Handedeou's jewelry is unique in that she utilizes bee's wax first to create three-dimensional forms over which she then weaves her intricate straw patterns. She was wearing one of the necklaces created in this technique and was very proud that since 1979 her work has received recognition at the annual Bamako artisan festivals, where she has won a total of eleven awards. Later, I discovered Handedeou's bracelets and necklaces for sale at the African Art Museum in New York, brought there by traders who referred to them as "Timbuktu gold."

Endnotes

1. Kim Naylor, *Guide to West Africa, The Niger, and Gambia River Route* (England: Bath Press, 1986), p. 93.
2. Barbara A. Worley, "Where All the Women Are Strong," *Natural History* Vol. 101, No. 11 (November 1992), p. 55.
3. René A. Bravmann, *African Islam* (Washington, DC: Smithsonian Institute and Ethnographia, 1983), p. 97.
4. Worley, p. 56.
5. Ibid.
6. Maude Wahlman, *Contemporary African Arts* (Chicago: Field Museum of Natural History, 1974), pp. 69, 71.
7. Ibid., p. 67.
8. Worley, p. 55.
9. Ibid., p. 56.
10. Bravmann, p. 93.
11. Ibid., p. 94.
12. Ibid., p. 95.
13. Eddy L. Harris, *Native Stranger, A Black American's Journey into the Heart of Africa* (New York: Simon & Schuster, 1992), p. 289.

Conclusion

At the beginning of my journey, my vision of Timbuktu was based on guidebook descriptions that confirmed the experience of Eddy Harris, as described in his book *Native Stranger, A Black American's Journey into the Heart of Africa*:

> Timbuktu's former glory is merely a whisper on the constant desert winds. The walls of the city are crumbling down, slowly surrendering to those desert winds and to the drought. . . . Its streets are narrow and dusty. . . . People beg continuously. An army of children hold out their tiny hands or little wooden bowls or empty coffee cans, anything they think you might drop a few coins into. They follow the foreigners everywhere. . . . Up close, the mystery dissolves.[13]

It is easy, at first, to see only this one aspect of a larger picture; and poverty is a relative word in Timbuktu as it is in New York City and elsewhere. I found that I was overwhelmed not by begging hands, but rather by creative hands. As I peered beyond the monotone surface, I discerned the women's strength, a culture of resilience and resistance. I was impressed by their ability to survive amidst centuries of enduring custom and tradition as well as their desire to integrate modernity into the culture. International organizations, staffed by Africans and Europeans, men and women concerned with health care and environmental issues, have introduced some modern technology. A few wealthy residents even own generator-operated televisions; there are approximately two hours of daily programming available that includes world news. There were other, more personal technological needs too, as exemplified by Mohammed's request. He asked me to send him a Walkman; he looked forward to listening to it when he joined his father for their long desert treks to dig and haul salt, an activity, he informed me, that he preferred to tourism.

I left Timbuktu with the realization that much more time would be needed to experience fully the revealing and concealing aspects of Tuareg culture. From this brief visit, I also sensed that the Tuaregs would somehow adapt in their rapidly changing environment. If necessary, they would continue to develop agricultural cooperatives, plant trees, or settle closer to cities and water wells. They would also use their traditional leather and metal skills for outreach to local tourists and to the international market.

I was impressed that some of Mohammed's friends, educated young men and women, had a strong sense of responsibility to their communities and wanted to return to small towns and villages to establish learning centers and to teach. Family ties and cultural pride remained strong. At the time of my leaving, Timbuktu no longer seemed so remote. Some cultural aspects would be modified, even persist, but they would forever be enhanced by women's increasing visibility and creative contributions.

Earth Magic

THE POTTERY OF MALI, CAMEROON, AND TOGO

The earth shapes life and is reshaped by life. This basic relationship is particularly evident in rural Africa where life and art merge. Here, art begins by imitating life (nature), then reshaping it. In Africa, it is fascinating to see the earth skillfully manipulated to create pottery for daily use (Fig. 1) or to see mud molded into brick to build the extraordinary temples, palaces, and mosques that spiritually bond individuals and communities (Fig. 2). The earth is also a source of pigments for the symbolic painted wall designs of Burkina Faso, and for the traditional mud cloth garments of Mali (Figs. 3 & 4). For centuries these related "earth-magic" skills, or the ability to transform the ordinary into the extraordinary, evolved undisturbed until the onset of colonialism and the imposition of Western values and material products. Although enamel pots for cooking and zinc metal for roofing are evident, they will never entirely replace pottery or thatched roofs, nor, for that matter, will they replace the potter whose work is eminently more beautiful, culturally significant, and affordable for most Africans.

In rural West Africa, pottery remains synonymous with life. The clay pots the women carry seem like appendages to their bodies as, daily, they take the requisite long-distance walks to pump well water or to find river water for drinking, cooking, or bathing. The water is stored in large, round-bottomed pots that are partially buried like treasure in a corner of each family compound (Fig. 5).

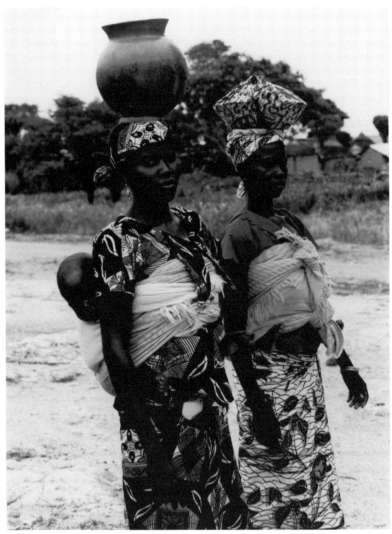

(Fig. 1) Carrying Water to the Farm, Cameroon, 1993.

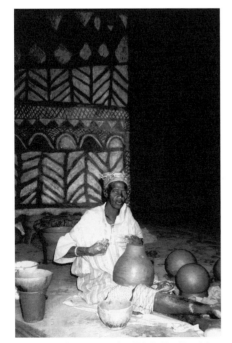

(Fig. 3) Painted Interior Wall, Po, Burkina Faso, 1993.

There are also smaller pottery forms related to ritual activities, including the celebration of the birth of twins as in Cameroon, or the voodoo practices in Togo (Figs. 6 and 7).

Since 1986, the beginning of my annual journeys to Africa, I have enjoyed seeing and touching these intimate yet monumental earth-magic forms. Indeed, observing the women as they created these works was a special privilege. There is a pervasive sense of solidarity among them as they form collective associations to establish prices and to coordinate transportation and marketing, as their earnings are necessary for the economic maintenance of their families. They take pride in their skills, developed over many years of practice and dedication.

The following are descriptions of three different experiences that took place during my visits to Tassakan, Mali (1993); Bamessing, Cameroon (1991 and 1992); and Tsevie, Togo (1991). All highlight some unique aspect of pottery making as well as some important cultural implications.

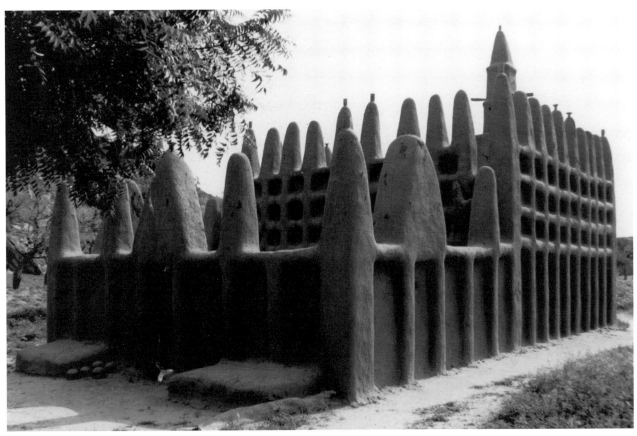

(Fig. 2) Dogon Village Mosque, Mali, 1989.

Tassakan, Mali

In recording the history of Timbuktu and the surrounding region, scholars frequently overlook the importance of women's contributions. For those who live in this arid environment, with temperatures reaching 140°F, pottery continues to fulfill basic survival needs. My first encounter with pottery of this region occurred at Koriam, the nearby Niger River port for boat travelers to Timbuktu. Impressed by the decoratively painted brown and white pottery that had just arrived from the river island of Tassakan, I was determined to meet the women who produced them (Fig. 8).

The following day, en route to Tassakan by a motorized *pinasse* I enjoyed sketching the island scenery (Figs. 9 & 10), but Mohammed Hamzata, my bilingual Tuareg guide, confessed that he felt more comfortable on a camel than in this boat, as he could not swim.

Approximately two hours later, when we arrived in the hot, sandy village of Tassakan, three women were at the shore sorting flat bricks they had just made for a merchant's house in Timbuktu. Nonetheless, they eagerly led us to the compound of Lala Ovoiar Selle, the village chief, where we were invited to sit in the courtyard on straw mats. First, the women made tea for us, then they prepared their materials for a brick and pottery demonstration. In the meantime, the chief allowed me to draw his portrait (Fig. 11).

(Fig. 4) Boy Wearing a *Bokolafini* or Mud Painted Shirt, Mali, 1989.

43

Soon two other women arrived, and as their children and neighbors looked on, all five proceeded to create their entire repertoire of clay forms.

Having worked together for many years, the women were well coordinated and supportive of one another. Two of them began by stamping the clay with their feet, then mixing in the rice dust and grog, ground from previously fired and broken pottery shards.

After mixing the clay, one woman hollowed a shallow, circular shape in the sand, sprinkled the hole with water, and then

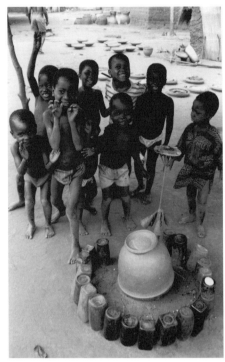

(Fig. 7) Ritual Pottery at the Fetish Market, Lome, Togo.

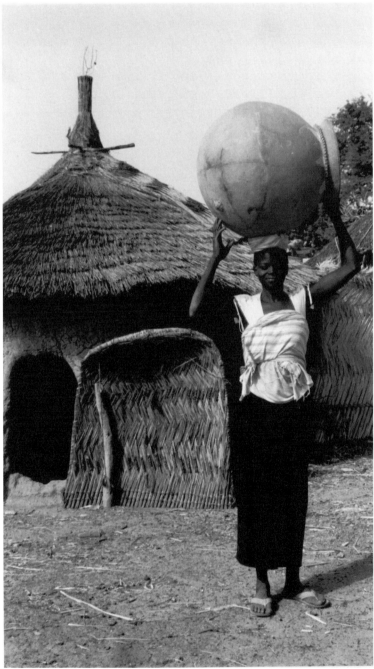

(Fig. 5) Carrying a Water Storage Pot, Burkina Faso, 1993.

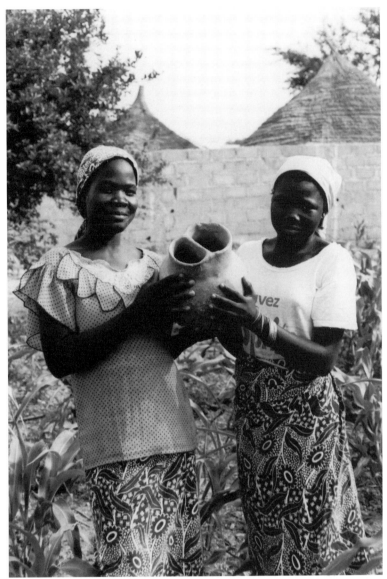

(Fig. 6) Ritual Pottery for Celebrating Birth of Twins, Cameroon, 1992.

placed a small, straw mat over it. Meanwhile, others proceeded to roll clay into short, thick coils that were pressed into metal molds for bricks (Fig. 12). Another woman formed a round ball of clay that she punched and pinched into a bowl shape. Then, she gradually raised the height of the bowl with coils, using the shallow indentation in the sand as a turntable. Their tools consisted of a combination of wood paddles, seashells, clay pestles, small pieces of cloth and leather, and a stick for rim decoration. As each woman worked intensely, her children nearby, she also chatted amiably. In a normal day's work, e.g., from early morning to evening, one woman could produce ten small pots, or five large ones.

The final stage, my favorite part of the process, was the painting of the pottery design, which began with catching a chicken, plucking three feathers, and tying them together to make a paint brush. I was told the white paint, *ging*, was composed of ground

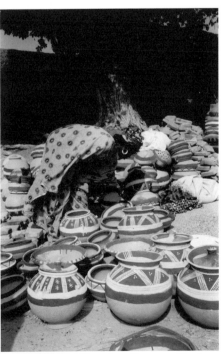

(Fig. 8) Selling Tassakan Pottery, Koriam, Mali, 1993.

45

(Fig. 9) Pinasse, Niger River, by Betty LaDuke, Pen Drawing, 11 x 14", Mali, 1993.

(Fig. 10) Niger River Islands En Route to Tassakan, by Betty LaDuke, Pen Drawing, 11 x 14", Mali, 1993.

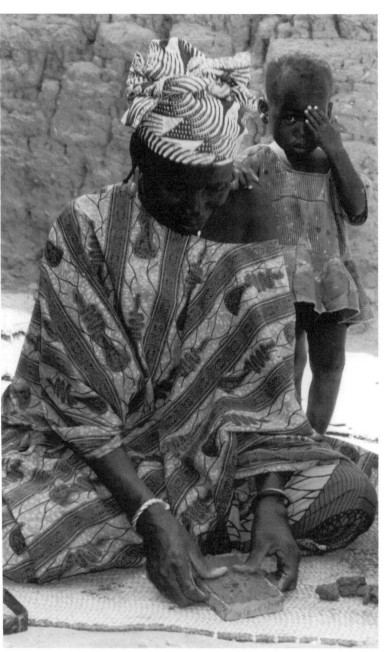

(Fig. 12) Forming Bricks, Tassakan, Mali, 1993.

animal bones (cow, sheep, and goats); while the red paint, *cadom*, was produced from ferrous earth or a stone oxide. The women seemed to enjoy painting, using rhythmic strokes that created thick and thin lines, and crisscross patterns that circled the pots. They claimed there was no symbolic meaning held in these designs (Fig. 13). The finished pots contrasted starkly with the crumbling adobe village. The village seemed almost deserted, though I was told there were three hundred inhabitants. Most of the men had either gone to fish or to work in the rice fields or to market in a neighboring village. Wood for pottery firing had to be purchased from another village. For their water-pump and tree-planting projects, many of these

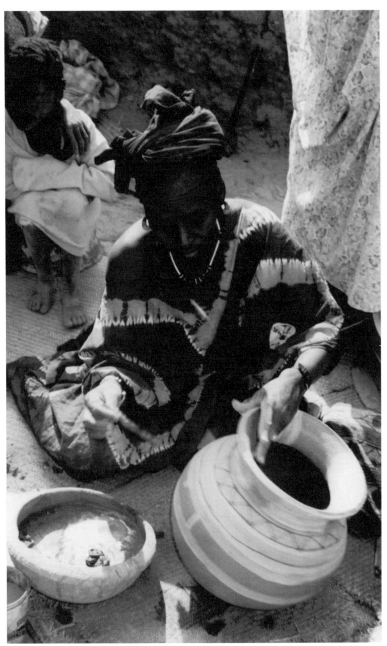

(Fig. 13) **Decorating Pottery with a Chicken Feather Brush, Tassakan, Mali, 1993.**

(Fig. 11) **Tassakan Village Chief, by Betty LaDuke, Pen Drawing, 11 x 14", Mali, 1993.**

Niger island villages now received technical equipment from the United Nations and Care.

In each village, there was a primary school, which some children attended; others were needed to work, thus contributing to the family's survival. By age seven, young girls would begin to assist their mothers with farming, child care, and pottery production. It was an enlightening experience to go beyond the attractive pottery facades first sighted at Koriam. The women not only created functional ware, but went a step further. They fulfilled an almost inexplicable inner need, i.e., to add beauty to the utilitarian pottery surface and to their daily lives.

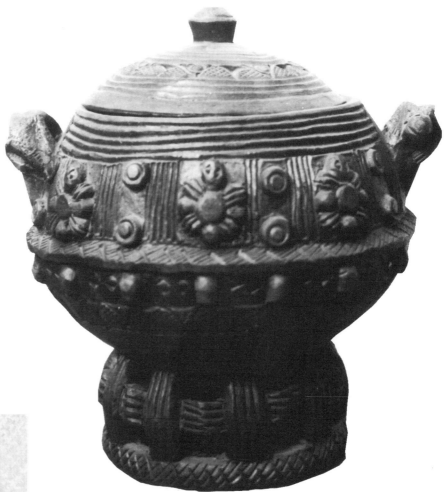

(Fig. 14) *Fon's* Serving Bowl, Bamessing Pottery Centre Collection, Bamessing, Cameroon, 1991.

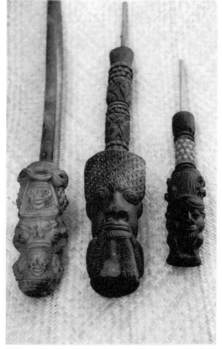

(Fig. 15) Traditional clay Pipes on Display, Bamessing Pottery Centre, Cameroon, 1991.

Bamessing, Cameroon

The town of Bamenda is situated in a cool, mountainous valley of an English-speaking province of Cameroon. I first saw the local pottery at Prescraft, a large commercial gallery, and was impressed by the figurative, animal, and insect motifs applied to the surfaces of bowls. These were all symbolic expressions of the regional Tikar peoples. Since I was told that the village of Bamessing is one of the primary sources of these ornate forms, I proceeded to venture there by "bush taxi," a small, crowded van, for the one-and-a-half-hour journey on an unpaved road.

When I first arrived, I was fortunate to meet Peter Futomah Fombah, who guided me to the pottery center, and Ueli Knecht, the

director since 1988. Knecht told me that the Bamessing Pottery Centre was first established by a pastor from the German Basel Presbyterian mission in the 1930s. (German colonization of Cameroon began in 1902 when the first mission post was established in this region and lasted until 1945. Then England and France became the trustees until the Republic of Cameroon was established in 1972.) Under German colonial influence, clay tiles for house roofs were an important production item. Now, the Centre focuses on fulfilling local traditional needs that includes pottery for celebrations honoring nature spirits and various life-cycle stages. There is also pottery for export and new, non-functional forms such as wall plaques featuring portraits of religious and political leaders, which appeal to the upper class.

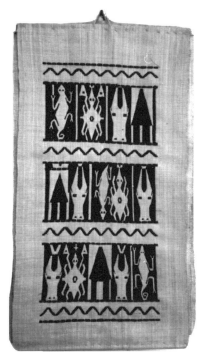

(Fig. 17) Straw Bag, Bamessing Pottery Centre, Cameroon, 1991.

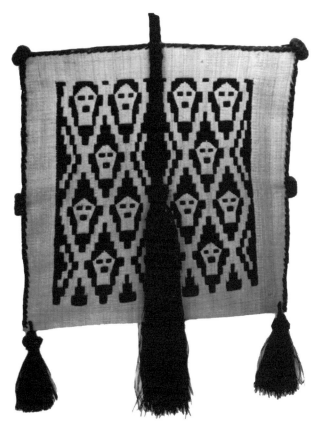

(Fig. 16) Straw Bag, Bamessing Pottery Centre, Cameroon, 1991.

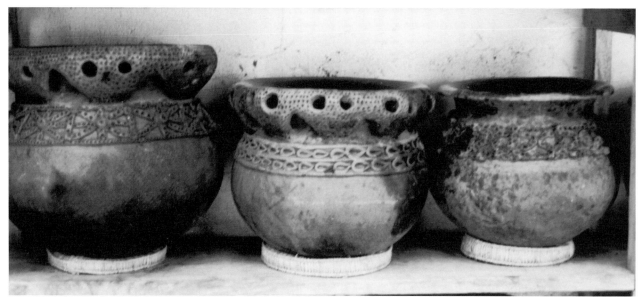

(Fig. 18) Mimbo Pots, Bamessing Pottery Centre, Cameroon, 1991.

Ueli Knecht, a graduate of the Zurich (Switzerland) School of Arts and Crafts, also informed me that the previous director, from 1984 to 1988, had introduced the pottery wheel, but "she had no interest in promoting local pottery." In contrast, Ueli's goal is to integrate traditional methods with new techniques, and to encourage young people to become involved and to "develop innovative quality work that will receive international recognition, 'Made in Cameroon.'" After seeing many examples of both older and recent Bamessing pottery, I began to believe that Ueli's dream was attainable.

Bamessing is located within the western grasslands, a region that evolved as a series of kingdoms controlled by *fons,* or chiefs. Therefore, a uniquely ornate form of pottery developed to serve the elevated status of the *fon* and other palace nobility (Fig. 14). Figurative imagery consisting of whimsical animal and human faces and figures were incorporated on the outer surface of pottery or on clay pipe heads that the *fons* used. The Bamessing men made pipes, but both men and women smoked (Fig. 15).

> *Women smoked in the fields at planting time to insure fertility. Sorcerers smoked at the end of a ritual to insure rainfall or to chase away bad spirits. Doctors used blended tobaccos as medicine to calm ailments such as migraines. Fathers smoked a double bowled pipe to celebrate the birth of twins.[1]*

The Bamessing Pottery Centre consists of a large complex of adobe workshops, storage units, a gallery exhibiting current work as well as historical collection, and offices, all of which are constructed around a central courtyard. Pottery production and kilns for firing are also located there. While only eight to ten men and women are directly concerned with creating pottery by the wheel and coil methods, over one hundred people are involved in related work such as: the cutting,

transporting, and splitting of wood logs for pottery firing; clay mining and preparation; commercial pottery glazing; and firing an assortment of glazed and unglazed pieces from dish sets to traditional food bowls, pipes, and mimbo pots. The Centre is currently expanding its international market, particularly in Europe, for exporting a variety of products.

In the Centre's sales room there are, among other items, intricately decorated shoulder bags. These traditional bags, finely woven from natural grass fibers by men and women, incorporated a variety of symbolic design motifs similar to the pottery (Figs. 16 & 17).

In Bamessing, women are now the main producers of pottery, but according to Peter, my guide, in the past there was a "demand for ritual pottery related to male circumcision and secret society rites. As the demand decreased [due to missionary activity], women then began to dominate pottery production." One of the unique forms produced at the Bamessing Pottery Centre are mimbo containers for palm wine and water. These large pots have an unusual, thick outer lip or rim that is folded over, which prevents excessive spillage. Pottery surfaces are decorated with one of the following motifs: water snakes, spiders, and toads, all related to male fertility, wisdom, or female fertility (Figs. 18 & 19).

Peter spoke of sacred shrines dedicated to the people's belief in "the gods of the stones, water, and trees." At these shrines, offerings of a fowl are made to the priest. Peter described how "the chicken's neck is cut on a sacred stone, so that the stone-god will wipe away the family's bad luck. The chicken will be shared with the priest, who concludes the ritual by making a camwood sign on

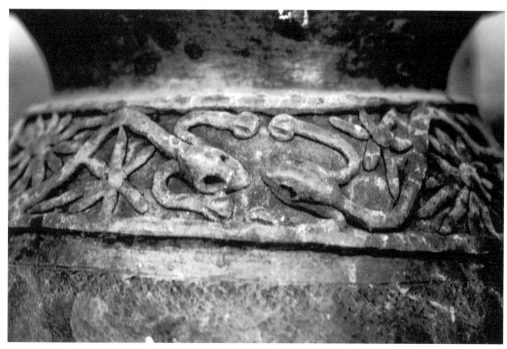

(Fig. 19) Lizard Motif on Pottery Surface, Bamessing, Cameroon, 1991.

each family member's face." It was interesting to learn that, "To be rubbed with camwood is an honor. . . . Camwood comes from a redwood grown in Northwest Cameroon . . . it is the key ingredient for creating red makeup used in special ceremonies, mixed with oil or water in a wood pestle bowl."[2]

There are many intriguing traditions related to agriculture. There is a special pot known as the "guardian of the crops," and, according to Peter, this clay guardian figure with a protruding navel is considered a link to the ancestors. The guardian, with a small opening in the back to receive offerings, is placed in the fields, a palm wine grove, or the doorway of a home.

For the sharing of the palm wine, there are also sacred ceremonies that promote family and community unity. Peter described one such ceremony: "For a deceased person there is a burial celebration, and all the family members come together. They each bring some palm wine which they pour into one large mimbo pot. Each family member then drinks this palm wine mixture in order to settle all previous disagreements, accounts, or debts with the deceased."

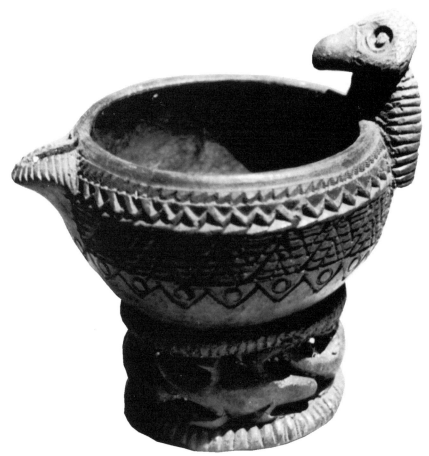

(Fig. 20) Traditional Serving Bowl by Johanna, Bamessing, Cameroon, 1991.

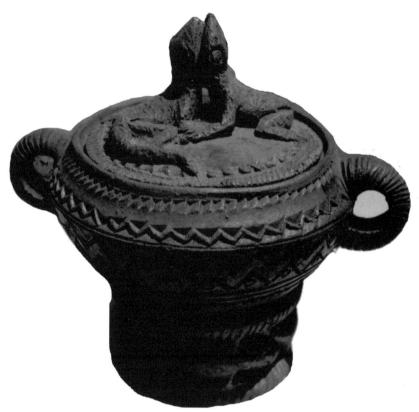

(Fig. 21) Traditional Serving Bowl with Lid by Johanna, Bamessing, Cameroon, 1991.

Hannah (Ueli's wife) described a similar communal event that occurs at the end of the year, when "palm wine is brought by all the residents of Bamessing village, and then blended and cooked together in one huge mimbo pot. This communal wine is then shared, and if someone doesn't join in, it means he (or she) has a bad heart." She also related that "the men dance, forming a chain by placing hands on each other's waists and, if someone breaks this chain, it is a bad omen." There are also special women's celebrations emphasizing fertility and respect for the *fon*. In "Dance of the Living Water,"
which can take place November through January, all the village women collect water in their calabashes from a nearby stream, and they place a small branch from a living tree into this water. The women then form a very long line, the tallest first and the youngest, three-year-old children, last. They carry their calabashes on their heads to the fon's palace where they all dance as one man plays a bagpipe. The meaning of this ceremony is that new life will come, starting from the palace.[3]

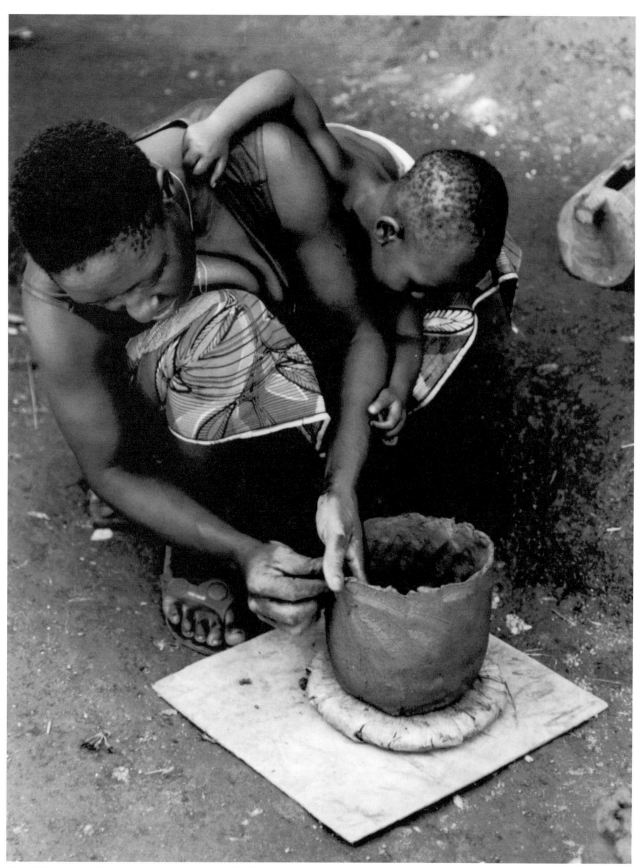

(Fig. 22) Johanna Constructing a Pot with Coils, Bamessing, Cameroon, 1991.

In April, there is a celebration reminiscent of Easter, as it is related to the *fon's* mythical disappearance and reappearance into and from a big stone cave. Hannah relates how the village people carry corn (the mainstay of their diet) and

> *other fine things to the stone cave for the Fon. There the village priest mixes camwood and puts a protective mark on everyone's forehead. Then there is a gathering of women, those who've had a lot of children and those who desire children. The priest sprinkles water over the bodies of women who want to become pregnant. If this ceremony is not done correctly, the corn will not grow and the people will suffer.*

Fascinated by these traditions, I was surprised during my second Bamessing visit to be greeted on the road by a group of young boys wearing masks, shredded burlap, and brandishing long sticks. The situation seemed portentous at first, but I was relieved when one young boy began to play his flute, the others did a menacing dance, and then they all quickly disappeared into the nearby corn field. When Hannah explained later that on this traditional Country Sunday the children wear masks and dance to frighten monkeys away from eating the corn during the harvest period. What a wonderful, safe outlet (except for the monkeys) for juvenile aggression! However, some of these traditions, such as the negative concept of women as witches, are disturbing. "Sometimes sickle-cell anemia kills many children in a compound; then one person is selected as a witch to blame for this misfortune," Hannah says, and she tries to explain to

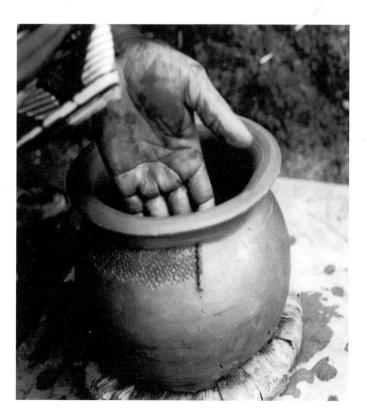

(Fig. 23) Incising Intricate Surface Patterns, Bamessing, Cameroon, 1991.

the people (with limited success) "the difference between disease and a witch."

Hannah also had some pertinent insights concerning the Bamessing Pottery Workshop. Since the workers (who must be Christian) receive a good income, the tendency is to consider themselves as "big men" and to create jealousy. Hannah also suspects "they join the church to get work, not because of their feelings of being a Christian. They think Christian missionaries have a lot of money. Missionaries attract people who think if they join, they will get money too." Peter had another perspective:

Before white men came, pots were always made locally, to be used for many ceremonial occasions, and it was also a source of income. Around 1962 pottery was dying out. But I saw what my father and his friends were doing, so I connected with this process while studying at the Baptist Mission primary school. Then Prescraft helped re-energize local pottery production through the establishment of the Bamessing Pottery Centre and commercial outlets.

At Peter's home, I was particularly fascinated by his wife, Johanna, and her pottery, which included a traditional serving bowl and lid with two playful lizards on the top, and a lizard motif that encircled the base (Figs. 20 & 21). Johanna eagerly demonstrated her work technique while carrying their youngest of eight children in a baby wrap on her back (Fig. 22). She began by punching a small ball of clay into a shallow bowl and then used coils to raise the sides, to the surface of which she added whimsical clay forms. This was particularly interesting, as well as the use of small, carved wood cylinders and metal objects for incising intricate surface patterns (Fig. 23). Johanna said that she had also made simple containers for each of their children's umbilical cords, to which she added a small amount of dried fish and oil. She dug a hole in the earthen kitchen floor to bury each pot, completing a ritual that forever links a child with its natal home.

Peter's work, surprisingly, consisted of realistic sculptural portraits, three-dimensional wall plaques of luminaries such as the President of Cameroon as well as the local Bamessing minister. After firing, his pieces were finished with commercial enamel paint (Figs. 24 & 25). Isaac, Peter and Johanna's 17-year-old son, sculpted men on motorcycles (one of his favorite themes), which he also painted. Isaac was inspired by "magazine pictures, imported goods, football trophy cups, ashtrays, and animals." These clay projects were also displayed at the Bamessing Centre in order to promote cultural continuity as well as change.

(Fig. 24) The President of Cameroon, by Peter Futomah Fombah, Bamessing, Cameroon, 1991.

(Fig. 25) The Rev. Henry Ante Awsom, by Peter Futomah Fombah, Bamessing, Cameroon, 1991.

Tsevie, Togo

Have you ever wondered how Ali Baba and the Forty Thieves, from The Arabian Nights fable, could hide themselves in oil storage jars? The answer became apparent almost as soon as I arrived in the town

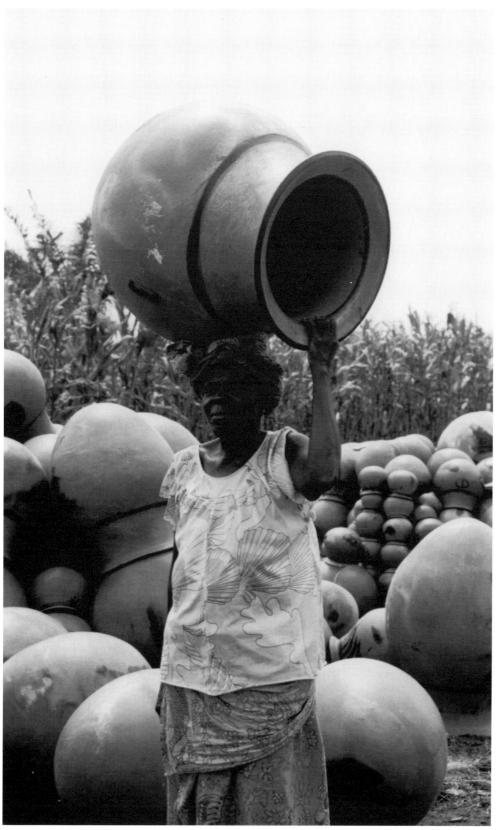

(Fig. 26) Loge Oudjingo Carrying a Water Storage Pot, Tsevie, Togo, 1992.

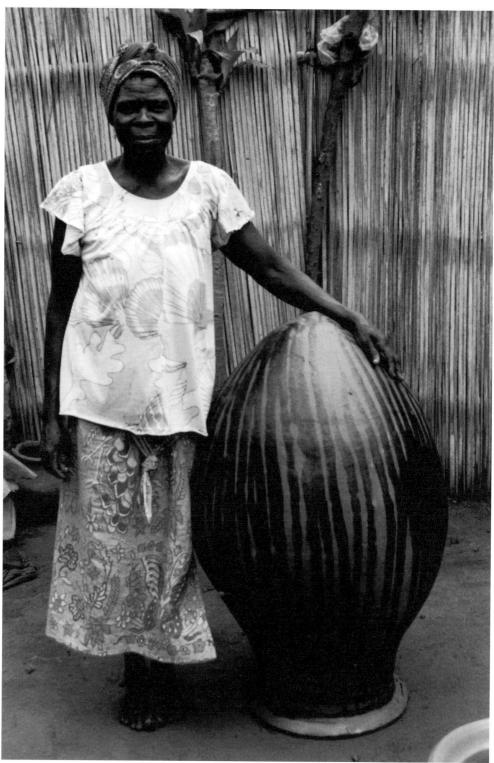

(Fig. 27) Loge Oudjingo Standing Beside her Water Storage Pot, Tsevie, Togo, 1992.

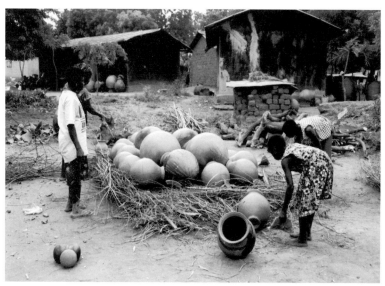

(Fig. 30) **Firing Pottery with Straw, Wood, and Animal Fuel, Tsevie, Togo, 1992.**

of Togo. While there are monumental water jars in every African village, none had caught my attention for their extraordinary size and graceful form as those produced near Tsevie.

And, like so many experiences in Africa, discovering clay pots is not what I had planned for that day, as I was traveling with my multilingual student guide, Yao Marco Dogbe, to visit the historical city of Notse. But when we had to change vehicles in Tsevie, I saw some of those graceful giants resting on their sides; others were standing upside down near the railroad station, carried there by the women who made them. They would carry one of these heavy pots on their heads, walking six kilometers or more from their village, as did Loge Oudjingo (Fig. 26).

Since my curiosity extended beyond the one quick photograph, and Marco spoke English, French, and Evie, the dominant language of southern Togo, we arranged to accompany Loge Oudjingo to her village (Fig. 27). There, for a small fee, she would demonstrate how these massive pots came into being. We all took a local bush taxi that passed near her village, Bolo Kpeme, one of three in the Tsevie district specializing in pottery production. We still had to walk what seemed a long distance along a very pleasant, tree-shaded pathway, passing many pottery compounds before finally reaching Oudjingo's. A bamboo fence encircled Oudjingo's one-room mud-and-thatch house as well as immaculate outdoor work space that contained a shaded area with a thatch roof, a bench, and a large water storage jar near her doorway. Beside the fence, there was some clay wrapped in plastic along with some calabashes, pails, and other tools. Only Oudjingo's fifteen-year-old daughter, a fifth-grade student, now shared this home, as her other two daughters were married. Though they had been taught pottery production, at present they just worked on their farms. Oudjingo told me that she learned to make pottery from her mother, and since her husband died ten years ago this has been her only source of income.

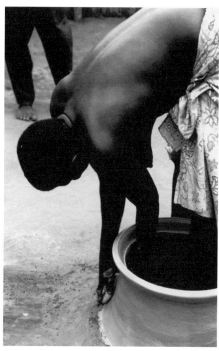

(Fig. 28) **Loge Oudjingo Beginning a Water Storage Pot, Tsevie, Togo, 1992.**

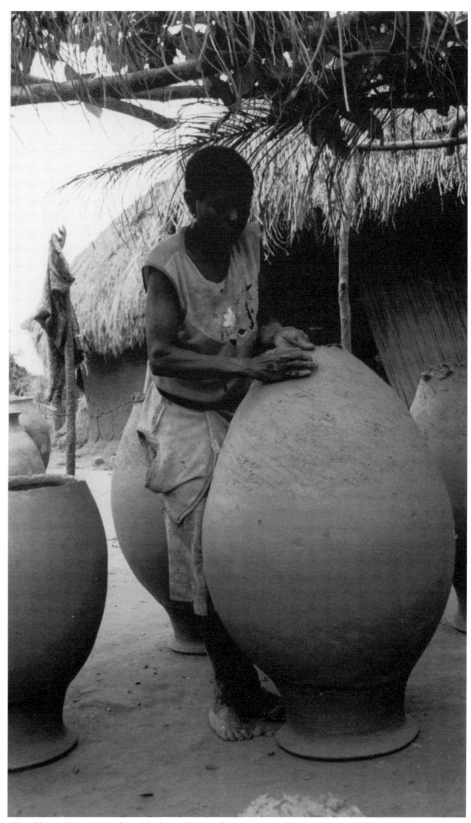

(Fig. 29) Adjoa Adeje Completing a Water Storage Pot, Tsevie, Togo, 1992.

I saw many local shrines in this area related to voodoo practices. Therefore, it was interesting to learn that Oudjingo had been a fetish woman of Shango, but last year she converted to Catholicism. Missionary activities were intense, but Oudjingo was not sure she would remain Catholic since the relief she had been promised for her problems was not forthcoming. Voodoo beliefs were dominant in Togo, but this day I would learn nothing more about these practices, but much about the extraordinary physical strength, discipline, and dedication it took to produce Ali Baba's jars.

The clay quarry was nearby, but the water well was one kilometer away. Since this was the beginning of the rainy season, it was hot and humid. Oudjingo, as was her custom, removed her blouse before she began kneading her clay and rolling out large, thick coils. Much to my surprise, her pots were created upside down, beginning at the top first. She stood with one foot inside the coiled area as she circled around, blending and raising each layer into a perfectly round, smooth form almost two feet tall (Fig. 28). After the outer lip was completed, and the clay had dried sufficiently to withstand more weight, this segment of the pot was placed upside down. Later, the broad belly of the pot could be created. Pottery production is begun early in the morning, but during the rainy season, each construction phase requires four days for drying. Therefore, Oudjingo begins four pots at the same time.

To see the final phase of pottery construction, we walked across to the neighboring compound, where Adjoa Adeje was busy at work on pots that were almost her height (Fig. 29). She was completing the final narrow, oval bottom enclosure on each of the four pots, and it was fascinating to observe her concentration as she added coils and then scraped and smoothed each one with a calabash segment, river rock, or thick, leather-like leaf for final perfection. Once a week, after the pots dried, they would be fired in a large pit; straw and wood were used for fuel (Fig. 30).

After the firing, each potter carried her pots, one at a time, on her head to the railroad station, where they would be shipped to Lome and other major market centers. These pots had an extraordinary duty to perform. They would be partially buried in the courtyard of the family compound where they were expected to withstand hundreds of pounds of pressure, as they were filled with both rain and well water. Most Africans still depended on pottery for obtaining and retaining this precious resource.

In addition to water storage vessels, Oudjingo also produced clay cookstoves and smaller water jars. I wondered how many years she could go on doing this work? She was an incredibly strong woman. She did not know how old she was, but it was obvious that every muscle in her lean body since early childhood had been utilized to capacity. She took pride in her skill and accomplishments.

At the end of the afternoon, we walked back to the railroad station, Oudjingo carrying three of her cookstoves on her head (Fig. 31). Though I would only walk this six-kilometer distance once this day, and was exhausted, Oudjingo would often repeat this hike

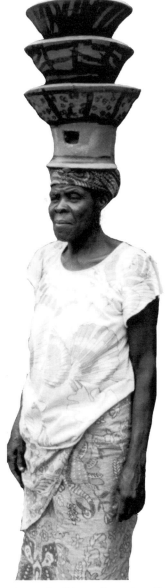

(Fig. 31) Loge Oudjingo Carrying Cook Stoves to Market, Tsevie, Togo, 1992.

61

Endnotes

1. *The Art of Cameroon in the Mt. Febe Benedictine Monastery (*Youande, Cameroon*)*.
2. *Ibid.*
3. Unless otherwise quoted, the following are traditional stories told to me by Hannah Knecht or Peter Futomah in 1992 and 1993 in Bamessing, Cameroon.

several times a day and an incalculable number of times each year while carrying pottery big enough to accommodate Ali Baba himself on her head. I admired this woman's fortitude, creativity, and ready smile.

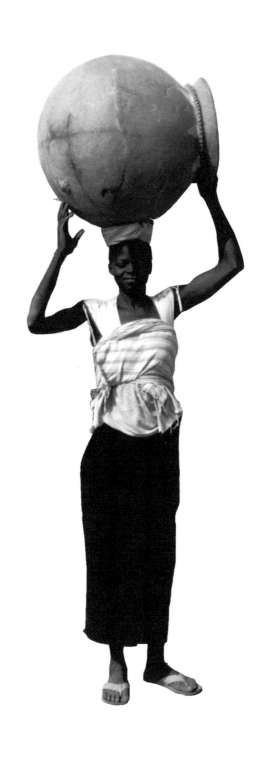

Cameroon

BEADS, *ANLU*, AND SOCIAL CHANGE

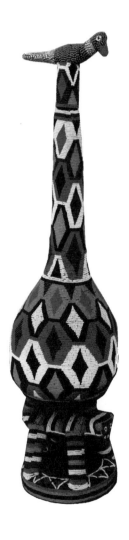

During my 1991 travels in Cameroon, I discovered wood sculptures that were entirely covered with beads fitted over their surfaces like a vitreous second skin. This extraordinary use of beads was further enhanced by the variety of sizes and shapes of the sculptures; from the palm-sized dolls on sale at commercial roadside stands to the monumental thrones, incorporating life-size figures of royalty, on display at the Bandjoun Palace Museum.

Bamenda is the capital of the western grassland region, which is divided into kingdoms that include Bandjoun, Bafout, Foumban, and Kom. In these kingdoms, beads were linked to royal power and status, a tradition that survived colonization and continues to the present, with some modifications. Art historian Christaud Geary offers the following historical perspective: "Beads were reserved for the king and the palace, so that everyday objects [calabashes, stools, bowls, handles of fly whisks, and ceremonial staffs] were elevated out of the ordinary to another dimension by means of bead embroidery" (Fig. 1). [1]

In Bamenda, I visited the Artisan Centre and, while viewing their display of traditional and contemporary art, I became particularly fascinated by the colorful form of a beaded calabash (gourd). It stood approximately forty inches tall, balanced on the back of a stoic beaded leopard. The original function of this hollow calabash was for the ceremonial serving of palm wine. At the apex of its elongated neck, a small bird nestled, serving as a cover or stopper.

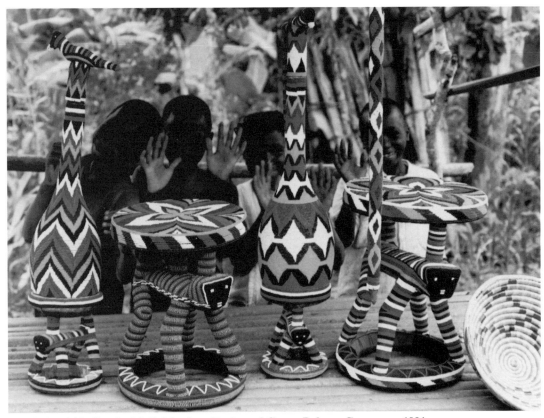

(Fig. 1) Roadside Stand with Calabashes, Stools, and Canes, Baham, Cameroon, 1991.

Unifying leopard, calabash, and bird were wide and narrow zig-zag bands of yellow, green, and black beads interspersed with white (Fig. 2). After closer observation I was surprised to find the calabash had been replaced with solid wood, negating its original purpose, i.e., serving palm wine. However, the bird perched on top greeted the world as if nothing had changed.

Since the director of the Artisan Centre informed me that, currently, women made the beaded forms in the nearby villages of Baham and Bandjoun, I decided to visit these communities. This bead-venture subsequently led me through a long labyrinth of Cameroon history and related topics such as: "great huts" and nationalism; Anlu, a Kom women's social action society; and the infamous theft of the Afo-a-Kom (a beaded throne) from the Kom Kingdom. Researching these subjects broadened my understanding of and appreciation for contemporary women's beadwork in relation to the process of social change. It also provoked speculation about the possibility of bead workshops, cultural exchange between African and African-American women artists, and the creation of beaded dolls that would be examples of new role models for the younger generation.

Bead History and Social Power

It was surprising to discover the adventuresome course of beads through time, geographic location, and as a means for expressing social power. R. P. Engelberg Myend traces the use of beads, seeds,

and cowrie shells to ancient Egypt, as early as 12,000 B.C., writing that "in antiquity, bead commerce seems to have penetrated into the heart of the continent."[2] White cowrie shells, which originate from the Indian Ocean and the east coast of Africa, were traded across the African continent and, according to Myend, "served a little everywhere as a money exchange. In addition, cowries were religious symbols associated with women's fertility and all the fertility cults."[3] In later centuries, some beads were still equated with human life. For example, Tamara Northern, in *The Sign of the Leopard,* discusses how "beads were used as a medium of exchange in the slave trade and in the trade of valuables. Hence, the bead is not only a symbolic allusion to wealth, but of itself constitutes wealth."[4]

Prior to the fifteenth century, Cameroon royalty came under the spell of beads when they became available through trade with Nigeria. The application of beads to sculpture was practiced by palace artisans. Historically,

> *the use of objects embroidered with beads and the wearing of bead jewelry were restricted to a small group surrounding the King, among them the Queen Mother, the maternal uncle, princes and princesses. . . .The King would also grant the privilege of wearing certain bead decorated things to others ... and this was a recognizable sign of royal favor and distinction."[5]*

It was also evident that not all beads were regarded equally, and, in later centuries, European beads, which were dull and opaque, red or blue in color, were considered extremely valuable. They also became a medium of exchange in the slave trade. These cylindrical beads were utilized for the Afo-a-Kom throne, as well as the thrones on display at the Bandjoun Palace Museum. Some of the Bandjoun throne stools were carved into seated figures draped with blue indigo cloth and wearing an elaborate, feathered crown and were covered with a combination of cylindrical and ordinary beads. Others held bowls or receptacles (Figs. 3 & 4) for the ceremonial serving of kola nuts or the sacred display of the deceased king's smaller bones. While many older beaded calabashes seemed indistinguishable from those currently produced, I did find one unique example among the Museum's collection that featured intertwined serpents, considered a symbol of royalty, along the calabash stem (Fig. 5).

Tracing the production of beaded art by commissioned artisans working for palace royalty to self-employed village women, Geary offers the following clue: In the kingdom of Foumban in the 1930s,

> *King Njoya encouraged his wives and daughters in the palace to produce bead embroidery, and consequently women, too, occupy themselves with this craft nowadays, embroidering small objects such as glass bottles, slippers, and statuettes for the tourist trade.[6]*

Since the reign of King Njoya in the 1930s, Cameroon has undergone the transition from colonialism to independence. Fred Ferretti refers to current examples of beadwork as "transitional art" and believes that:

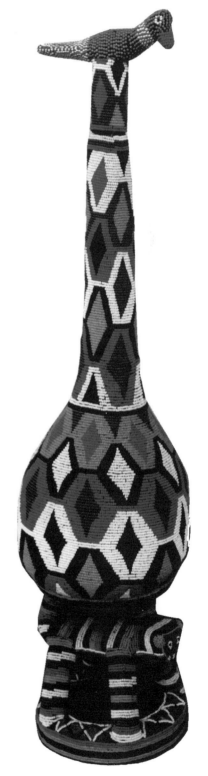

(Fig. 2) Beaded Calabash, Bamenda Art Centre, Bamenda, Cameroon, 1991.

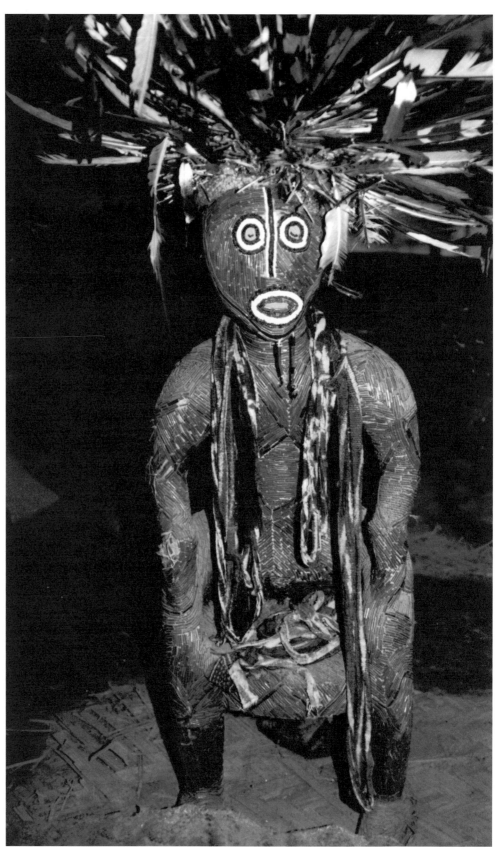

(Fig. 3) Beaded Throne with Indigo Cloth and Feather Crown, Bandjoun Palace Museum, 1991.

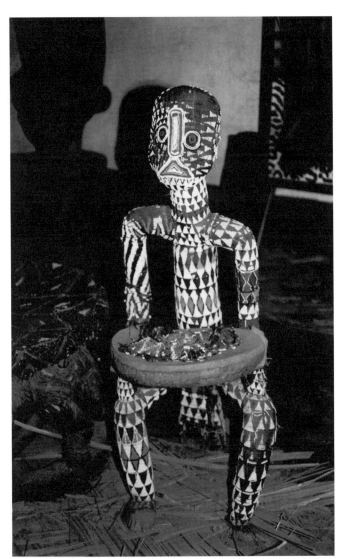

(Fig. 4) Beaded Figure Stool with Bowl, Bandjoun Palace Museum, Cameroon, 1991.

This art, which utilizes most traditional forms and techniques, lacks the religiosity, the ancestral respect, and often the fervor that the traditional artist became imbued with as he began to work. These pieces are not necessarily poor. In fact, "transitional" African art is often quite excellent technically. But it is being made to sell . . . not to use in a burial ceremony, or a puberty rite, or to increase the yield of the fields. And so it must lack a heart."[7]

Beads With Heart

Does the transition of bead production from full-time male artisans working at the palace for royalty to freelance production by village women who sell their work to tourists and upper-class Cameroonians necessarily mean that their beadwork will "lack a heart"? Of course not! My response is based on my encounter with the women who are currently creating beadwork and my meager

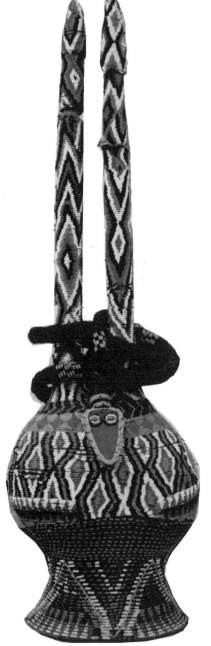

(Fig. 5) Beaded Calabash with Serpents, Bandjoun Palace Museum, Cameroon, 1991.

67

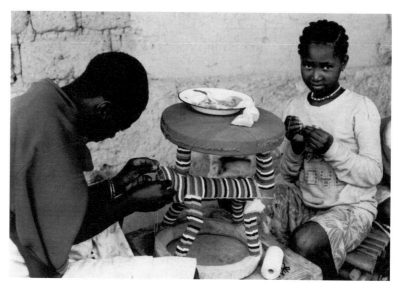

(Fig. 6) Beading a Cloth Covered Wood Stool, Baham, Cameroon, 1991.

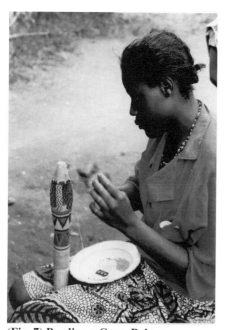

(Fig. 7) Beading a Cane, Baham, Cameroon, 1991.

understanding of their technical process and the economic and so-cial significance of bead production in their daily lives. My educa-tion was facilitated by Luz, Carmen, and Cecil, Spanish nuns and secondary school teachers at the Baham Catholic Church. The nuns had worked for over sixteen years in the village of Baham, located near the Bandjoun Palace, and were very pleased that I could con-verse with them in Spanish. They were eager to assist me in my research venture. So, it was quite fortuitous that the bead workers were the mothers of their students and the nuns could translate the local dialect.

After Sunday Mass, our series of visits began at the local Baham roadside stand, where the women's Association des Artisans dis-played their projects. In addition to a dazzling assortment of stools, canes, bowls, and calabashes, there were also small birds, lizards, and a most unusual, traditional beaded cloth elephant mask. This display stood in front of the Association members' workshop, which contained a storage facility for supplies and finished projects.

The cooperative had formed several years earlier and now had over fifty members. One of its primary functions was to serve as an outlet for sales, an important economic supplement to the women's farming activities. Since each beaded object necessitated a large in-vestment in supplies (the wood form, cloth, thread, and beads), this was also facilitated by the cooperative. Each woman commissioned the desired forms from a local woodcarver, and beads and cloth were purchased at the nearby Bafusam market.

Before the beading process could begin, the cloth was cut into segments and stitched to fit snugly over the entire wood sculpture (Fig. 6). Then approximately ten beads were threaded together with a fine needle and sewn onto the cloth surface. The women's tech-nique was impeccable, as there were no gaps between the rows of beads. The designs were intricate and created spontaneously or from memory. The women worked individually on small projects and

sometimes together on a larger object. Canes might take one or two days to produce, while small birds might require one week (Figs. 7 and 8). The complex calabash could require approximately three months to produce, and I was told a monumental throne combined with a figure could take as long as one year to complete. Most of the beadwork was finished after harvest when there was more leisure time.

Using the local "bush taxi" for our transportation, the nuns and I arrived at Rosette Mono's small adobe home. We found that she was busy shelling her recently harvested beans, and as we spoke, the nuns also helped her. Mono told us that she was taught to do beadwork by a woman from her village, and that she now has twenty years of experience. For the past two years, her oldest daughter, Georgine, has assisted with large projects such as beaded stools; but Georgine also does her own work, which includes crocheting traditional caps displaying many little fingerlike surface projections. Caps of this design were formerly worn by royalty.

Mono has seven children, and the money she earns from beadwork is a major part of her income for the family's clothes and food. She is not a member of the cooperative; "it is too far away," she says. So she relies on her own roadside stand, which Georgine oversees. Mono admits that before she was married she did not have the money to invest in basic materials, but her husband was able to help her get started. After shelling her beans, Mono eagerly showed me the stool she was beading and demonstrated the technique (Fig. 9).

The price of beaded objects was not fixed; bargaining was expected before any purchase. Smaller birds sold for approximately ten dollars, while calabashes (Fig. 10) and stools could cost as much

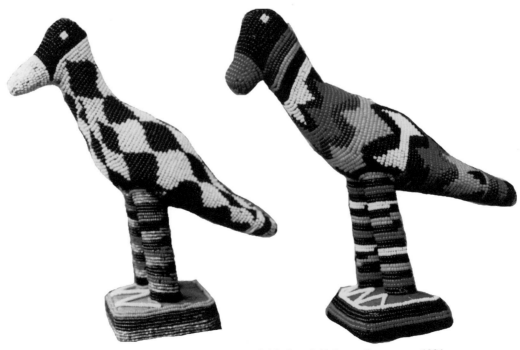

(Fig. 8) Beaded Birds, Baham Roadside Stand, Baham, Cameroon, 1991. **69**

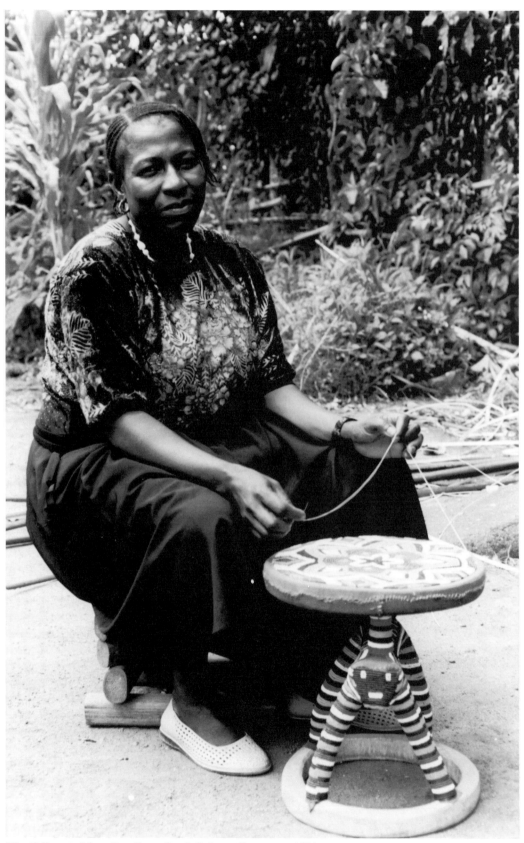

(Fig. 9) Rosette Mono Beading a Stool, Baham, Cameroon, 1991.

as one hundred dollars. Though most of the women told us that they did beadwork "to make money," it was obvious, when observing them, that they also experienced pride and pleasure from their work. Though designing and creating beaded patterns required intense concentration, the women's shared camaraderie added enjoyment to this activity.

As a matter of competitive pride and in order to attract buyers, the women maintain high aesthetic standards. The supplement to their farming income ameliorates the family's diet as well as the education of their children, for, although school is free, school uniforms, shoes, and books are not. Therefore, women are producing beadwork "with heart," not only for the pleasure they themselves derive from the creative process, but for the added income and, more importantly, for the potential power to improve the future for their children through education, a newly desired rite of passage.

Beads: Good To Think With

In Cameroon, decorative motifs such as spiders, lizards, frogs, and snakes frequently embellish beadwork, wood carving, and pottery. While most of these motifs are associated with fertility, the spider is also considered an "instrumental agent in divination practices throughout the Grasslands, thus aiding in the control and manipulation of known social and unknown supernatural forces.[8]

The leopard and the elephant are also powerful symbols utilized in beadwork. Tamara Northern discusses their communal significance as follows:

> *It is not necessarily specific qualities and attributes of specific animals that command human attention for metaphorical use and analogy it is rather human perception of this animal world . . . stemming from the structure of human society. The adoption of specific animals as regal or as emblems of power only requires, as Levi-Strauss has suggested, that they be "good to think with."*[9]

Northern found that leopards and elephants are particularly "good to think with," as "they embody a force and power, and a totality of survival qualities and abilities to master their environment." These animals assume human form and "the King may, at his will, turn into a leopard or an elephant."[10] Therefore, these motifs continue to be important, though the animals have long been extinct in the grassland region of Cameroon.

The function of the cloth elephant masks on display at the Baham roadside stand and at the Bandjoun museum (Fig. 11) is related to secret societies and the "rigid rank system operated to maintain social and political order," which perpetuated "social inequality."[11] Beaded elephant masks, with their circular ears and extended long trunks, were worn as a head covering by male secret society members during ceremonial events. These masks indicated the wearer's wealth, rank, and privileged status.

Northern's personal comment, written in *Crafts and the Arts of Living in 1982*, is surprising: "At the marketplace in both

(Fig. 10) Beaded Calabash by Rosette Mono, Baham, Cameroon, 1991

(Fig. 11) Beaded Elephant Mask, Bandjoun Palace Museum, Cameroon, 1991.

Bandjoun and Bafoussam, I met the last artisans in beads who offer their work to tourists."[12] I'm sure she would be pleased to know that more than ten years later Cameroon beadwork, largely due to the efforts of village women, has persisted and is alive and well. Though labeled as "transitional art," it flourishes in the vicinity of the great palaces, created by women "with heart" for anyone who can afford it and for those who find them "good to think with."

The "Great Huts" and Nationalism

Since elaborate beaded forms were linked with palace royalty, it was important that I investigate the environment that nurtured their existence. The grasslands region evolved as a series of hierarchically stratified chiefdoms. Each chief, *fon* or king, resided in a palace or "great hut," surrounded by numerous small huts, one for each wife and her children. The size and grandeur of the Bandjoun Palace is startling; it is circular and over fifty feet wide in circumference. A second circle of elaborately carved wooden poles rising over twenty feet in height extend around the exterior and support the thick thatched roof (Fig. 12). The wives' huts on either side of the road leading to the Palace also demanded attention, as doorways were elaborately framed with symbolic carvings of ancestors and fertility motifs (Figs. 13 & 14). The chief was formerly considered semi-divine and had

power and jurisdiction over local villages, in both the criminal and customary courts.

Many of these local institutions of power were weakened or destroyed by colonization, which began with the Germans in 1884. After the First World War, when Germany was defeated, colonization continued under a 1917 League of Nations mandate. The British were given Western Cameroon (which includes Bamenda), and the French had the larger area of Eastern Cameroon. This lasted until the end of the Second World War, when the Cameroons were administered as a United Nations Trust Territory. Foreign domination culminated with the Cameroon independence movement, initiated in the 1960s, leading to independence in 1972. The French and English territories were then united into the Federal Republic of Cameroon. Though there are many local dialects, French or English are still spoken in these former colonial territories.

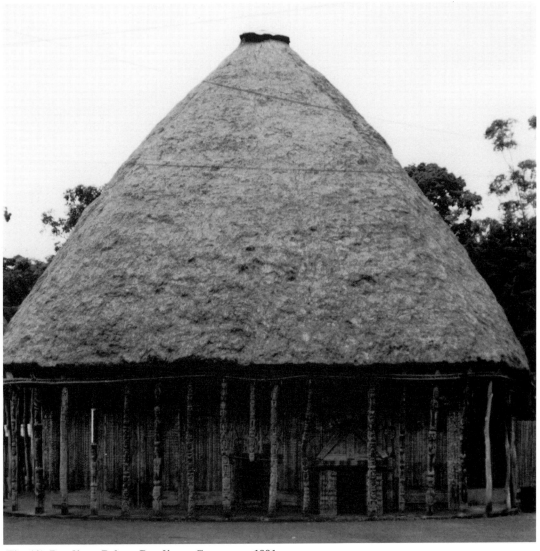

(Fig. 12) Bandjoun Palace, Bandjoun, Cameroon, 1991.

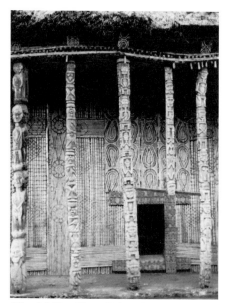

(Fig. 14) Bandjoun Palace Doorway, Cameroon, 1991.

During the colonization process, there were missionaries who looted and then destroyed the palaces; the palace contents, however, were frequently "transferred" to European museums and private collections. The missionaries subsequently constructed churches on the site of the traditional palaces and assembly halls. Nevertheless, some palaces did survive, and others have been rebuilt.

There are varied views of the past. While some historians continue to regard chiefdoms and palaces as feudal, others consider them authentic foundations for initiating social change and promoting cultural continuity. It was fascinating to note the belated respect given to these impressive architectural structures and their accompanying social institutions by both foreigners and Cameroonian scholars. For example, in *Art of Cameroon*, Paul Gebauer, a Baptist missionary and one of the first collectors of Cameroon art, states: "Perhaps the most startling expressions of

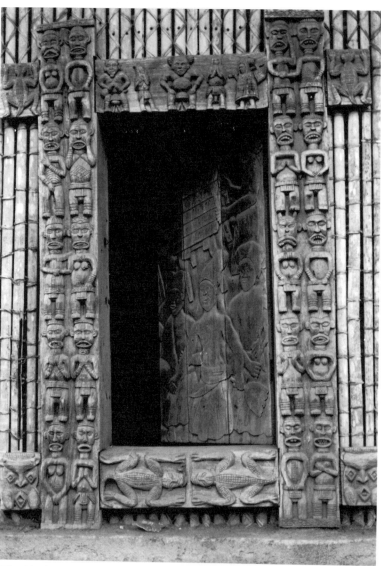

(Fig. 13) Carved Doorway of Wife's Hut, Bandjoun, Cameroon, 1991.

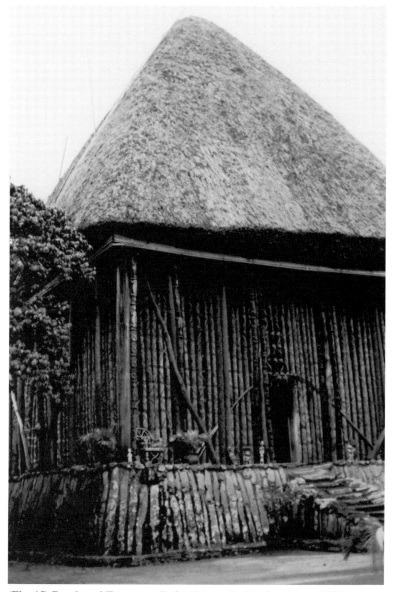

(Fig. 15) Porch and Entryway, Bafut Palace, Bafut, Cameroon, 1991.

royal art lie in the structure of feudal palaces. . . . The Bandjoun complex is a monument to daring and skill." [13]

Gebauer's opinion is shared by other scholars. William Fogg of the British Museum describes the *fon's* dwelling as "probably the most impressive wooden palace in Africa, the great porches sometimes rising to thirty feet or more with elaborate wood carvings in the vigorous style of the area" (Fig. 15).[14] Art historian Jocelyne Etienne-Nugue considers the Bamenda (Bamileke) civilization "as one of the best structured and most original of the Cameroon and of Black Africa in general."[15] Palaces are, she notes:

> *The last refuge of pomp and extravagance, of power and order, the last cathedrals of Bamileke tradition, the "Great Huts" are all standing, just as they were when first described many decades ago by travelers*

*and administrators. They seem to have come full blown
out of the Forest, out of the sacred wood upon which they
lean, in their severe harmony of evenly spaced bamboo,
their colonnade of sculpted trunks.[16]*

What is the relationship of the "great huts" to contemporary politics? Dr. Michael Aletum Tabuwe, a Cameroon political science scholar, believes that his nation should not adopt verbatim the modern political systems of the Western European world. He recommends, rather than dismissing the chiefdoms as autocracies, it is important to realize that "the Councils of Elders" had "a system of checks on the arbitrary exercise of chiefly powers."[17] Tabuwe recommends that certain aspects of traditional African institutions, noted

(Fig. 16) Embroidering a *Fon's* Robe, Bamenda Market, 1991.

(Fig. 17) Royal Figures from Kom, Laikom, 1976, Photo by Dr. Hans-Joachim Koloss, Museum for Volkerkunde, Berlin.

for their high standard of socialism, be incorporated as con-
temporary governing models. It is by

> *getting nearer these institutions that the African politi-
> cal scene could be brought near the people and could
> effectively solve the numerous problems characterized
> by the African environment. . . . Community living is the
> characteristic of the African society. . . . The well-being
> of people should be the political ideology of African
> politics, be it modern or traditional.* [18]

In the past, the palace nurtured and controlled the production of
certain traditional arts. Now, women at the Bamenda market stall
embroider fiber arts (including elaborately embroidered *fon's* robes),
which are available to all who can afford them (Fig. 16).

The Afo-a-Kom Odyssey

The Afo-a-Kom is related to the Kom tradition of carving symbolic
life-size portraits of royalty to honor and preserve their memory.
The matrilineal Kom kingdom received international attention when
one such portrait, the Afo-a-Kom throne, was stolen (Fig. 17) from
Laikon, the Kom capital in the 1960s. The Afo-a-Kom was subse-
quently found in a New York art collection. The process of its

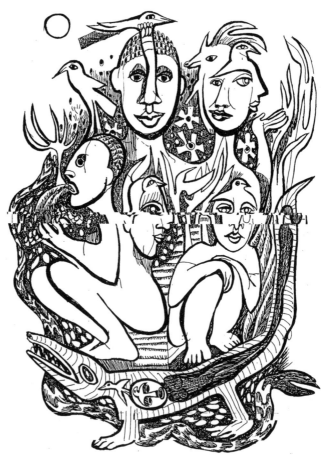

(Fig. 18) *The Fon and His Wife*, by Betty LaDuke, Pen
and Ink, 14 x 11", Cameroon, 1991.

righteous recovery and return to the Kom peoples seven years later
was avidly recorded by the *New York Times* reporter Fred Ferretti.
This event also became the subject of his book, *Afo-a-Kom, the
Sacred Art of Cameroon,* in which Ferretti describes "The Afo-a-
Kom [as] a living religious symbol . . . the pillar, inspiration, con-
cept of sovereignty, and the linkage between the past, present, and
future of most African traditions."[19]

The Afo-a-Kom is one of a set of three portrait sculptures of
the royal family of Fon Yuh, considered the most powerful of the
fons. Fon Yuh was revered as semi-divine; he who "mediates be-
tween the world of the living and the world of the dead."[20] There-
fore, these beaded thrones have power, since they "have the ability
to control behavior of others or produce a desired reaction in them
. . . an ordinary Kom person regards the statues with dread, an
attitude that arises from beliefs about the powerful ancestors who
cause many, if not most difficulties for the living."[21]

Before his sudden death in 1974, Fon Nsom referred to an-
other aspect of the Afo-a-Kom's importance: "that statue is beaded
with beads exchanged for people in the days of the slave trade, so
each bead represents a Kom person."[22]

The theft of the Afo-a-Kom and the distorted international media attention it received (including a total of twenty-two articles in the *New York Times*) over a two-month period in 1973, often revealed the ethnocentrism of the reporters. Their reporting "left far more questions than answers; many lessons are still to be learned."[23] In her article "The Odyssey of the Afo-a-Kom," Eugenia Shanklin reviews cross-cultural interactions from the Kom perspective. Of considerable interest is the fact that in the past, the Afo-a-Kom throne was seen only by Kom notables, but since its return to Laikon, it has three new audiences:

> *The Kom people, most of whom had never seen the statue before but who are very proud of the furor it caused; other Cameroonians, who began making copies to sell to gull-ible Westerners soon after the object's return; and West-ern connoisseurs of African art. . . .*[24]

Why the extensive international media attention to the Afo-a-Kom's theft and return? In an *African Arts* article, "The Press Meets the Afo-a-Kom," Walter Brasch and Gilbert Schneider include diverse comments concerning the infamous theft. For example, William Siefkin, desk officer of the U.S. Department of State, told the *New York Times*: "I'm glad it received as much coverage as it did because it brought out the problem of stolen art treasures." Jane Rosen of *The Manchester Guardian*, offers a political perspective: "It has some heavenly attributes because it has diverted the Americans' attention from Watergate and even from the Middle East."[25]

The process of returning the Afo-a-Kom was highly political, and the Cameroon ambassador was concerned about the divisive effect of media emphasis on the Kom people. In contrast, he explained that "the different beads with which [the Afo-a-Kom] is covered affirmed the unity in diversity." This national slogan refers to Cameroon's attempt "to integrate its many ethnic groups into the national governmental process and to prevent one ethnic group from becoming more powerful than others."[26] Ferretti is disturbed by our "Western arrogance," noting that:

> *we tend to ignore the history and traditions of others, and, when we are aware of them, to discard them. In the case of Africa, many of us talk glibly of its primitive-ness, while we admire the sophistication of its art. We do not concern ourselves with the African people ex-cept to force on them new religions and new govern-mental forms. Most often this is done to peoples who have had governable societies and intricate, satisfying religions for centuries.*[27]

In retrospect, it would have been a step in the right direction for cross-cultural communication, says Shanklin, if the press had realized "that there are two sides to a story such as that of the Afo-a-Kom's odyssey," and had taken the opportunity to use this episode to promote non-racist cultural perceptions of a world that Western-ers hear too little about except in the most critical and negative circumstances. A better balance might be achieved if the media

regularly featured the ongoing integration of art and life in non-Western cultures to build our awareness and appreciation of the cultural diversity and the many proud traditions that exist in Africa.

Anlu: A Women's Institution for Social Action

In Cameroon, women have historically cooperated for purposes of social security, social justice, and economic survival. In addition to the beadwork cooperative, there is *Anlu*, an organization that has a long history of enforcing social justice. Unfortunately, examples of women's strength and unity are seldom publicized. In contrast, polygamy, a sensational topic for Westerners, is often discussed. As a result, we are left with a one-dimensional view of women in African society. For example, within the palace social system, a king, *fon* or chief may have an unlimited number of wives. The ruler of the Kom Kingdom was reputed to have over one hundred wives, but it is important to understand that they were

> *wives only in title. They have nothing to do with the fon physically. All of the women are of royal lineage, some are the wives and sisters of former fons, who exist in a "social security" society in which there are layers of power generally dependent upon age, rank, and relation to the fon.[28]*

However, the institution of *Anlu,* which has existed for over three hundred years in the Kom Kingdom, is an extraordinary example of social interaction among women. It remains, however, a story seldom reported. Is the reason for this neglect due to *Anlu's* function as a powerful means of publicly making women's voices known and respected through their social actions? A remarkable episode of *Anlu,* which occurred in 1958, is described in one of the few references available on the subject, by Robert Ritzenthaler in *Anlu: A Women's Uprising in the British Cameroons*: that the women of Kom are farmers and when they perceived a threat to their land, which they regard as sacred, seven thousand of them in the Bamenda province acted as a political pressure group "to unseat the party in power and vote in the opposition party in the January, 1959, elections." Ritzenthaler describes the solidarity and impact of *Anlu* when "two thousand women of the Kom tribe, bedecked with vines, entered the government station at Bamenda after a thirty-eight mile march of a day and a half, in protest at the summoning for interrogation of four of their leaders."[29]

Anlu is also reminiscent of Aristophane's classical Greek play *Lysistrata*, in which Athenian men are coerced into respecting women's judgments related to social justice.

> *Men who attempted to interfere with Anlu were chastised by their wives who might refuse to feed them . . . and there were stories of women hiding all the clothing of their husbands so they were restricted by modesty to their compounds.[30]*

According to Ritzenthaler: "The invoking of *Anlu* was a serious affair and used sparingly."[31] Ferretti notes: "When the women collectively

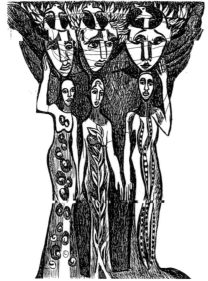

(Fig. 19) *Calabashes and Spirits,* by Betty LaDuke, Pen and Ink, 14 x 11", Cameroon, 1991

become angered at some offense committed by a man against a woman, they publicly ridicule him with what is called an *'An-Lu,'* a public revilement designed to make the man plead for mercy."[32] Ritzenthaler describes some offenses committed by both women and men, from lack of proper birth control to physical abuse, that could provoke retribution from *Anlu.*

> *These included a man's beating or insulting (by uttering such obscenities as "Your vagina is rotten")... beating of a pregnant woman; incest... the pregnancy of a nursing mother within two years after the birth of the child; and the abusing of old women.*[33]

Kom women were active feminists, dealing with issues of social welfare and justice long before Western societies were willing to unveil the taboos regarding discussion and prevention of population explosion, incest, and physical abuse. Rather than living in fear and isolation, when a woman was offended she "would summon women to her aid by sounding a war-cry . . . a man could present his complaint to the head women of his compound," and the issue would be discussed by the older women who would decide on a course of action. When the offender was summoned, he could offer an apology and the payment of goats and fowls, or if he was an habitual offender, more drastic action was taken. This might include public ridicule, "demonstrations of dancing and singing of mocking songs, bedecking the person with vines and garden eggs when demonstrating, and the use of the garden egg plant as a sign of stigma. . . . A person thus ridiculed rarely could hold out more than two months."[34]

It is interesting to note that current anthropological literature concerning grassland kingdoms focuses on the power of *fons* and notables, but little attention is given to women's organization or to the new *Anlu.*

Heading this organization is a queen who also determines policy and law.

> *The idea of a Queen chosen by the women to represent them is an ancient one in the Kom area. In former times such a woman had considerable authority and even had her own stool (symbolic of chiefly rank), but the previous fon had suppressed this office.*[35]

Perhaps the reason for suppression is that Anlu was an effective political force for a series of mass actions that by "the summer of 1958 had seized the power from the men, rendering the Fon and his executive council ineffectual, a breakdown of traditional authority."[36]

There is an aspect of *Anlu* that selectively assists social change with good and bad results, depending on one's perspective of "progress." Ferretti describes a range of "nativistic elements" in the new *Anlu:* some members wanted to reject Western elements such as missionary schools, zinc roofs, and all European things; while others wished "to retain such European-introduced institutions as the public corn-mill and the maternity hospital." [37] Curiously,

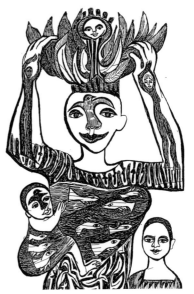

(Fig. 20) *Cameroon Women Spirit*, Betty LaDuke, Pen and Ink, 14 x 11", Cameroon, 1991.

81

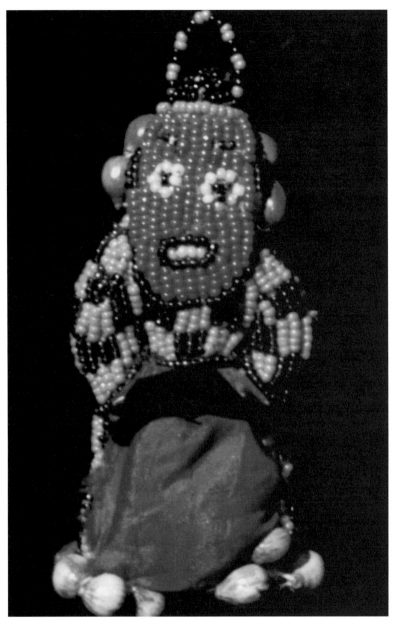

(Fig. 21) Beaded Doll, Bamenda, Careroon, 1991.

however, in his discussion of the "great huts" in *Institutions in Modern Politics*, Tabuwe ignored *Anlu* as a potential model for activating Cameroonian women's leadership in post-nationalist development and their contributions to society. It would be interesting to know if the Baham women's beadwork cooperative, Association des Artisans, was also a form of *Anlu*. In retrospect, I wish I had asked more penetrating questions and pursued more detailed answers.

Women, Beadwork, and Social Change

Could beads and bead imagery become a future source of self-empowerment for women and their daughters? Some Cameroonian women focus on the production of small, mixed-media beaded dolls (Fig. 21). These dolls are described by Etienne-Nugue as "an am-

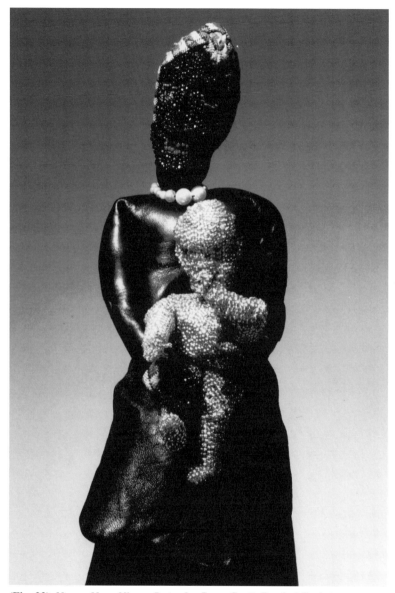

(Fig. 22) *Nanny Now, Nigger Later,* **by Joyce Scott, Beaded Sculpture, Baltimore, Md., 1989.**

biguous object, combining the profane with the sacred which, as a gift to a little girl, assures a concrete bond between the child and the family, with her womanhood and her future motherhood." [38]

But what would happen if village women like Rosette Mono had the opportunity to explore new representations of the feminine form? Would they benefit from exposure to the mixed-media images of African-American artist Joyce Scott and her beaded figure *Nanny Now, Nigger Later* (Fig. 22) or from Faith Ringgold's masked, life-size figure *Aunt Bessie*? Lowery S. Sims, associate curator of twentieth-century art at New York's Metropolitan Museum of Art, discusses Scott's work in *Next Generation: Southern Black Aesthetic*:

> *Scott's work has emerged from an extended autodialogue about body language, body type and self image . . . the sculptural works demonstrate her unchallenged mastery*

Endnotes

1. Christaud Geary, *Things of the Palace, a Catalogue of the Barnum Palace Museum in Foumban* (Wiesbaden, Germany: Franz Steiner, 1983), p. 86.
2. R.P. Engelbert Myend, *L'Art et Artisanat Africans* (Yaounde, Cameroon: Editions CLE, 1980), p. 72.
3. Ibid, p. 72.
4. Tamara Northern, *Sign of the Leopard, Beaded Art of Cameroon* (Storrs, Conn: William Benton Museum of Art, 1975), p. 21.
5. Geary, pp. 86.
6. Ibid., p. 87.
7. Fred Ferretti, *Afo-A-Kom, the Sacred Art of Cameroon* (New York: The Third Press, 1975), p. 142.
8. Tamara Northern, *Royal Art of Cameroon Catalogue* (Hanover, N.H.: Dartmouth College, 1973), p. 21.
9. Ibid., p. 21.
10. Ibid., p. 19.
11. Ibid., p. 147.
12. Ibid.
13. Paul Gebauer, *Art of Cameroon* (Portland, Ore.: Portland Art Museum, 1979), p. 77.
14. Ibid., p. 77.
15. Jocelyne Etienne-Nugue, *Crafts and the Arts of Living in Cameroon* (Baton Rouge, La.: Louisiana State University Press, 1982), p. 49.
16. Ibid., p. 49.
17. Michael Aletum Tabuwe, *Cameroon, Bafut Institutions in Modern Politics* (Yaounde, Cameroon: Supercam, 1990), p. 54.
18. Ibid., p. 54.
19. Fred Ferretti, p. 9.
20. Eugenia Shanklin, "The Odyssey of the Afo-a-Kom," *Africa Arts,* Vol. 23, No. 4, October 1990, p. 65.
21. Ibid., p. 67.
22. Ibid., p. 64.
23. Ibid., p.62.
24. Ibid.
25. Walter Brasch and Gilbert Schneider, "The Press Meets the Afo-a-Kom," *African Arts,* Vol. 8, No. 1, 1974-75, p. 85.
26. Ibid., p. 63.
27. Ferretti, p. 9.
28. Brasch & Schneider, p. 69.
29. Robert Ritzenthaler, "Anlu: A Women's Uprising in the British Cameroons, *African Studies,* Vol. 29, No. 3, 1960, p. 151.
30. Ibid., p. 151.
31. Ibid., p. 152.
32. Ferretti, p. 24.
33. Ibid.
34. Ritzenthaler, p. 151.

35. Ibid., p. 153.
36. Ibid.
37. Ferretti, p. 24.
38. Etienne-Nugue, p. 107.
39. Lowery S. Sims, "On Notions of the Decade, African-Americans and the Art World," in *Next Generation: Southern Black Aesthetic* (Winston-Salem, N.C.: Southeastern Center for Contemporary Art, 1990), p. 11.
40. "Being a Woman Is Black Feminist Artist's Problem," *The Chattanooga Times*, Sunday, September 8, 1974.

of beading, as well as her ability to give visual form to political concepts. Scott reminds us of the dispensability of black women in this society in Nanny Now, Nigger Later.[39]

Ringgold created all her masks, including Aunt Bessie, with their mouths open, "symbolizing the need for women to speak out for themselves, to articulate their problems and their issues." Ringgold is optimistic about feminist progress in Africa and says "women's liberation in these countries will never be true and complete until the women pick it up as their own cause."[40]

In speculating about the future, I wondered if a women's collective art association would receive sponsorship for bead workshops that would actually enable them to explore doll-making as social satire, social criticism, or new role models for women? What if some of these role models were teachers, doctors, and government administrators? There have been many workshops for painters throughout Africa. Why not sponsor some for traditional rural beadworkers? With short-term subsidy, women could then afford to take creative risks that might not result in immediate commercial sales but could lead to innovative aesthetic results for the future.

It would also be edifying to see women's beadwork utilized as a vehicle for international dialogue and cultural exchange. This opportunity might encourage village women who have had no opportunity for social or aesthetic exposure beyond their local traditions to expand their vision. Indeed, this might result in the creation of new doll and parent role models for the younger generation, that could raise consciousness for social change from a women's perspective.

Zimbabwe

SHONA WOMEN SCULPTORS

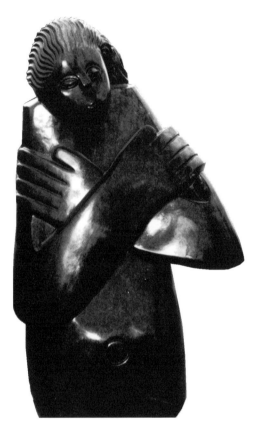

After several years of looking at book reproductions, it was an enlightening experience finally to see original "Shona" sculptures. It was a pleasure to meet the men and women who created these stone poems based on their personal experiences, cultural myths, and traditions. Guiding the Shona sculptors along their impressive path of achievement were various determined and visionary individuals: Frank McEwen, director of the National Art Gallery of Zimbabwe; Roy Guthrie, director of the Chapungu Sculpture Park; and Tom Blomefield, founder of the Tengenenge Community.

While Shona men have been sculpting for over thirty years, four women sculptors, the focus of this section, have been working relatively few years. Nevertheless, their consistent efforts merit the acclaim they are currently receiving.

Agnes Nyanhongo and Colleen Madamombe both work at Chapungu Sculpture Park; Alice Sani lives and works at the Tengenenge Community; and Mavis Mabwe lives and works at Chitungwiza, a Black township near Harare. Unlike other young mothers pounding millet with pestles, these women spend most of their days pounding stone with mallets and chisels in their hands (Figs. 1–4). How had this identity and career as "artists" evolved for them? What had nurtured their talent?

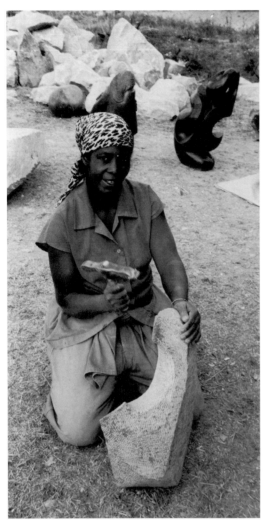

(Fig.1

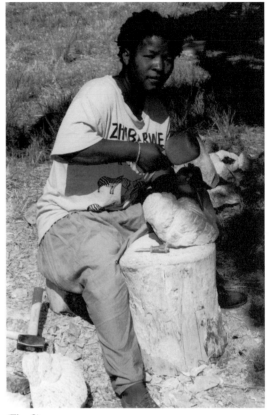

(Fig. 2)

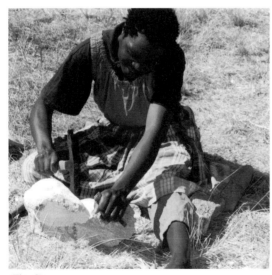

(Fig. 3)

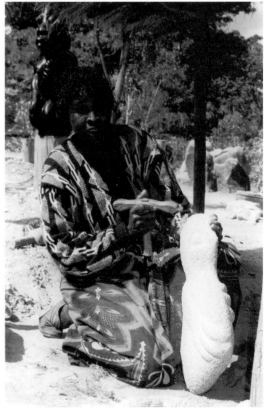

(Fig. 4)

After meeting the women at their homes or studios, I found their work diverse in style, but they all shared a common theme, the female form. I wondered what these forms reveal about women's lives and experiences. I was also concerned about the specific circumstances that allowed each woman's talent to surface and mature, and the ongoing professional support they received to sustain their creative development.

Before focusing specifically on Nyanhongo, Madamombe, Sani, and Mabwe, a brief historical overview follows to discuss the contributions of McEwen, Guthrie, and Blomefield, men who persisted in promoting Black art at a time when it was not popular to do so. Another significant supporter of the Shona sculpture movement is Diane Mwamuka, director of the Mabwe Gallery. Mwamuka is Zimbabwe's first African woman gallery director, and she offers a different perspective of the contemporary art scene before and after independence. The interplay among the artists and teachers/mentors and patrons produced dynamic results. According to Ray Wilkenson, writing in *Newsweek* on September 14, 1987, Shona sculpture is "perhaps the most important new art form to emerge from Africa in this century."[1]

Frank McEwen and the National Art Gallery of Zimbabwe

Born in Mexico in 1907, but raised and trained as a painter in England, Frank McEwen was a teacher before he relocated in Paris. There he became a successful art critic and organized major international art exhibits featuring Picasso, Matisse, Giacometti, Arp, Brancusi, Moore, and others. McEwen also was

> *a keen follower of the psychologist Carl Jung who saw many positive attributes in what he identified as the "spontaneousness" vitality of the so-called "primitive" societies. . . . He promoted the concepts of mysticism and spontaneity in art as opposed to what he saw as the logic and objectivity of a modern world deprived of soul.*[2]

When McEwen was invited by Southern Rhodesia (as Zimbabwe was called before independence) to be the first director of the recently constructed National Gallery, he found that "the gallery had been conceived by the authorities as a showpiece for the exhibition of European artists." Celia Winter-Irving comments, "When he [McEwen] arrived in 1957, he was horrified at the colonial suppression of genuine indigenous cultural expression in the country, and appalled at the existing proliferation of mechanistically produced art for the tourist trade." She describes how, with "remarkable insight he commandeered . . . the intuitive and untutored talent that lay within the Shona."[3]

In the 1960s, McEwen established the National Gallery Workshop School and "invited indigenous people to come . . . to make art."[4] At the Workshop School the emphasis was on painting first "with astonishing results," but, based on the artists' preference, they

(Fig. 1) Mavis Mabwe Carving Stone, Chitungwiza, Zimbabwe, 1993.

Fig. 2) Colleen Madamombe Carving Stone, Chapungu Park, Harare, Zimbabwe, 1993.

(Fig. 3) Agnes Nyanhongo Carving Stone, Chapungu, Zimbabwe, 1993.

(Fig. 4) Alice Sani Carving Stone, Tengenenge, Zimbabwe, 1993.

shifted to carving stone. "Artists acquired an understanding of art for art's sake, as opposed to craft or 'airport' art and the use of Shona mythology as a source of inspiration."[5] McEwen asked the sculptors "to imagine 'the shapes that could please their ancestors or the spirits.'"[6] He described some mythical spirits frequently utilized by Shona sculptors as they

> *recount their visions, their waking or sleeping dreams. . . Tsuro, a benign, imaginary spirit-creature who offers sympathetic company and protection to the believer. [This composite being can share attributes of man, hare, baboon, buck, bird, or ant-bear.] . . .The revered Baboon Man, or faith in a baboon spirit possessed of certain knowledge. . . The Eye Concept which derives from a belief once found widely among so-called 'primitive' peoples, that man's life, his acts and thoughts, are constantly observed by unseen powers . . . and the head is enlarged, for that indicates the significant location where the Spirit resides.[7]*

While some white Rhodesians supported the sculptors and bought their work, most considered it "a grotesque type of art . . . monstrosities conceived by a diseased mind," as they "did not understand African art and saw no place for it."[8] To avoid increasing tensions and frustrations, in 1968 Frank McEwen established the Vikutu Workshop in a remote area, where sculptors came to live and work. However, the situation was different in Europe. In 1970, at the first major overseas exhibit held at Musée d'Art Moderne, everything sold on the first day of the showing. In 1971, over one hundred Shona sculptures, including "several terra cotta works by women," were exhibited for the second time in Paris at the Musée Rodin and "completely sold out."[9] In her 1992 *African Arts* article, Claire Polakoff enthusiastically notes that "Since the inception of the Workshop School some fifteen years ago, between six and seven thousand pieces have sold to people from all over the world." Polakoff describes the excitement of the event as a

> *myriad spectacle of form, color, substance, and line. The force of the mystical Shona spirits emanating from the miraculously magical carvings filled the viewers with that intangible quality through which non-verbal communication is perceived and received. This was art in its ultimate dimension.[10]*

At first, the sculptors used soapstone. But soon most sculptors preferred the harder serpentine stone. It can vary in color from green to red, brown, or black. Springstone found in the Tengenenge region is the hardest form of serpentine, while steatite is softer, with more varied surface colors. Most artists work directly without referring to sketches, using their hand tools, hammers, mallets, chisels, punches, and rasps. The pieces are brought to a smooth finish with emery paper and then polished with many layers of clear wax to bring out the surface colors. Some sculptors juxtapose smoothly polished surfaces with rough, unfinished sections of the rock. Guthrie states "That the stones live and have 'life' is apparent to any discerning viewer."[11]

In 1973, due to political uncertainty and harassment by the government, Frank McEwen resigned and returned to England, where, until his death in 1994, he continued his passionate support of Zimbabwe sculpture. Oliver Sultan describes the intense war period, 1973 to 1980, as a "difficult one for sculptors in terms of movement, sales, access to stone, etc. Their greatest support during these years came from friend and patron Roy Guthrie of Chapungu."[12] Ten years would pass before the momentum of sales and the critical acclaim achieved in Paris and at other international exhibits would be revived.

Under the leadership of Cyril Rogers, the next appointed National Art Gallery of Zimbabwe director, McEwen's legacy continued to expand. Particularly important was the establishment of an art-education program, the BAT Workshop, funded by British American Tobacco Zimbabwe Limited, which has stimulated a second and third generation of sculptors. The first two women to attend were Agnes Nyanhongo and Colleen Madamombe. Their work also reflects the influence of life drawing classes as well as the encouragement they received to use their own lives and experiences for sculptural themes.

Chapungu Sculpture Park: Roy Guthrie

The most exciting aspect of Chapungu Park, located in a rural suburb of Harare, is the enormous diversity of monumental sculptures integrated within the landscape, so that wherever one walks there is a breath-taking sense of surprise and discovery. There are works in the permanent collection by major first-generation sculptors that include Nicholas Mukomberanwa, Joseph Ndandarika, Tapfuma Gutsa, Moses Masaya, John Takawira, Sylvester Mubayi, Thomas Mukarobwa, and Bernard Matamera. I particularly enjoyed Matamera's *Rhinoceros Man* (Fig. 5) and I was glad to have had the opportunity of meeting him later at Tengenenge, his home (Fig. 6). At Chapungu, visitors are welcome to take the pathways that lead to the sculptor's work station, which for the past five years, in addition to the sons of some of the artists, have included Agnes Nyanhongo and Colleen Madamombe.

When I spoke with Roy Guthrie,[13] the director of Chapungu Park, I learned that his interests had developed from being a successful refrigeration and electronics businessman to becoming a passionate promoter of Shona art. In 1973, when Guthrie invested in Gallery Shona Sculpture as a business venture, he also had the foresight to invest not only in the sale pieces, but in major works retained for a permanent collection, now recognized as the best in Zimbabwe. But during the decade of the seventies, "as the war for independence heated up," Guthrie's goal was basically limited to "keeping artists alive and working, to offer them a ray of hope . . . a place where they could sell their work." Rhodesia, under the White minority rule of Prime Minister Ian Smith's government, was isolated by the economic sanctions imposed by the international community. "It was also a time characterized in Zimbabwean literature as a period of 'drought and hunger.'"[14]

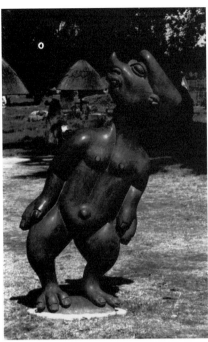

(Fig. 5) *Rhinoceros Man* by Bernard Matamera, Chapungu Park, Harare, Zimbabwe, 1993.

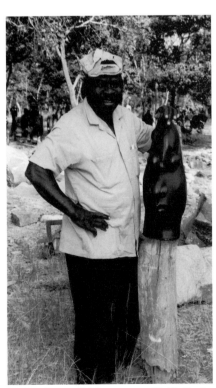

(Fig. 6) Bernard Matamera with his Sculpture, *Eagle Man,* Tengenenge, Zimbabwe, 1993.

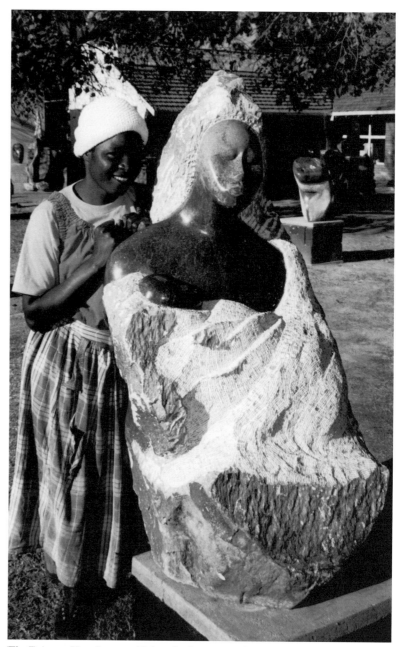

(Fig. 7) Agnes Nyanhongo with her Sculpture, *Mother and Child,* **Chapungu Park, Harare, Zimbabwe, 1993.**

In 1980, after independence, Guthrie initiated Chapungu Sculpture Park, where he could expand the permanent collection and provide the sculptors with large stones and a work space. The collection was also an important inspiration for the younger generation of artists and gave tourists and collectors an historical perspective of Shona sculpture. Celia Winter-Irving comments that Chapungu allows

> *an artist to see progress in terms of his career and his development in terms of changes of style and formal approaches, and is of great assistance to scholars. . . . It permits a critical and comparative assessment of work to be made over a period of time.*[15]

Guthrie's role in promoting Shona sculpture and sales is significant, as he arranges major overseas exhibits, the creation of accompanying catalogs that feature biographies of the artists, and publicity. In addition, there are the Chapungu Annual Group Exhibit and a monthly Chapungu Newsletter[16] to maintain contact with worldwide visitors and collectors. Guthrie's initial business investment in Shona sculpture evolved as a cultural commitment in Zimbabwe's future, which now includes women artists. While Guthrie is optimistic, he is also aware of

> the pressures of commercialism, copying and mass production, but to witness the innovation, experimentation, imagination, and technical prowess of these artists gives a confident picture for the future. . . . I believe we have only seen the beginning.[17]

Agnes Nyanhongo

For the past three years, Colleen Madamombe and Agnes Nyanhongo have been colleagues at Chapungu Sculpture Park in Zimbabwe. I had two encounters with them.[18] The first time they were sculpting at their work stations, and I felt uncomfortable interrupting them. Therefore, I found our second visit more congenial, as I arrived during their afternoon break for tea, which I was invited to share with them. As we spoke of their work and how it reflected women's experiences, I decided to show them photographs of my Africa-inspired paintings, as well as my family (children and grandchildren). These images established some of our common personal and professional references.

Born in 1960, Agnes Nyanhongo, at age thirty-three, is now considered by Roy Guthrie as "one of the most prominent and successful of the 'second generation' of Zimbabwe's sculptors, and one of the few women artists in her field."[19] There are currently eight hundred sculptors in Zimbabwe, but fewer than twenty are women. Why have there been so few women sculptors since the initiation of Shona sculpture in the 1960s? Some women have had exposure as daughters of well-known sculptors (like Claud Nyanhongo) and have learned, as Agnes Nyanhongo has, by first polishing the work of their famous fathers, uncles, brothers, or husbands. But few women have deliberately made the creation of sculpture their professional goal early in life or received the necessary encouragement to sustain this hard work. In Nyanhongo's case, Celia Winter-Irving notes that

> it was her conscious decision to become a sculptor herself. She studied for three years at the National Art Gallery's (BAT) Workshop and saw that experience as improving her technique and, most importantly, broadening and deepening her understanding of art.[20]

Agnes Nyanhongo's subsequent marriage to sculptor Joseph Munemo also provided continuity for her professional goals. In addition, her roles as wife and mother of three children have affected Nyanhongo's aesthetic and thematic concerns. Guthrie comments:

(Fig. 9) *Chapungu,* by Agnes Nyanhongo, Chapungu Park, Harare, Zimbabwe, 1993.

She works extensively with the human form, sometimes specifically with female issues, but always expressing a calm and watchful strength that seems so true to her own personality and character.[21]

Outside the Tengenenge and Vikutu community, the BAT Workshop has been the only other location where so many sculptors have been brought together to work. Having the consistent support of Guthrie and Chapungu for the past five years has been significant. But the reasons for their success are fourfold. First, the twelve resident sculptors are surrounded by an incredible permanent collection of Shona sculpture. Second, they have access to a constant supply of large and choice stones. Third, they have the stimulus of interacting with other sculptors. Fourth, they have the critical support of a formal gallery system for exhibits and sales. Guthrie constantly plans national and overseas exhibits and takes care of all the details and transportation.

All year long the work of these twelve sculptors is visible to collectors, as finished pieces are immediately displayed at the park. Smaller pieces are placed within the enclosed Shona Sculpture Gallery. The sculptors' names are clearly visible, along with biographical information, and there are informed gallery guides in attendance. Occasionally Nyanhongo and other artists travel with Guthrie to participate in international exhibits. This has given Nyanhongo an opportunity to visit museums, galleries, and artists' studios in England and in the United States.

Since Nyanhongo was participating in the 1993 United States Sculpture in the Park Exhibit, some of her work had already been shipped. However, several sculptures remained on display and offered a view of Nyanhongo's style and diverse themes. In *Mother and Child* (Fig. 7), the smooth, gently curved surfaces of the green serpentine stone portray a mother's face and shoulders with her baby nestled against her. In contrast with the smooth surface of their features, the figures are enveloped in unpolished rough stone that suggests a protective cloth.

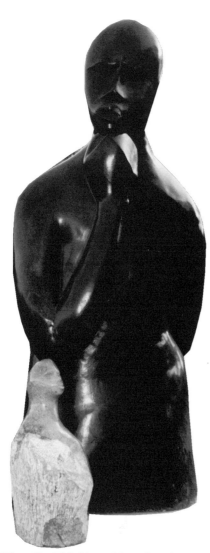

(Fig. 8) *Thinking Man* by Agnes Nyanhongo, Chapungu Park, Harare, Zimbabwe, 1993.

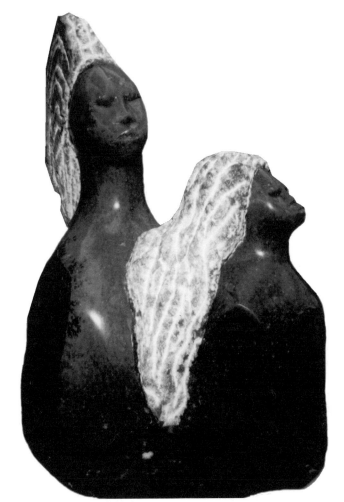

(Fig. 10) *Sisters,* **by Agnes Nyanhongo, National Art Gallery of Zimbabwe, Harare, Zimbabwe, 1993.**

Nyanhongo is influenced by the shape and texture of the stone, by her own experiences, and more recently by Shona myths. According to Guthrie, "As a mother she recognizes the value of such a cultural history and the importance of passing this on to her children."

Another recently completed piece is the five-foot tall, slender-torsoed *Thinking Man* (Fig. 8). This figure stares solemnly into space with eyebrows furrowed, and one hand placed under his chin. The form is conceived as a simplified rhythmic mass, with the body's weight shifted slightly to one side.

Standing on the pedestal beside *Thinking Man* is a smaller version (fourteen inches tall) of *Mother and Child* (see Fig. 7). The stone, left rough along the vertical sides, suggests the mother's arms. A textured cloth envelopes the baby, exposing only its round, peaceful face. In both the large and small sculptures of *Mother and Child*, the stones are white, permeated with irregular grains of red and yellow ochre. In each sculpture, Nyanhongo sensitively integrates the diverse coloration into the sculptural composition.

In a horizontal piece, *Chapungu* (which means "eagle" in Shona), Nyanhongo created a feeling of continual flow by the turning of the eagle's head toward an extended wing. *Chapungu* (Fig. 9) is set on the ground and projects an intense energy, as the bird's round, incised eyes seem to keep a sharp vigil. The bird is the national symbol

of Zimbabwe. Shonas believe that a "family's or individual's guiding spirit may appear as a bird, the Chapungu, who makes the link between the spirit world and that of the living."[22]

Nyanhongo has participated in the Annual Exhibition by the National Gallery of Zimbabwe in 1985, 1987, 1989, and 1990. She has received numerous awards of merit, including one in 1989 for *Refugee Mother and Child*, which was described by Winter-Irving:

> *The eyes on both are sightless. Feeling that they have no place in the world, they both seem oblivious to it: seeing nothing and avoiding its presence. The African quality in the work is unmistakable, but the feelings it conveys are universal and applicable to many similar situations.[23]*

Another earlier piece, *Foetus*, has also been extensively reviewed. Winter-Irving describes *Foetus* as "the artist's idea of a stage of development in her body before her first baby was born, the heaviness of what she was carrying, and the feelings of discomfort before and during labor."[24] Guthrie considers *Foetus* as "almost abstract; its simplicity spoke to audiences across cultural and spiritual barriers . . . Agnes feels it essential that the idea is communicated successfully to men as well as women."[25]

Nyanhongo is disturbed about "the role that women play in society and the way they are being treated. They are still not free. They are struggling for freedom. Men must also see this because it is something that exists between them."[26]

The opportunity to study art at the BAT workshop made her aware of the role of art in society, that "art was part of the mainstream of African art and international art." For her professional development she credits "the encouragement I was given as a student that helped me establish myself as a professional artist in a highly competitive male-dominated field."[27] One of her sculptures, *Sisters* (Fig. 10), is featured in the first women's mixed media art exhibit at the National Art Gallery of Zimbabwe, August 1993.

Colleen Madamombe

Colleen Madamombe was born in Harare in 1964 (Fig. 11). She and Agnes Nyanhongo have been friends for a long time, as they both attended the BAT Workshop. Their work, however, is very different. Madamombe is also married to a sculptor, Fabian Madamombe, whom she met at the BAT Workshop. He has been working at Chapungu for six years. Together they have four children.

Both Madamombe and Nyanhongo realize they are role models for a younger generation of female students who come to visit Chapungu on school tours. They say, "We are the lucky ones. Most people ask us, 'Is this your job?' They don't think we can make a living sculpting." When I asked how their parents felt about their work, I was told, "Our mothers and fathers are very proud."

Madamombe's pieces almost always incorporate a sense of drawing on the stone surface. Unpolished areas are filled with carefully incised lines that echo the rhythmic movement of the form. In *Lovers* (Figs. 11 & 12), which stands over four feet high, the repetitious

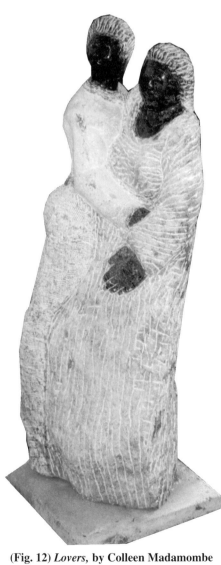

(Fig. 12) *Lovers,* **by Colleen Madamombe at Chapungu Park, Harare, Zimbabwe, 1993.**

(Fig. 11) Colleen Madamombe with her Sculpture, *Lovers*, Harare, Zimbabwe, 1993.

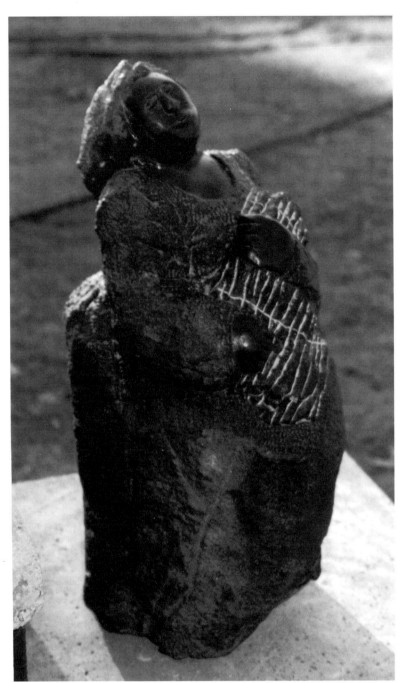

(Fig. 14) *Woodgatherer* by Colleen Madamombe, Chapungu Park, Harare, Zimbabwe, 1993.

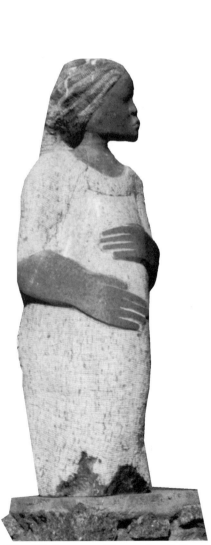

(Fig. 13) *Pregnant Woman,* by Colleen Madamombe, Chapungu Park, Harare, Zimbabwe, 1993.

lines suggest a dress pattern or folds in cloth as the lines progress along a sleeve. There is a tender feeling between the couple, though they are not looking at each other. Their merged forms are separated by different surface textures. Only the couple's hands and faces are smooth and polished black.

Pregnant Woman (Fig. 13) stands with her hands across her slightly protruding belly. She seems to look inward with the wonder and expectancy of giving birth. The pregnant woman's dress is inscribed with lines that circle around her horizontally; only the hands and face are left smooth.

I noticed that many of Madamombe's figure proportions are robust and strong, as they are involved in survival activities such as *Woodgatherer* and *After the Harvest*. In *Woodgatherer* (Fig. 14), approximately four feet tall, the woman's face is turned upward; the firewood she is holding seems to merge with her sturdy form. In *After the Harvest* (Fig. 15), approximately three feet in height, the woman's seated form seems to parallel the round basket filled with grain that she holds on her lap; she concentrates on the extensive processing required before a meal can finally be prepared. Madamombe also produces smaller pieces as she is conscious of the fact that her work must be affordable to a wide range of collectors. In some of these pieces she explores psychological states and relationships such as *I'm the Boss, Husband's Sister*, and *The Grandmother*.

In an interview, Madamombe told Roy Guthrie that "women's movement and stature reveal more pride than that of the opposite sex and give great scope for sculptural depiction . . . rather than simply being bound by her own feelings, she also tries to portray the experiences she witnesses in other women." In addition to themes of pregnancy and birth, Madamombe "looks forward to portraying feminine experience through to old age."[28]

In contrast to these somber figurative pieces, *Ant Hill* (Fig. 16) is playful in mood. Rather than a mythological interpretation, these are real, greatly magnified ants that crawl along the stone surface. They are carved in relief and stained brown and black, contrasting with the stippled grey background of the ant hill. Guthrie, says:

> *She gives importance to seemingly insignificant subjects*
> *such as ants, bees, butterflies and caterpillars. Spending*
> *much time watching insects (ants, in particular), Colleen*
> *admits to a fascination with their apparent humility–a hu-*
> *mility which she feels the human race has lost.*[29]

In comparing Madamombe and Nyanhongo's treatment of the human form with the work of older male sculptors such as Bernard Matamera, one finds some interesting differences. In this early stage of their careers, Madamombe and Nyanhongo are primarily literal in their interpretations, leaning heavily on their life experiences. They have no women role models to follow, so, as pioneers, it seems they must first explore their realistic identity as women within their families and their community before plunging inward for a more imaginative or mythical interpretation. However, they do explore a wide range of themes–from physical activities to relationships–that include *Lovers, Mother and Child, Sisters*, and political issues such as *Refugee*. Their personal experiences of pregnancy are also evident and vary from each other. For example, while Madamombe portrays an exterior pregnant view, Nyanhongo's concept in *Foetus* is more abstract and symbolically interpreted. The fetus shape is derived from experienced physical sensations rather than observation and is closer in formal concept to Bernard Matamera's work, which Cecilia Stone vividly describes:

> *Matamera opens up the options of sexuality. He sees sexual*
> *pleasure not only as the privilege of man and woman, or*

(Fig. 16) *Ant Hill,* **by Colleen Madamombe, Chapungu Park, Zimbabwe, 1993.**

*the thin and rich, but of children and animals, the mis-
shapen and the grotesque. He opens up the prospect for
sexual pleasure and extends the potential for coupling.
Overall his sculpture states that sexuality is not only the
pleasure of the few but the right of the masses. . . . We are
asked to reshape our notions of beauty and engage in a
number of erotic pursuits, to enter a word of romping and
rolling, of games for the flesh and playtime for lust.[30]*

Perhaps in time, Nyanhongo will turn once again to abstractions of
her experiences—or will she continue in a more literal direction re-
inforced by her European museum visits and exposure to "old mas-
ters"? It was wonderful to see Rodin's *Thinker* interpreted as a black,
vertical torso, with the face turned upward, pondering his own or
possibly Black Africa's communal destiny and future. In contrast,
Matamera's *Rhinoceros* "ponders on the various uses of its horn. Al-
ready it seems that metamorphosis is imminent, and that bodily
changes will soon take place."[31]

As Nyanhongo and Madamombe gain more experience and ex-
posure, there will most likely be transformations in their work, while
they maintain a consciousness of their position and an obligation to
the next generation of women sculptors. Will they allow themselves
the erotic playfulness manifested in Matamera's work, or maintain
the dignified, clothed proximity of male and female as expressed by
Madamombe in her *Lovers*? Will Zimbabwe's Black or White soci-
ety readily accept a woman's open, honest visual interpretation of
sexuality and sensuality that exposes more than a polite exterior eti-
quette? There are other issues of interpersonal freedom and equality
between male and female that need to be addressed by women art-
ists, as they are important personal and societal concerns. Some of
these themes are visible in the work of Alice Sani and Mavis Mabwe.

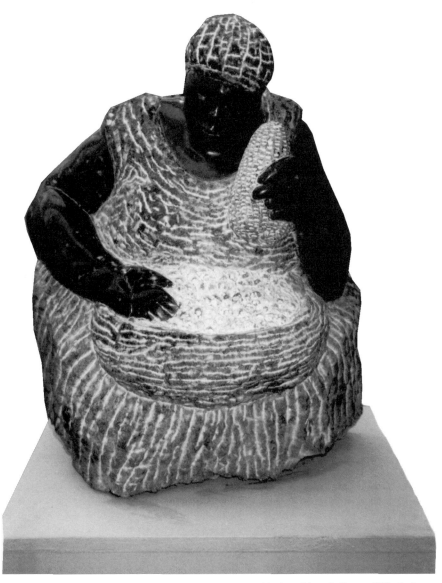

(Fig. 15) *After the Harvest,* by Colleen Madamombe, National Art Gallery of Zimbabwe, Harare, 1993.

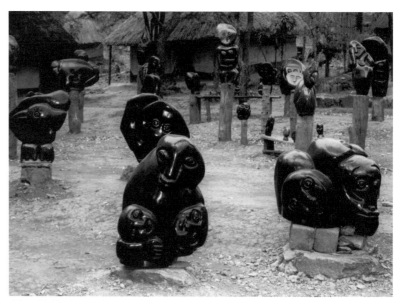

(Fig. 17) Sculpture Display, Tengenenge, Zimbabwe, 1993.

Tengenenge Sculpture Community: Tom Blomefield

It wasn't until I left the confines of urban Harare for the 150-km journey to Tengenenge to meet Alice Sani that I began to appreciate the Zimbabwe landscape. The recurring sight of huge boulders, rocks, and stones teased the eyes with their precarious formations, as if they had spilled from a circus juggler's hand. That the hammer and chisel deliberately reshaped these rocks to reflect the joys and travails of the human spirit is exuberantly visible at Tengenenge (Figs. 17 & 18). Throughout my day-long visit, I encountered an endless diversity of forms created by older resident sculptors such as Bernard Matamera, as well as very young sculptors including Alice Sani's son, Chakanetsa Muzhona.

Shortly after arriving I met Steven Blomefield,[32] the son of Tom Blomefield, who was then in Europe. Tom was the founder of this exemplary community of Black resident sculptors and their families about twenty-eight years ago. Before introducing me to Sani, Steven proceeded to give me his personal perspective of the community's history.

On this twelve-hectare farm, every grove of trees is alive with a new kind of undergrowth—stone sculptures. Each grove reflects the artist's individual personality. Smaller sculptures, one to three feet high, are displayed on top of log stands; while larger pieces, four to six feet tall, rest on the ground. Most artists and their families live beside their sculpture displays in mud-and-thatch homes. They do their carving nearby, usually under the shade of a tree. According to Steven, there are approximately two hundred sculptors currently working at Tengenenge Village, and a recent inventory counted over ten thousand sculptures. Within this profusion, there is a clearly visible distinction between the magnificent older generation of sculptors and those still in their formative stages of developing style and

technique. Steven's enthusiasm contributed to my understanding of this fascinating living community "pioneering new directions in the art of Zimbabwe."[33]

Tom Blomefield's comfortable life as a wealthy tobacco farmer was abruptly interrupted in the 1960s by international economic sanctions imposed during the long, drawn-out war for independence. Tom is a self-taught artist and, according to Steven, in the mid-1960s "Crispin Chakanyuka, a sculptor, offered to teach my father." Also very important to the entire development of Tengenenge was the fact that "Crispin made Tom aware of the abundant serpentine stone surrounding the farm. It was a treasure. Gradually Tom became involved creating sculptures, but was not satisfied until he got everyone else interested: the cook, the tractor driver, all the farm laborers." Oliver Sultan writes, "The animal and anthropomorphic figures which they produced, once shown to McEwen, gained the attention of the National Gallery."[34]

I asked Steven what it was like as a child to experience Tengenenge and about his relationship with the sculptors. Steven's response was candid: "I grew up in a colonial period with European values. When you are the son of a farmer, you have absolute authority. It was a big change to be told by your father, 'We want you to be nice to artists.' It was a shock to be asked to be 'nice' to people."

> *Despised by neighboring white farmers and living in a war operational zone, Tom Blomefield's personality played an important part in the success and development of the artists' community. He spoke several of the local languages . . . and created a peaceful environment of mutual respect, which was unique at the time.[35]*

At Tengenenge, sculptors also come from the southern African neighboring countries of Zambia, Mozambique, Malawi, Botswana, Angola, and South Africa. In addition to the Shona, who form seventy percent of the almost nine million population in Zimbabwe, there are Ndeble, the second most populous group, and Zulu, Yao, Chewe, and others.

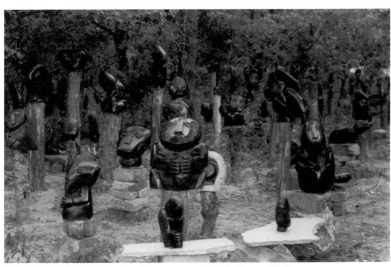

(Fig. 18) Sculpture Display, Tengenenge, Zimbabwe, 1993.

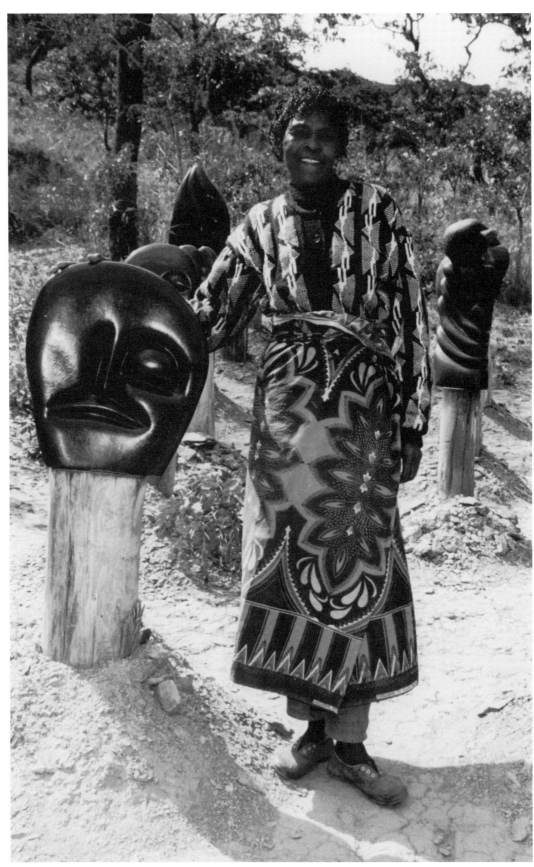

(Fig. 19) Alice Sani with her Sculpture, *One-Eyed Man From Mozambique*, Tengenenge, Zimbabwe, 1993.

Slowly Steven began to recognize traditional distinctions between peoples and refers to "those beginning lessons, and the discovery of the beauty of each of these cultures," especially important as he began to discern the individual expressions of each sculptor. Some produce as many as ten or fifteen sculptures each month.

In her interview with Blomefield, Winter-Irving notes that "the artists are given a sense of personal direction in their art. While they have conceptual freedom, they are constantly asked to question and define their reasons for making art and to objectify these reasons. An artist's clear conception of art and why he is an artist is necessary for the quality of his work."[36]

In 1979, Tom Blomefield moved to Harare as "the country surrounding Tengenenge was occupied by guerrillas fighting for independence," but he returned again in 1985. Since then there have been national and international exhibits of Tengenenge sculpture in countries that include Bulgaria, Holland, England, and Australia. Tom defines the community as a "living and growing thing. It is not just the art but the people who make the art. . . . Administration must come from within."[37] In more recent years, Steven has taken a more active interest in the future of the Tengenenge community.

Steven describes his process of interaction in Tengenenge. "I have to flow with the local culture, while I retain my own. It's like a long journey of discovery, really, getting to know local people properly to understand the deeper themes of their work. There is a personal story behind each piece of sculpture, of which the piece you see is the climax." He encouraged me to "be sure to ask the sculptors to tell you more than the title of each piece."

Alice Sani

Alice Sani's intense eyes and broad smile reflect satisfaction with her present achievements and relationships at Tengenenge. Since Sani, who was somewhat shy at first, does not speak English easily, I would have left Tengenenge seeing only the surface markings of her forms without Steven's personal insights, relating her sculpture to her life (Fig. 19).

According to Steven, there are few paths open for Black African women with limited education to explore, and he laments, "It is a terrible thing for a woman to be alone at age forty. She can become a prostitute, sell beer, or survive *by* marrying." Sani was first married at age fifteen, and her son was born shortly thereafter. She came to Tengenenge in 1988, after two failed marriages. At that time, she was in love with the Tengenenge cook. Though that did not last, Sani was urged by Tom Blomefield to stay on, and she gradually became rooted in the Tengenenge community through their stones as a carver. "Gradually her work matured. She began to do good work and to make a good living from her art. We encouraged her."

But Steven quickly adds: "You cannot make an artist. It has to be her own initiative, work, and ideas." The process of recognition at Tengenenge is both "from within the community and outside. It is a natural process. Art collectors come. They start talking about one

(Fig. 20) **Steven Blomefield and Alice Sani with** *Hungry Woman* **by Alice Sani, Tengenenge, Zimbabwe, 1993.**

person and buying their pieces. The community brings people to her and she benefits, and the community ends up benefitting from her. It's a symbiotic relationship."

Sani's compound has two thatched huts, one for sleeping, the other is a kitchen. These circular huts are coated with cement, each painted a cheerful earth yellow and circled with colorful decorative patterns. The inside appears comfortably furnished with a bed and chests for clothes and other possessions. Cooking is usually done over an iron grill fueled with wood. Steven told me the building materials for a home—mud bricks, thatch, and cement—are *gratis*, but the artists must pay labor costs for construction. Sani's son, Chakanetsa, lives nearby in a separate hut, and their work sheds and sculpture display areas are parallel to each other. Their sculptures are easily distinguishable, as each has left a personal impact upon the stone.

The themes of Sani's sculpture reach beyond a decorative façade. They are provocative and reflect personal, cultural, and political experiences. For example, the thirty-inch form of *Hungry Woman* (Figs. 20 & 21) reflects the people's suffering during Zimbabwe's recent droughts in 1991 and 1992. Sani explains, "The woman is hungry." The woman's arms repeat the rhythmic spiral pattern of her deeply grooved rib cage. While her downward tilted head rests on top of her shoulders, the mouth is slightly open as if a deep sigh of exhaustion is escaping. In referring to the rhythm of the rib cage, Steven says, "With three lines Sani has reduced a complex emotion. She is a good judge of character. I don't call it psychology, just part of life and her past experiences with sorrow, deprivation, and aloneness."

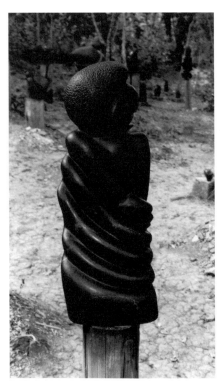

(Fig. 21) *Hungry Woman* **by Alice Sani, Tengenenge, Zimbabwe, 1993.**

In Sani's *Mother and Child* (Fig. 22), which is over four feet tall, a sleeping child is securely nestled in a carrying cloth on the mother's back. In front, the mother's arms and hands curve around and blend with the curve of her breast. Sani's simplified forms sometimes merge or flow together. For example, the mother's dominant facial feature is her protruding nose, but the mouth and chin recede and flow downward toward the breast.

Standing nearby on log pedestals are a group of smaller portraits. *Wife* and *Thinking Husband* (see Fig. 22) is a dual piece, as the wife is portrayed on one side and the husband with his hand raised to

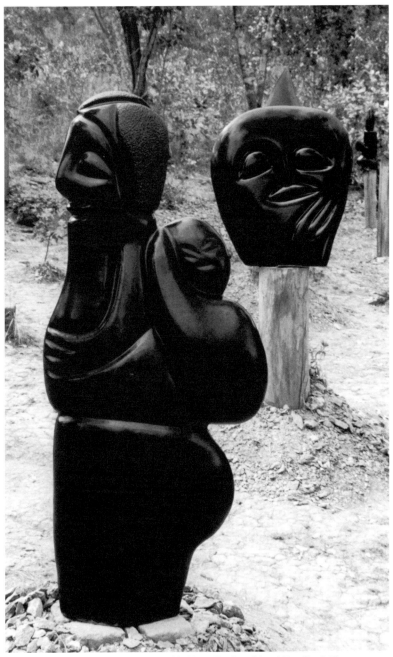

(Fig. 22) *Mother and Child* **and** *Thinking Husband* **by Alice Sani, Tengenenge, Zimbabwe, 1993.**

his chin is visible from the other. Their features, rather than protruding, are flat or incised and rhythmically conform to the stone's shallow depth. The husband's face is gently tilted upward. Light and shadows encircle the incised features, emphasizing the oval, downward–cast eyes and mouth.

The features of *One-Eyed Man from Mozambique* (Fig. 19) are also incised on a flat, oval surface. The chin forms the horizontal base of the sculpture, which rests on a log pedestal. This vertical movement is emphasized by the pedestal, which seems like an extension of the neck, and the vertical direction is reinforced by the long, thin line of the nose. The horizontal segment of this cross motif is formed by the incised, down-cast lines of the mouth. One large eye glances downward, but only a smooth, empty space stares back at us where the second eye should be. This piece relates to Sani's heritage, as she is from Mozambique. Steven explained that her generation has been involved in liberation struggles from the legacy of colonial rule that even now continue to engulf southern African nations, physically and culturally.

Though there are repetitious qualities in each of Sani's portraits, there are also variations in the facial expressions. In *Woman and Snake Totem*, the long neck supports an oval face that is tilted slightly backward. A snake's form harmonizes with the rounded forehead with its head resting along one side of the face. The snake is Sani's family totem.

Guinea Fowl Looking at the Sun (Fig. 23) and *Tortoise Coming Out of Shell* are smaller sculptures in which Sani suggests the essence of their movements or gestures. Sani sells her work regularly. Like all the Tengenenge sculptors, Sani is prolific, but carving stone is not easy, especially, Steven Blomefield reminds me, "for an older woman. Stone carving is usually considered 'men's work.'"

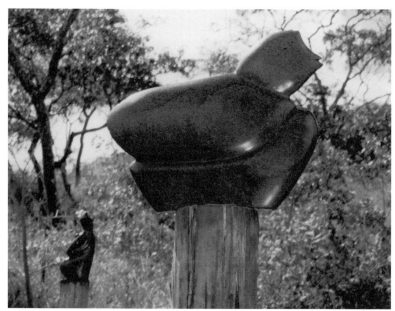

(Fig. 23) *Guinea Fowl Looking at the Sun,* **by Alice Sani, Tengenenge, Zimbabwe, 1993.**

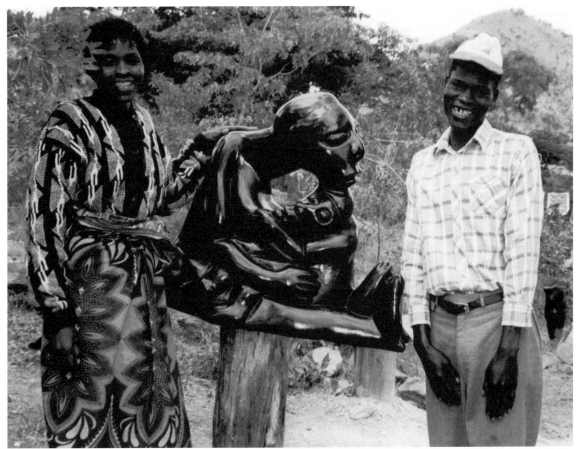

(Fig. 24) Alice Sani with her Son, Chakanetsa Muzhona, and his Sculpture, *Mother and Child,* **Zimbabwe, 1993.**

Most importantly for Sani is that she is no longer alienated from her son, Chakanetsa Muzhona, now twenty-four. From mining the abundant serpentine stone, his first job, he gradually became interested in sculpting. This became his full-time profession, and he is now considered among Tengenenge's most talented younger generation of sculptors. In his seated *Mother and Child* (Fig. 24), Muzhona depicts himself as a child tenderly reaching to his mother for comfort and nurturing, as she bends over him protectively. In truth, he has received a special kind of nurturing from his mother, as it is most unusual for a Zimbabwean woman to be a professional role model for her son.

In contrast to the spousal and family support that Nyanhongo, Madamombe, and Mabwe receive, Sani's artistic encouragement came from a community of artists, a haven for artists/refugees. Sani is also a refugee, a theme reflected in her work *One Eyed Man from Mozambique.* While all three women occasionally turn to nature, as in *Ant Hill, Chapungu,* and *Guinea Fowl Looking at the Sun,* the human form is their consistent point of reference. At this time, Sani's work is less realistic and has a more fluid, linear quality.

Steven Blomefield reminds me that, "Alice's circumstances are most unusual. She has not had a background in sculpture or the family support to count on from a husband, father, or brother, as other

107

women have." Alone, but with the encouragement of the Tengenenge Community, she has managed to forge her own creative pathway and has become an important role model for the younger generation. Sani has also managed to turn her life around. The previously dominant feelings of isolation and despair have been replaced with pride in her creativity and the sense of roots within the larger Tengenenge family. Sani's success is marked by a material sign as well: she is the third person at Tengenenge to own a television set.

Mavis Mabwe

Mavis Mabwe (Fig. 25) and her husband, David Chirambadare, share a large studio space in Chitungwiza, a Black township outside of Harare, the capital of Zimbabwe. [38]

In this largely residential community of row after row of small, cement brick houses with corrugated metal roofs, surrounded by little vegetable and flower gardens and playing children, Mabwe and Chirambadare have a spacious one-acre lot for their creative endeavors. There are storage and work sheds and lots of exhibit space; they have just bought their own home, located in Chitungwiza.

When I first arrived, my eyes danced about, unable to focus, as the lot was filled with so many diverse pieces of stone forms. However, as I walked around, the aesthetic, emotional, and thematic distinctions between this couple's works soon became apparent.

Also apparent was David Chirambadare's professional support and respect for Mabwe, as he immediately informed me, "She's doing something tremendous, I tell you." While Chirambadare has been carving for many years, Mabwe only began to carve after their marriage in 1985.

Mabwe told me that they met in Harare. Chirambadare was working at his mother's place, and Mabwe walked by and was immediately attracted by his sculptures. This attraction and the sculptor soon became her passion, and the two artists began to work together, soon married, and continued working together while raising two children. Mabwe was born in 1961; her husband is four years younger.

It can take approximately one month to complete a large piece, but they work on several at a time. Chirambadare has students who help wash and polish their sculptures. He also trains them "to carve and to handle the sculptures so they won't easily break." Mabwe sculpts almost every day, as they can afford child care. Chirambadare takes care of business arrangements and told me, there is "no problem to sell." They show their work at the Vikuta Gallery in Harare, but buyers also come from both Europe and the United States.

Mabwe explores diverse emotional expressions through the human form. The scale of her work is large, from two to five feet in height. Her themes vary from lovers, pregnancy, and motherhood to experiences of pain and conflict. Combining both rectangular and curved forms, Mabwe exaggerates physical proportions to emphasize rhythmic movement and expression. For example, in *Mother and Child* (Fig. 26), the mother's head leans forward from the rectangular shoulders and rests above her ample breasts. The mother con-

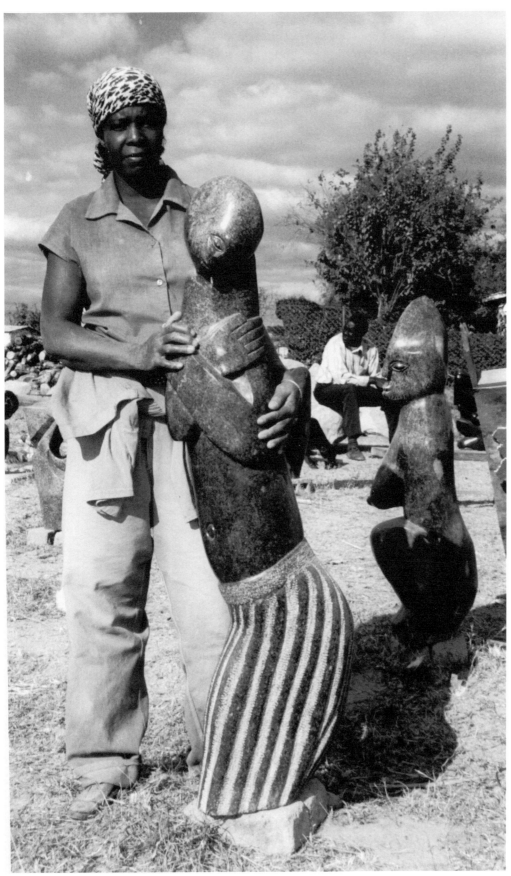

(Fig. 25) Mavis Mabwe and her Sculpture, *Feeling Pain,* **Chitungwiza, Zimbabwe, 1993.**

tentedly observes her nursing child. Her arms are carved without the extraneous details of muscles and elbows, which curve into a nest for the child held beneath her breast. This newly completed piece is approximately four feet tall.

Since the couple are not facing one another in *Lovers, What Are We Doing?* (Fig. 27), an emotion of guilt or sorrow rather than joy dominates. The man stands behind, and his arm reaches around and rests above the woman's belly. Her head is thrust downward from the straight line of her shoulders and protrudes even farther than her belly. For me, the emotional impact of *Lovers* is reminiscent of Picasso's Blue Period in which aesthetic cubist principles of form simplification merge with a disturbing sense of sadness. Is there a moral lesson to be learned from Mabwe's interpretation? In her work, hands are always prominent, as the long, rectangular fingers rhythmically follow the contour of each figure, as in *Feeling Pain* (see Fig. 25). The concave head and features are nestled within the shoulder-chest cavity of this tall, elegant woman whose lower torso is wrapped in a textured skirt. What provoked the pain? I wondered, and Mabwe responded, "A bee sting."

Desperate Woman (Fig. 28) is in a kneeling position with her legs bent under, supporting her whole body. Her large head rises from the shoulders and is turned, looking outward. One large hand crosses over the chest, where the suffering is contained, while the other rests on her lap. The pain is an internal experience and suggests that there are no remedies.

In *Proud Lady* (Fig. 29), elbows are extended outward, as the arms rise and cross over one another and rest on the chest. The woman's round head is perched on her small, square shoulders, adding to the exaggerated perspective of the angular hands as they move upward. Her hair is designed as a wavy, rhythmic pattern and contrasts with the smooth surface of the facial features.

In Harare, I enjoyed seeing Mabwe's work in a professional setting, at the Vikutu Gallery where many first-generation sculptors were also represented. There, along an outdoor pathway with a tropical foliage background, were several of her sculptures including *Feeling Cold* (Fig. 30). Mabwe's style is distinguishable anywhere, as her large, powerful hands always dominate. They reveal inner strength and dignity, while wrapping around, protecting, and comforting each form. In *Feeling Cold*, the head and upper torso are small, the hands are large, and below, the thighs swell into exaggerated rotund and sensual proportions. Since Mabwe's forms are usually angular, I wondered if her use of curved, rhythmic forms, also visible in her most recent work, *Mother and Child*, might indicate a possible new direction in her imagery.

In a Zimbabwe June–July 1989 *Everyhome* magazine article, "Woman Sculptor Speaking Through Stone," Mabwe's work is described as "a fusion of decorative, sociological, and intellectual aspects."[39] The author cites Mabwe's concern with "the social and customary laws surrounding the modern Zimbabwean woman" in her sculptures *Muroona* (daughter-in-law) and *Chirikadzi* (widow), which

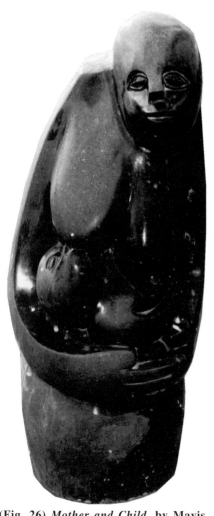

(Fig. 26) *Mother and Child,* by Mavis Mabwe, Chitungwiza, Zimbabwe, 1993.

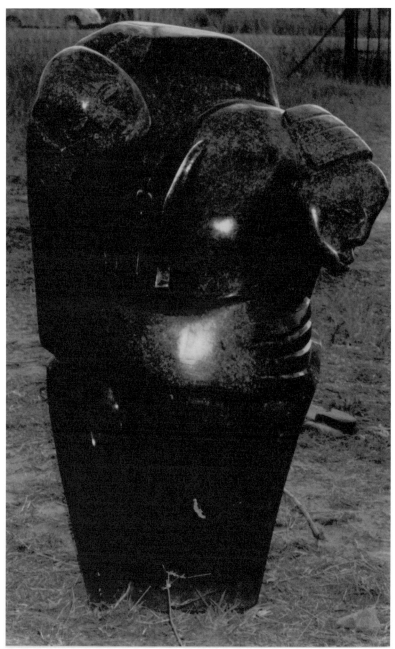

(Fig. 27) *Lovers, What Are We Doing?* **by Mavis Mabwe, Chitungwiza, Zimbabwe, 1993.**

were in Le Forum Exhibit, organized by the French Cultural Centre, April 1989. This exhibit featured the works of six women, among them Alice Sani, Agnes Nyanhongo, Colleen Madamombe, and Mavis Mabwe.

Though Shona sculpture has been primarily created by men, women sculptors are gradually emerging and receiving critical attention. The *Everyhome* article points out some of the obstacles to women's creating consistently: "The women love their work and many recognize the difficulties that they have to face in a world so dominated by men. Many of them have families and some have responsi-

bilities too of looking after their artist husbands."[40] Very few receive the support that Mabwe, Nyanhongo, and Madamombe have, enabling them to hire full-time household help and leaving them time to experiment and to mature as sculptors, taking pride in their work and the earned label of "artist." Success is also related to the forcefulness of one's personality and persistence. I agree with Winter-Irving's statement:

> *It is hoped that through the examples of Agnes Nyanhongo [Colleen Madamombe, Alice Sani, and Mavis Mabwe,] other Zimbabwean women will be able to see art as part of their overall self-expression—a way of expressing an individual and collective world view, and reflecting the changing position of women in society.*[41]

The lack of visibility and discussion of African women artists by Western art historians is evident even in current publications such as *Africa Explores*, 1991. Susan Vogel acknowledges this gap as "regrettably unsolvable here."[42] Since women artists are contributing to the contemporary art scene, some of the conclusions about African art that Vogel derives from the male art perspective need to be reconsidered—for instance, when she says, "Artists rarely deal with personal imagery or autographical subjects.... The most personal works that come to mind are all related to the commemoration of the dead."[43] In contrast to this observation of only a few years past, Shona women sculptors offer a refreshingly vivid, feminist, and life-affirming perspective.

Independence, Diane Mwamuka, and the Mabwe Gallery

Approaching Zimbabwe's cultural development from the perspective of Harare's only Black woman gallery director, Diane Mwamuka,[44] added another dimension to my research. The Mabwe Gallery, featuring primarily Shona sculpture, is located in a remodeled, modest older home opposite a major high-rise hotel. Visitors are immediately enticed by the intimate front entryway and garden filled with a diverse display of big and small sculptural forms.

When I spoke with Mwamuka in her sunlit office, I asked how she happened to venture into the gallery business. First, she credited her education in private schools as giving her a "broader spectrum" and exposure to the arts. She referred to Frank McEwen and the National Art Gallery, and how sculpture "would have remained out in the villages" if McEwen had not recognized and supported the existing talent. In her own way, this is what Mwamuka has been doing for approximately ten years. In her gallery, she exhibits the work of some of the lesser known women sculptors: Monica Chakawa, Ester Chidayaenzi, and Erina and Letty Akuda, who are mother and daughter. Since the mid-1980s, Tony Mhondo notes, "The number of practicing black artists rose from a mere 200 to 850";[45] however, there are still fewer than twenty known working and exhibiting women sculptors.

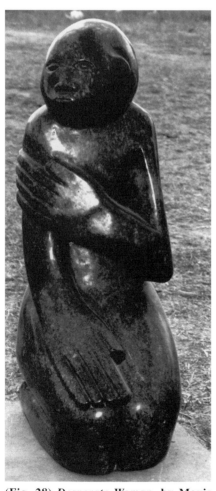

(Fig. 28) *Desperate Woman*, **by Mavis Mabwe, Chitungwiza, Zimbabwe, 1993.**

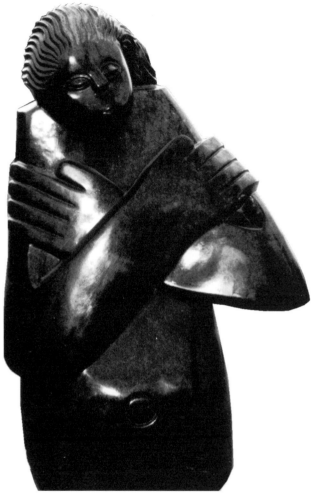

(Fig. 29) *Proud Lady,* by Mavis Mabwe,
Chitungwiza, Zimbabwe, 1993.

Establishing a link between artists and the public began mod-
estly for Mwamuka when she got to know the artists in the villages
and brought their work to her home, where she gradually sold pieces
to friends. She also brought people to the villages to meet the artists.
As a result, she said, "The artists asked me, 'Give me a permanent
platform [gallery] for my work.'" This eventually led to the opening
of the Mabwe Gallery. Mwamuka is pleased that she is on good terms
with the sculptors in order to "promote them so they can make
progress."

Mwamuka regrets that "art is at the bottom of everyone's priori-
ties." For most people, "the struggle to provide basic necessities for
the family dominates." However, she is also disappointed that "even
the black upper middle class does not have much interest in or ap-
preciation for art." Thankful that she was exposed to art at an early
age, Mwamuka relates people's ignorance to the fact that "most gov-
ernment schools don't offer art as a subject, or arrange field trips to
the National Gallery. Very little art is displayed in public places."

In his book *Education, Liberation and the Creative Arts*, Tony
Tafirenyika Moyena confirms Mwamuka's experiences. He points

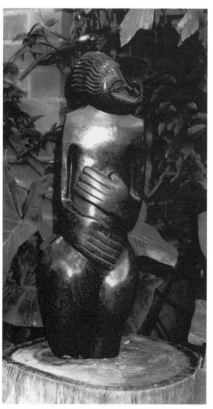

(Fig. 30) *Feeling Cold,* by Mavis Mabwe,
Vikutu Gallery, Harare, Zimbabwe, 1993.

113

out that in old Rhodesia (now Zimbabwe), the population ratio of Whites to Blacks was one to sixteen, but

> *Political and economic power was always held by white men sworn to rule forever. . . . The problem for white people in Rhodesia was always how they could create an education system for blacks that would keep the latter in a state of permanent servitude when the injustices perpetrated on them were so clear . . . the school [was used] as a processing plant for the alienation and domestication of the African child, thus turning that child into an obedient, pliable and worshipping servant of things white and Western.[46]*

As a result of this educational process, Mwamuka is outspoken in her concern about the "colonial hangover," and that many Black people still feel that "White is right." She regrets that most often "something plastic, or a watercolor landscape painting, is bought as a status symbol." The lingering effect of colonial education is further analyzed by Moyena:

> *Victims of cultural imperialism develop a split personality; they become people of divided emotional, intellectual and psychical allegiances. Despising their own culture "as something [they] should be ashamed of rather than a source of pride," they develop an admiration for the oppressor whom they try to imitate.[47]*

However, in regard to the Shona sculpture movement, Mwamuka admits, "without white people, I don't think there would be any art in this country." She refers once again to Frank McEwen who "recognized what was coming out of the villages" and then gave artists the backing and support of the National Art Gallery. She laments that since Independence, "support for art is at the bottom of the government's list." Cultural blindness is verified by Tony Mhondo in a 1991 *Herald's Sunday Magazine* review. He states,

> *It is a cruel irony that a country which boasts some of the finest stone sculptors in the world should have commissioned the design of a memorial to Zimbabwe's war dead from North Korean architects; the statue and murals in the grounds are carved in a manner quite at odds with the nation's indigenous culture.[48]*

When we returned to the issue of women's position in society, Mwamuka said, "Whether you are white or black, men look at you as a second-rate citizen." She also realizes that "most people see artists as misfits, a little crazy, and don't understand what they're trying to do. If men find it difficult to be an artist, it is even more so for women, especially if you don't have a platform or gallery."

Mwamuka feels since Independence Zimbabwe has "opened up to the world. Artists began to find outside visitors liked what they were doing and were willing to put money into their work and took their work out to the rest of the world. This changed the whole perspective." But it has also led to a proliferation of "good and bad artists" that started drifting into Harare and "street art."

Luness Mhlope, a recent graduate of the BAT (British American Tobacco) Workshop established in 1981, a painter and now on the staff of the National Art Gallery, claims, "Lack of art education results in artists . . . standing on the street corner selling their art to tourists."[49] I am sure "street art" is also the result of personal desperation and the current high level of unemployment.

A summary of some of the hopeful signs on the horizon related to the future education of Zimbabwean artists includes the following: plans for the establishment of a School for Art and Design in Harare; increasing the establishment of regional cultural ties with SADC (or Southern Africa Development Community); and the initiation in 1992 of the quarterly publication *Southern African Art*, edited by Celia Winter-Irving. In this important regional publication, the many voices of artists, teachers, art historians, collectors, and gallery owners discuss the remarkable changes in Zimbabwe, including the development of women artists since "Frank McEwen gave chisels and hammers to a group of untutored rural-born Africans."[50]

Shona Sculpture and International Art

The term "international artists," as defined by Susan Vogel, can be applied to Shona sculptors "who are academically trained or who have worked under the guidance of a European teacher/patron." However, while most Shona sculptors do not "live in cities," many do "represent their governments in international gatherings, are more widely traveled than other artists, and have a higher standard of living." Rather than selling their work on the streets, they "are shown in exhibitions, and may be sold to foreigners and international businesses as well as to the governments of the elite of their own countries."[51]

Since independence, there has been a need to build a national allegiance.[52] "'Tribalism' was not only backward in the eyes of many, it was dangerously divisive. The first mission of the new national art at the time of independence was to raise the people above their old ethnic antagonisms."[53]

In the early years, Shona sculptors were predominantly inspired by African traditions and mythology. However, the thematic parameters are rapidly expanding to include new African and international realities and concerns such as personal relationships, war, refugees, hunger, drought, women's rights, and AIDS. Gradually, women are also beginning to find their own lives and relationships as worthy themes for expression. As the younger generation takes aesthetic and thematic risks, their works may not meet the tourists', art critics', or commercial establishment's expectations of African art. Vogel offers this significant insight:

> the question *"How African are these artists and their works?" is a false one. It rests upon a narrow, stereotypical idea of what it is to be African, and has been used to challenge Africans who do not conform to that stereotype— to question their cultural "purity."*[54]

Endnotes

1. Lois M. Snook, "Artistic Influence and Evolution," in Frederick H. Gonnerman, ed., *Spirit in Stone* (Northfield, Minn.: Luther Northwestern Theological Seminary, 1990), p. 10.
2. Oliver Sultan, *Life in Stone* (Harare, Zimbabwe: Baobab Books, 1991), p. 3.
3. Celia Winter-Irving, *Stone Sculpture in Zimbabwe* (Harare, Zimbabwe: Roblaw Publishers, 1991), p. 41.
4. Gonnerman, *Spirit in Stone*, p. 6.
5. Winter-Irving, p. 41.
6. Sultan, p. 6.
7. Frank McEwen, "Shona Art Today," *African Arts,* Vol. 5, No. 4, Summer 1972, p. 8.
8. Sultan, p. 6.
9. Claire Polakoff, "Contemporary Shona Sculptors at the Musée Rodin, Paris," *African Arts,* Vol. 5, No. 3, Spring 1972, p. 57.
10. Ibid, p. 59.
11. Roy Guthrie, "Introducing Shona Sculpture," in Gonnerman, ed., *Spirit in Stone* (Northfield, Minn.: Luther Northwestern Theological Seminary, 1990), p. 2.
12. Snook, p. 7.
13. LaDuke interview with Roy Guthrie, Chapungu Sculpture Park, Harare, Zimbabwe, July 1993.
14. Lois M. Snook, p. 6.
15. Winter-Irving, p. 177.
16. Roy Guthrie, *Chapungu Newsletter* (The Chapungu Sculpture Park, P.O. Box 2863, Harare, Zimbabwe), Vol. 1, No. 1, December 1992.
17. Roy Guthrie, Foreword, *The Chapungu Annual,* 1993 (Chapungu Sculpture Park).
18. LaDuke interview with Agnes Nyanhongo and Colleen Madamombe.
19. Roy Guthrie, *Chapungu Newsletter,* Vol. 1, No. 2, March 1993, p. 10.
20. Celia Winter–Irving, *New Frontiers in Art* (Harare, Zimbabwe: BAT Workshop of the National Gallery of Zimbabwe, 1992).
21. Guthrie, *Chapungu Newsletter*, Vol. 1, No. 2, March 1993, p. 10.
22. Sultan, p. 12.
23. Winter-Irving, *Stone Sculpture in Zimbabwe*, p. 125.
24. Ibid., p. 125.
25. Guthrie, p. 10.
26. Ibid.
27. Winter-Irving, *New Frontiers in Art*.
28. Guthrie, *The Chapungu Annual*, 11.
29. Ibid.

30. Winter-Irving, *Stone Sculpture in Zimbabwe*, p. 10

31. Ibid., p. 101

32. From interviews with Steven Blomefield and Alice Sani at Tengenenge, July 1993.

33. Winter-Irving, *Stone Sculpture in Zimbabwe*, p. 59.

34. Sultan, p. 12.

35. Ibid., p. 10.

36. Winter-Irving, *Stone Sculpture in Zimbabwe,* p. 66.

37. Ibid., p. 69.

38. Betty LaDuke interview with Mavis Mabwe at her Chitungwiza studio, July 1993.

39. *Everyhome Magazine* (Harare, Zimbabwe, June–July 1989).

40. Ibid.

41. Winter-Irving, *Stone Sculpture in Zimbabwe*, p. 125.

42. Susan Vogel, *Africa Explores* (New York: The Center for African Art, 1991), p. 12.

43. Ibid., p. 188.

44. Unless otherwise cited, all quotes are from a Betty LaDuke interview with Diane Mwamuka, Director of the Mabwe Gallery, Harare, Zimbabwe, July 1993.

45. Tony Mhondo, "The Role of the Media in the Visual Arts of Zimbabwe," *Southern African Art,* Vol. 1, No. 1 (1992), p. 4.

46. Tony Tafirenyika Moyena, *Education, Liberation and the Creative Arts* (Harare: Zimbabwe Publishing House, 1989), p.35.

47. Ibid., p. 19.

48. Tony Mhondo, "The Herald," *Sunday Magazine*, Nov. 16, 1991.

49. Luness Mylope, an interview, "The State of the Art of Zimbabwe," *Southern African Art*, Vol. 2, No. 1 (1993), p. 18.

50. Celia Winter-Irving, "From the Chisel to the Classroom," *Southern African Art,* Vol. 1, No. 1 (1992), p. 14.

51. Vogel, p. 11.

52. Ibid., p. 178.

53. Ibid., p. 188.

54. Ibid.

What seems most important is that, gradually, since independence, Black and White Africans are working together on all levels to promote the arts through the educational process, new publications, critical reviews in the local press, public outreach programs, and exhibits. Zimbabwe's artists and art establishment are consciously attempting to move away from the extremes of tourism-commercialism and Eurocentric elitism to educate the public, promote more women's participation in the arts, and make art an experience to be shared by all.

6

Zimbabwe

RAINBIRD WOMEN AND
WEYA WOMEN'S ART

The missionary legacy in Zimbabwe is twofold: In addition to the cross, the other visible but seldom discussed symbol is the crochet hook. This tool has become a subtle means of encouraging women's passive creativity as they produced endless yards of intricately designed white tablecloths and doilies for upper-class White and Black Africans and tourists. However, due to the intervention of German artist Ilse Noy (Fig. 1), Zimbabwean women's aesthetic expression has become vibrant in color, diversified in media, and filled with themes that no longer conceal but rather reveal many aspects of their own reality.

Noy's objective when she first came to Africa in 1984 was rural development. She hoped to provide women with marketable skills to supplement their subsistence income from their communal farming. Noy, sponsored by the German Volunteer Service, first directed her efforts to reorganizing the Cold Comfort Farm Weaving Collective, which is located outside Harare, Zimbabwe's capital. There, she was not only concerned with the technical aspects of weaving and marketing but also with changing the women's self-image. For example, when promoting innovative designs for their weaving projects, she would suggest that the women "do something that is important about your own life."

From 1987 to 1989, Noy's philosophy, "validating African women's experiences as themes for art-making," was extended to a second project site, the Weya Women's Training Center, located 170 kilometers from Harare. At Weya, Noy promoted the art of fabric

appliqué, painting on wood or on cloth, with an innovative *sadza* resist technique. Three years later, after the Weya Women's Collective was successfully established, Noy returned to Cold Comfort Farm to work with the weaving collective and to assume responsibility for managing the newly constructed Amon Shonge Art Gallery located at the Farm.

When I first saw the Weaving Collective's tapestries and Weya art projects at Harare's prestigious National Art Gallery in 1993, I was impressed by their technical quality and vibrant thematic content. The Weya fabric appliqués were reminiscent of the *arpilleras* of Chile, documented in *Companeras: Women, Art, and Social Change in Latin America.*[1] These Weya appliqués also had personal hand-written notes inserted in pockets that explained the appliqué story in detail and sometimes contained autobiographical information about the artist. I had seen much craft work throughout my African journeys, but I now felt that this creative and interactive process that Ilse Noy had initiated was a unique form of consciousness-raising that benefitted its producers while attracting and pleasing the

(Fig. 1) Ilse Noy at Cold Comfort Farm, Harare, Zimbabwe, 1994.

consumers. The line between art and crafts seemed to vanish, and I wondered how these simple yet sophisticated projects came to be?

When I finally met Ilse Noy at Cold Comfort Farm, I felt that a door had been opened to a woman with extraordinary vision. She had the capacity to motivate people creatively, enticing them so that they could mature and continue to grow as independent artists. Though Noy described the workshops in detail, explaining aspects of the women's lives as related to their projects in her book *Weya Women's Art,*[2] she included very few clues concerning her own professional background. This piqued my interest, and I planned to return to Zimbabwe the following year, 1994, hoping to gain a clearer understanding of Noy's life, as well as the lives of the artists she inspired.

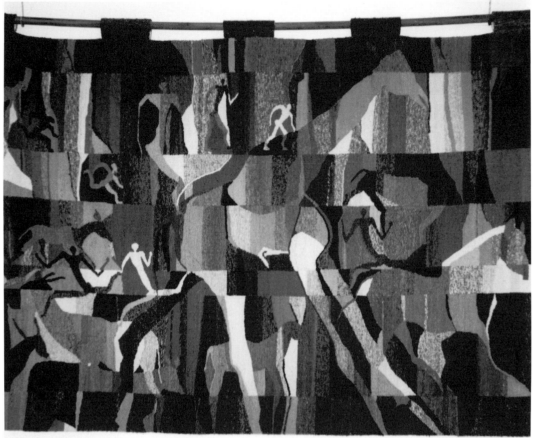

(Fig. 2) Dombashawa Cave Painting, Designed by Ilse Noy.

Ilse Noy: From Germany to Africa

When we met again in 1994 at her office in Cold Comfort Farm, Ilse Noy's enthusiastic comments revealed not only her ten years of proud achievements, but her many frustrations in working with rural African women as well. In the process, Noy's personal values also underwent radical transformations. Gradually I began to realize how Noy's innate ability to empathize with the Cold Comfort Farm Weavers and the Weya women was partially related to her own rural German background and the resulting social stigma she experienced as a child.

Noy was born in 1953 in a village near Bonn in Germany. "It's not a question of White or Black, but the real world always started beyond the boundaries of our little village," she explained. As a child she spoke with the heavily accented dialect of her German village. "I felt," she said, "like the Weya women when they go to Harare, not quite good enough or educated enough compared to the big city people." As a young student, Noy was also obliged to work part-time in her family's small hotel and restaurant business. She learned not only how to shop, cook, and prepare potatoes and other foods, but to calculate work-time, cost-effectiveness, and profit. These survival skills proved to be extremely useful for the success of her rural development projects.

(Fig. 3) Maslin Nyajurilca Weaving *Moonface*, **Cold Comfort Farm, Harare, Zimbabwe.**

Noy's advanced studies at the University of Mainz, Germany, were in literature as well as in art (drawing, painting, weaving, and graphic design). After receiving a Master's degree in 1979, she trained as a teacher at the University of Bremen. For two years Noy taught art at a secondary school near Hamburg, taking time off later to travel to Thailand, Indonesia, the Philippines, Brazil, and Cuba, where an unknown world of non-Western art and culture unfurled before her.

When Noy was accepted into the German Volunteer Service, she hoped to work in Latin America; instead, they sent her to Africa. The service, created in 1950, is similar to the United States Peace Corps, but "volunteers are better paid, and a more extensive educational background is required for acceptance."

Shortly after arriving in Zimbabwe, Noy said, she was "fortunate to meet Anton Barach," also from Germany. He was the financial manager of Cold Comfort Farm Trust. Several months later they married and have continued to work together. The German Volunteer Service had renewed their two-year contracts four times, but

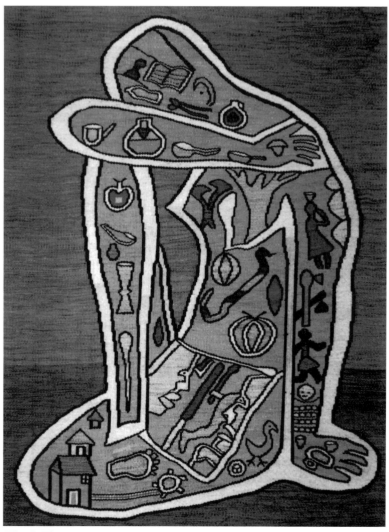

(Fig. 4) *The Mourning Woman,* **Designed and Woven by Leocadia Masongo, Cold Comfort Farm, Harare, Zimbabwe, 1994.**

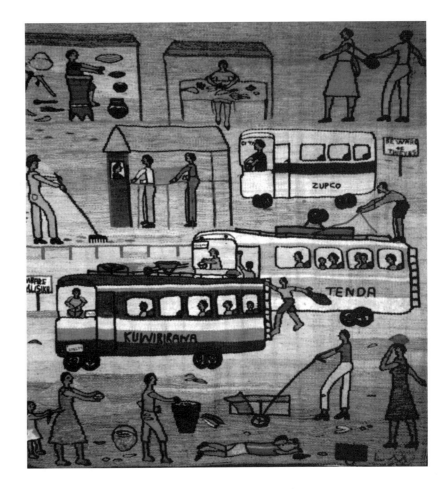

(Fig. 5) *Mbare Market*, **Designed and Woven by Leocadia Masongo, Cold Comfort Farm, Harare, Zimbabwe, 1993.**

they recently decided to join World Peace Projects (WFD), as this non-governmental organization has more autonomy. Noy explained that WFD "had also done rehabilitation work with Jewish people in Israel, to make good what Germany had done wrong during the war."

It was surprising to learn that only "ten percent of [Noy's] effort is art teaching, while ninety percent is toward successful marketing and making the projects cost-effective with minimum time or input." She told me that she had an "emotional feeling for prices and costs, while Anton will arrive at the same results with the calculator."

Cold Comfort Farm and the Weaving Collective

Cold Comfort Farm was first established in Rhodesia (before independence) as a private retreat in the 1950s during Ian Smith's colonial regime in which apartheid was institutionalized and the best land usurped for whites; Africans were sent to tribal trust lands comparable to American Indian reservations. During this period, a government official bought farm land to fulfill his retirement dream of the "natural life," but instead found rural farming isolating and physically stressful. Therefore, he named his farm after Stella Gibson's popular English novel, a satire on returning to nature, called *Cold Comfort Farm.* In 1965, the farm was sold to a group of "white liberal women" who were filled with Christian idealism about Black and White families cooperatively living and working together on the land. The farm soon became a political target of the Ian Smith

121

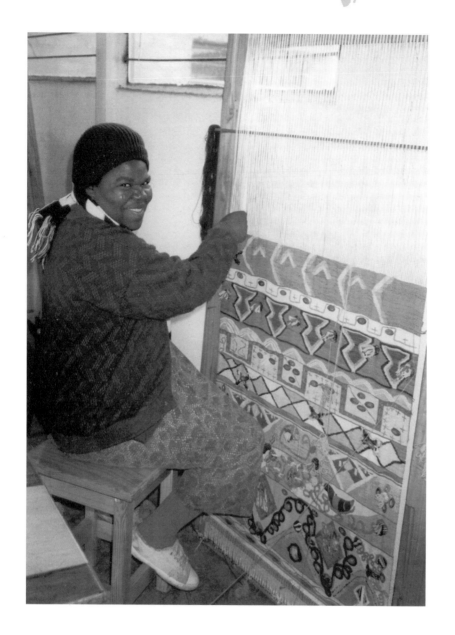

(Fig. 8) Dalia Chivau
Weaving *House Designs*,
Cold Comfort Farm, Harare,
Zimbabwe, 1993.

regime, and many Blacks were incarcerated, while Whites were deported or exiled. By 1971, the farm was forced to close.

Amon Shonge had been the Cold Comfort Farm cook, and since he was not harassed and less known publicly, he was able to return to Weya, his communal land. There he established a small but successful agricultural co-op and initiated the Weya Women's Training Centre or Collective. "Since Amon Shonge died recently, and he was the person linking Cold Comfort Farm with Weya," Noy told me, "the art gallery was named after him."

With substantial economic support from the German government, Cold Comfort Farm reopened in 1980, after independence, when the country known as Rhodesia became Zimbabwe, with Robert Mugabe as the first African president. Currently the farm has eighty members, many of them farm laborers of the previous White owners. Now they all own the land equally, and as collective members they each have small, modest homes, with schools nearby, a children's nursery, a dispensary, and a store. Their charter guarantees equal rights for men and women. There are skilled and educated African farm managers, and since 1984 the Farm has shown a profit,

one that is shared by all its members. Under the new management, there is a new sense of hope and enthusiasm for the future and for their work.

A weaving collective had previously been established on the farm, but it is now defunct. When Noy arrived in 1984, she initiated a new weaving program with five women and began by sitting at the tapestry looms with them day after day. The looms were simply constructed; sturdy frames with nails protruding top and the bottom for the warp threads. "I was one of the weavers. We were each taking turns to spin wool one day per week, as well as collecting dye plants. We didn't have currency to buy commercial dyes, so we experimented, eventually finding 140 wild plants which produced dyes." Noy then published her first book, listing and illustrating all these plants so that others would benefit too.

Since these five women had never woven before, Noy designed the first projects with colored pencils on paper. One of her first tapestries was complex, inspired by Zimbabwe's ancient Domboshawa cave paintings. The weavers created a series of strips of varying widths that were then stitched together. A sense of transparent movement is achieved; overlaying the tall, dominant image of a giraffe are smaller figures that chase and hunt other animals (Fig. 2).

Zimbabwe's Shona sculptures have also been a source of inspiration, as exemplified by *Moonface* (Fig. 3). Once again a sense of transparency prevails; a round moon face outlined in black is superimposed over subdued, brown and beige, rectangular shapes.

At first Noy did many of the designs, but gradually she tried to involve the women weavers. The process of tapestry weaving required a small color sketch as a reference. Then a black line drawing of the design was enlarged to match the loom size and placed behind the warp threads as a guide. Noy continually involved the women in the design process, asking them "to think of motif variations or other stories," and then encouraged them during the weaving process to add their own colors and improvisations.

The weavings were sold, and the workshop expanded as orders for tapestries increased. Soon they had a three-year backlog of orders to fill. They hired more weavers, and there are now twenty-one, with twenty other people carding, dyeing, and spinning wool. Their wool comes from the distant highland region of Nyafaru. John Gotore, a graduate of the Youth Training Center at Mt. Hampden, was first hired as a weaver and then became their first manager, overseeing all aspects of production. Noy states, "The weaving collective success depends on a repertoire of standard designs, and as a safety net, sixty designs are needed for repetition."

The workshop is located in three large, rectangular and adjoining structures. There are high ceilings, cement floors, and glass windows. Weaving is segregated from wool processing (carding, spinning, and dyeing). The atmosphere is boisterous and informal, with a radio blaring music and news, but sometimes it is ignored, as the women spontaneously prefer to sing their familiar call-and-response gospel songs. They also talk together, but they work consistently

(Fig. 7) *Birds*, **Designed and Woven by Juliet Makombe, Cold Comfort Farm, Harare, Zimbabwe, 1993.**

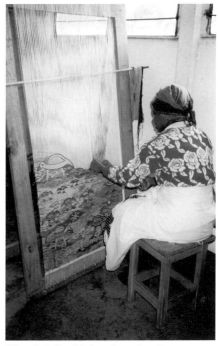

(Fig. 6) **Juliet Makombe at her Loom, Cold Comfort Farm, Harare, Zimbabwe, 1993.**

123

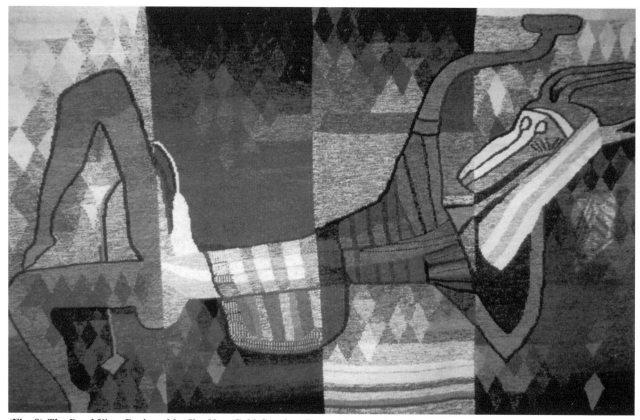

(Fig. 9) *The Dead King,* **Designed by Ilse Noy, Cold Comfort Farm, Harare, Zimbabwe.**

(Fig. 10) *Chapungo,* **Designed by Ilse Noy, Cold Comfort Farm, Harare, Zimbabwe.**

and take much pride in the finished product. They have two tea breaks and a lunch hour during their eight-hour shift. The rate of pay is good, and a weaver earns almost double the government's established minimum monthly salary. But the cost for housing, even renting a single room in the nearby high-density communities for Blacks, is high. Most weavers also send money back to the communal lands of their parents and families who take care of their children. At this stage, Noy explains, the Cold Comfort Farm Co-operative cannot afford to expand, as it would necessitate building more houses for the members.

Since Noy felt the need to increase the number of weaving motifs, she offered workshops with financial incentive, that is, paying an honorarium for any good designs. As a result, Leocadia Masango, originally recruited to the weaving collective in 1986 from Weya, created two designs related to her own experiences, which have become weaving staples. *The Mourning Woman* (Fig. 4) is seated with her head resting on her arm. Her body contains in miniature all the things necessary for the good life that she is dreaming about: a house, animals, farm tools, kitchen utensils, children, etc. But this woman mourns because she does not have them.

The second design, *Mbare Market* (Fig. 5), shows the local buses at the Harare market filling up with passengers as they buy their tickets and have their purchases packed on top of the bus. There is factual information as well as humor in Masango's weaving, which

shows a pickpocket, a street cleaner, a man sorting a garbage pail, a child pulling at her mother's dress, and a napping drunkard.

Two years ago, Noy offered another four-week workshop at Weya in which 200 people competed to participate. The selection test was based on Noy's re-telling of a familiar African legend, after which she asked each participant to illustrate the theme imaginatively. Those who developed successful designs were paid, "so their incentive was good!"

Some original designs emerged from this workshop, among them *Birds*, conceived and woven by Juliet Makombe (Figs. 6 & 7), and *House Designs* by Dalia Chivau (Fig. 8). In order to avoid boredom, the weavers rotate so that one person does not produce too many of the same design, even when the design is their own.

Several of Noy's own designs have been very popular, especially for the European market, and they have been repeated "over a

(Fig. 12) *Funnyface*, **Designed by Ilse Noy, 1994.**

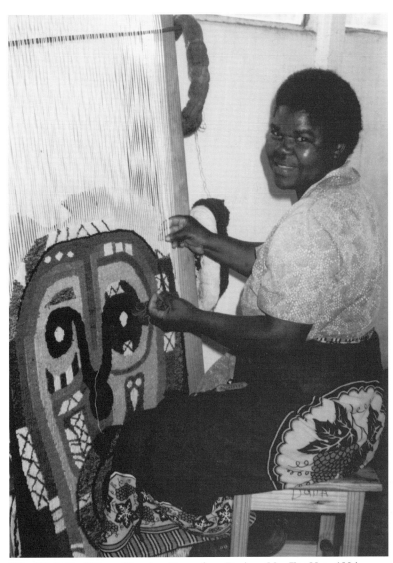

(Fig. 11) Dalia Chivau Weaving *Funnyface*, **Designed by Ilse Noy, 1994.**

125

(Fig. 14) *Clay Pots*, Designed by Ilse Noy, Cold Comfort Farm.

(Fig. 13) *Clay Pots*, Designed by John Gatore, Cold Comfort Farm.

thousand times." One of the most popular is *The Dead King* (Fig. 9), based on a Jungian myth in which the reclining King is dying and is in the process of passing on his royal power to his successor. This is symbolized by seminal fluid flowing from his penis to the earth below.

Particularly engaging is Noy's long, stylized form of *Chapungo,* an eagle who gives his royal spirit to a man (Fig. 10). *Funnyface* (Figs. 11 & 12), like *Moonface,* was also inspired by Shona sculpture. There are two examples of *Clay Pots* (Figs. 13 & 14). One, redesigned from a photograph by John Gatore, is somewhat realistic; the other, based on Noy's interpretation, emphasizes the pottery designs.

Rainbird Women

It was fascinating to see one of my own paintings *Africa: Bird Women, Keepers of the Peace* (Fig. 15), become part of the weaving workshop repertoire. When I first spoke with Noy in 1993, I spontaneously decided to share with her my recently filled sketchbook impressions from West Africa, as I had just been to Burkina Faso and Ghana. I also showed her some note cards of my Africa-inspired paintings. "This looks like the real Africa," she responded—

(Fig. 15) *Africa: Bird Women, Keepers of the Peace,* by Betty LaDuke, 1986.

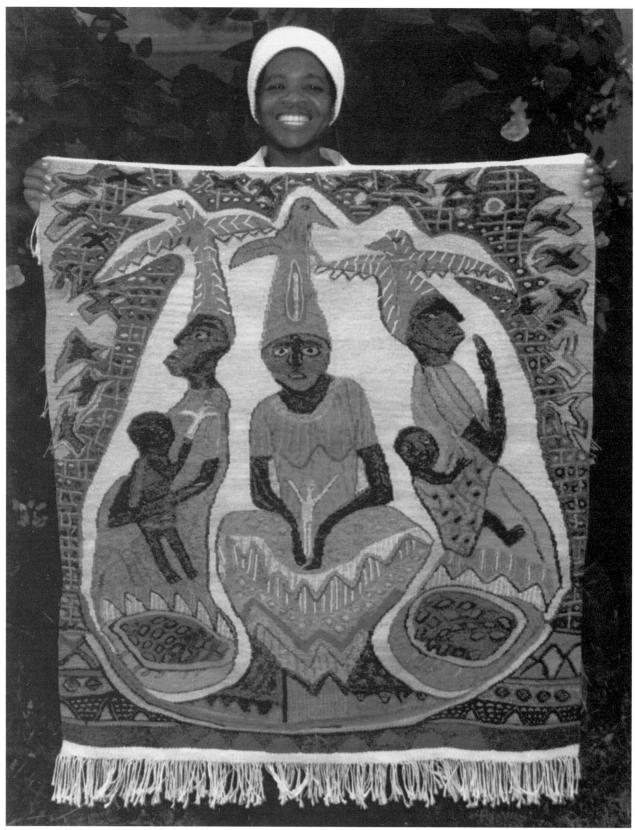

(Fig. 16) *Rainbird Women*, **Designed by Betty LaDuke, Woven by Juliet Makombe, Cold Comfort Farm, Harare, Zimbabwe, 1994.**

(Fig. 17) *Rainbird Women*, **Designed by Betty LaDuke, Woven by Leocadia Masango.**

all the more startling since there are enormous cultural differences between the vibrant West African and the subdued Southern African countries due to the latter's long history of apartheid. So, it was an unexpected but happy surprise for me when Noy suggested the Weaving Collective might be interested in considering one of my paintings for their projects!

When I returned to Oregon, I sent Noy six posters of my paintings. She told me that she hung them on a wall and called the women together to discuss the images. "Look," she explained, "we have been weaving for ten years now, making our own designs, and then looking for other sources. Otherwise it would get boring for customers. I have even another idea" (referring to my posters). She had confidence that it would "also be good from the marketing standpoint," and asked whether they agreed. They discussed some of the

(Fig. 18) Dahomey *Appliqué* **from Benin, West Africa, 1992.**

design details and colors and recognized it would be difficult to translate, but the majority decided in favor of the project.

Juliet Makombe agreed to weave the first one, always the most difficult one. It is never sold but remains in the workshop as a reference. When I returned to Zimbabwe in 1994, I was very pleased with Makombe's interpretation of my painting, which the weavers renamed *Rainbird Women* (Fig. 16), since the black birds around the borders of my work are similar to those that appear in Zimbabwe during the rainy season. Instead of filling in each shape with one flat color, skin tones were varied, and strands of brown, red browns, and deep yellows were blended together to emulate the paint quality. Some textural details were embroidered with wool on the surface of the form.

Leocadia Masango was then weaving the second *Rainbird Women* (Fig. 17), approximately 50 by 52 inches, while my original painting is 68 by 72 inches. I enjoyed seeing both Makombe's and Masango's interpretations, though they seemed very similar. I noted the slight changes in the left facial profile in the weavings as the chin is more pronounced. I thought that the center bird in the woman's hands in the weaving now looked more like a little child. However, I was very pleased to hear that the weavers identified with my imagery because "it looked African." Ultimately, the label on the backs of the weavings will read: "LaDuke, designer"; and either Juliet Makombe or Leocadia Masango will be credited "weaver." The Collective plans to weave an edition of twenty, and my payment will be one of the weavings. I felt honored to have my vision of African life validated by African women.

Leocadia Masango and Juliet Makombe

Leocadia Masango, born at Weya in 1965, applied to become a weaver and was accepted at the Collective in 1986. She had completed grade seven at school and was also a graduate of the Mt. Hampden Youth Training program. She is proud that her own designs, including *Mourning Woman* and *Mbare Market*, have frequently been utilized as weaving themes. She now lives at Kuwadzana, a high-density community for Africans outside Harare.

Masango is not married but has one child, seven years old, who stays with her mother at the village of Gakwe on the Communal Lands, but she provides for his education and other necessities. Masango visits as often as she can (she has twenty days annual leave), and they visit her too, especially during holidays.

Juliet Makombe was born in 1955, married in 1971, and has seven children. She is a gentle person and is respectfully referred to as Mai Nini, which means "young mother." She and her family have benefitted from being original members of the Farm Cooperative since 1985.

Although at first glance their work shows a superficial similarity, Makombe interprets *Rainbird Women* from a religious perspective, presenting the women seated on a hill at prayer while holding angels. Masango, however, saw the women as powerful witches. How ironic to find, in Zimbabwe, two such contrasting interpretations of

my painting *Bird Women, Keepers of the Peace*—originally inspired by Nigerian market women and Yoruba mythology, miles across the diverse African continent.

Weya Women's Art: Appliqué

In 1987, this time at the Weya Women's Training Centre, Noy worked once again with women who had never had any formal art exposure, but who were highly motivated to learn any craft that would generate some income. Conditions at the Weya Communal Lands were wanting. Noy told me they have "poor soil, unreliable rains, overpopulation, skinny cattle, and the men leave for long periods of time for cash jobs. Women need money to buy staples like sugar, salt, soap, tea, cooking oil, to pay for clothes, medical treatment, school fees, and bus fare. There is hunger if they've not had a good harvest of corn to make their sadza, or corn meal, their staple."

(Fig. 19) *Hair Styles*, by **Elizabeth Murangani, 1994.**

131

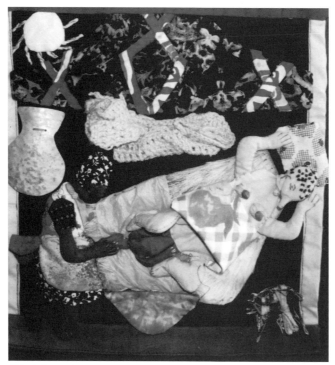

(Fig. 20) *Birthing Scene* (Designer Unknown).

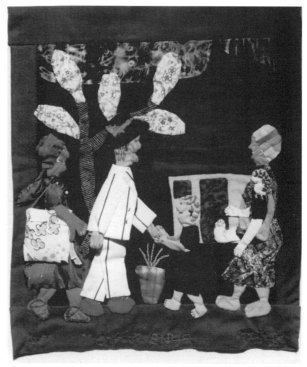

(Fig. 21) *Visiting*, by A. Chakwenya.

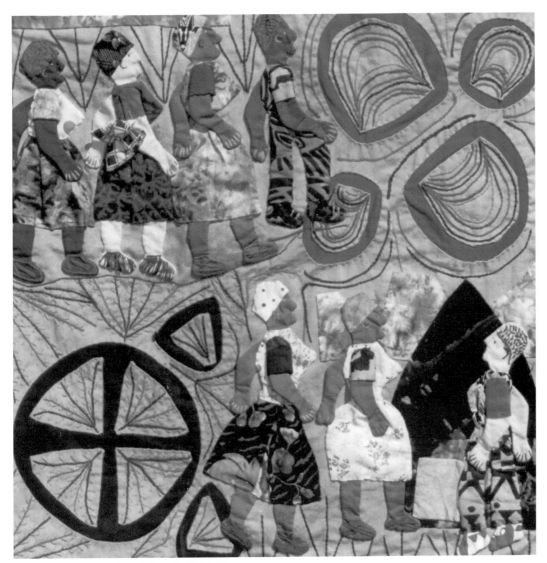

(Fig. 22) *Man With Three Wives*, by P. Mudgoza.

Prior to Noy's arrival, some women had attended a Weya dressmaking workshop, which proved unsuccessful, as factory-produced clothes were less expensive. Therefore, there were many doubts about Noy's appliqué workshop, its objective to create wall hangings from scrap fabric. But she inspired the women when she showed them contemporary examples of appliqué made by women from the Kingdom of Dahomey in Benin, West Africa (Fig. 18).

At first, Noy reported, "The women resisted. Then they began to cut and shape people, animals, their huts, and conditions of rural life which they applied to dark blue, black, or burgundy backgrounds." Their confidence grew when they were invited to exhibit their Weya appliqués at the National Art Gallery in 1988. They were delighted when their work was praised in the national paper, *The Herald*, as this was the first time that African women's aesthetic achievements were being recognized. Each woman sews a folded piece of paper on the back of her work, adding a description of the circumstances that provoked each image. Sometimes a woman will

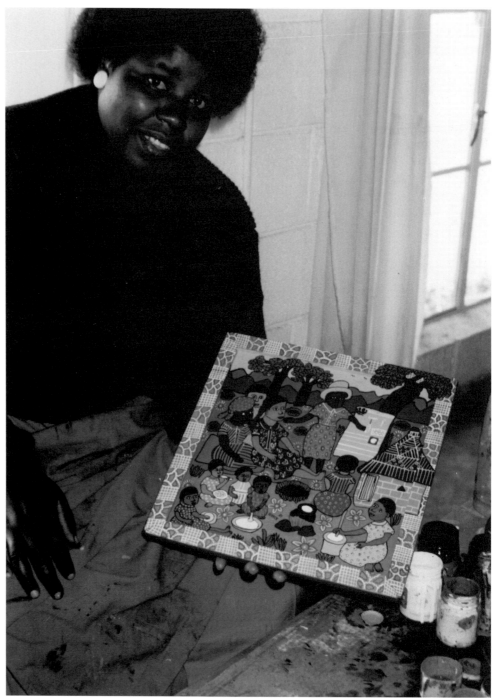

(Fig. 23) Grace Chigumira, Adding a Condom to *Family Planning*, 1994.

also embroider her name on the border. The smallest appliqué segment is approximately 14 by 16 inches, but any number of segments can be joined together to compose detailed stories about their hardships, their joys, and cultural events.

The juxtaposition of colors, textures, and patterns is vibrant. Figures can be flat or three-dimensional. Embroidery is added to embellish an image or to delineate facial features, hair, and other details. In the beginning, women of the Weya program borrowed the materials (fabric backing, embroidery threads, etc.), which they repaid from their sales. In addition, there was a twenty-percent charge for administration and record-keeping and a ten-percent charge for sales promotion. At first they shared the money from sales equally, but that was not satisfactory. Now each woman is paid individually, once a month.

Weya artists' earning power has affected personal relationships, as women's income exceeds men's, allowing women to indulge in buying new clothes and household products and visiting beauty salons, their business also helping the local economy. Ilse Noy has observed that women invest more in the family, whereas some men tend to squander their earnings on drink and prostitutes when they are away from the family for long periods of time.

I did not have the opportunity to visit Weya, but I was able to see a variety of examples of their art at the Amon Shonge Gallery and the National Art Gallery. I was astounded by some of the complex compositions and stories. Some need no special explanation, such as *Hair Styles* by Elizabeth Murangani (Fig. 19) or *The Birthing Scene* (Fig. 20). (I was sorry that the paper identifying the creator of this detailed scene was lost.) In *The Birthing Scene*, the mother's bed is on the floor of the hut, where she lies on a piece of goatskin that is strategically covered with plastic. A midwife is present to receive the child, shown in the process of leaving the womb. A pale blue knit hat and sweater prepared for the baby are also on the floor beside the mother. Added to this appliqué are some collaged items: a little basket constructed of wire and twigs to hold wood for a fire, and a calabash segment shaped like a clay pot for boiling water. I particularly like the embroidered expression on the mother's anguished face and her detailed breast and nipples.

In another delightful small appliqué by A. Chakwenya, whose name is also embroidered on the bottom appliqué border, there is a little note inside the woman's purse as she walks beside a man with a very elaborate suit. The note says, "**VISITING**. A man and his wife are going to see their mothers. Their mother is holding a baby and their sister is greeting them" (Fig. 21). In *Man with Three Wives* by P. Mudgoza (Fig. 22), we can see, in the top left corner, three women walking together led by the husband. The note states, "He sent one wife back to her parents because she was a witch. Now he has two." In *Weya Women's Art*, Ilse Noy offers the following insight:

> *Before taboos restricted women from talking about certain things in public, but with appliqués they felt free.*
> *For example, the new media allowed them to show even*

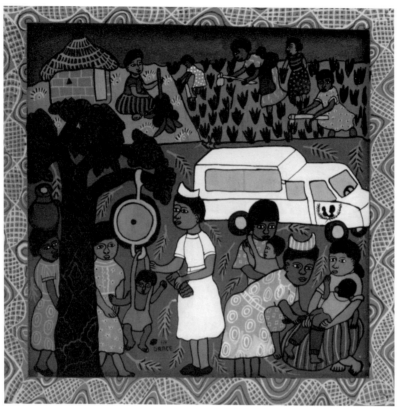

(Fig. 24) *UNICEF at Weya*, by Grace Chigumira, Acrylic on Wood.

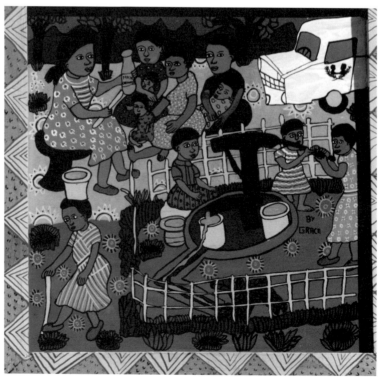

(Fig. 25) *Getting Water from the Well*, by Grace Chigumira, Acrylic on Wood.

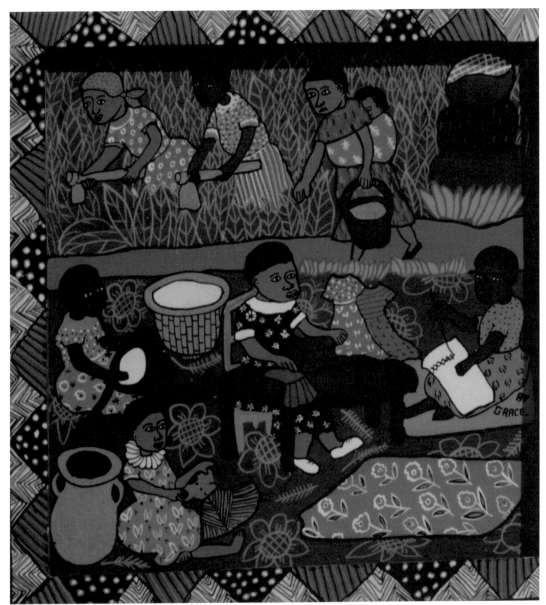

(Fig. 26) *Weya Women's Cooperative*, by Grace Chigumira, Acrylic on Wood.

private parts of men and women in detail, if there was a
story to justify it. Women's secrets like medicines for love,
laughing about drunken men in beerhalls who lose all
pride and urinate in public, having sex with a prostitute
in public . . . everything is possible to illustrate now.[3]

Grace Chigumira, Painting on Wood

When I first met Grace Chigumira at Cold Comfort Farm, she was
seated behind a table with five small pieces of framed plywood laid
out before her (Fig. 23). Each piece contained a pencil drawing or
outline that Chigumira created freehand. She patiently and methodi-
cally proceeded to fill in all the basic shapes and their backgrounds
with varied colors. Meanwhile, she continued to talk to Loice

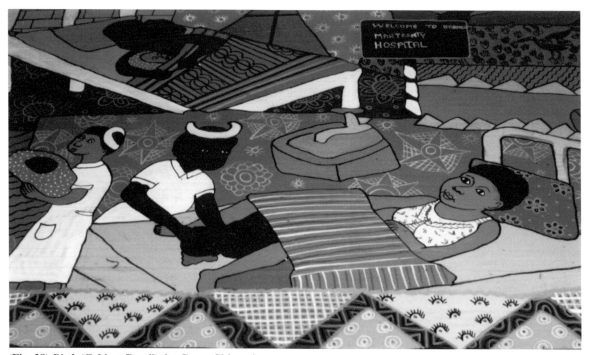

(Fig. 28) *Birth* (Cabinet Detail), by Grace Chigumira.

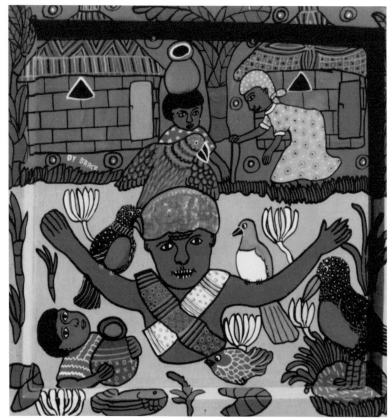

(Fig. 27) *Spirit Medium of Chaminuka Village* (Cabinet Detail), by Grace
Chigumira.

Chirubuu, who was nearby working on a series of *sadza* paintings. At the time of my visit, Chigumira and Chirubuu had been working together for three months at this Cold Comfort Farm studio, which they share. They informed me proudly that Ilse Noy had invited them there because "we were each number one, or the best in our field from Weya." They were happy to have this opportunity to work at Cold Comfort Farm and demonstrate their techniques for visitors, as tourists seldom come to Weya. In turn, they could sell their paintings directly, bypassing the forty-percent commission of the Amon Shonge Gallery.

Grace Chigumira told me she first learned to paint at a 1991 Weya workshop that Ilse Noy organized. Prior to that, she said, "I just worked on the farm." She buys her own acrylic paint and, with five colors (red, yellow, blue, black, and white), she can mix about twenty-six colors. They are all contained in individual jars, so that she has a great variety of ready-mixed colors from which to select. After applying flat colors to her scenes, she adds many diverse overlays of textures and patterns. She then carefully outlines faces, figures, and all the details with a fine black line, before applying a clear coat of protective varnish to the finished paintings.

A group of small (15-by-18 inch) paintings were displayed along one wall. Some paintings are fantasies, such as *Animal Band* and *Sphinx*, while others have very clear, pertinent messages, such as *Family Planning* (Fig. 23). In the latter painting, a health worker at Weya displays a chart with a variety of birth control methods (the loop, tablets, injections, and condoms) to a group of interested women. In *UNICEF at Weya* (Fig. 24), a health worker is portrayed weighing a child, giving injections, and discussing the treatment of diarrhea. In *Getting Water from the Well* (Fig. 25), a health worker teaches women methods of preventing diarrhea, i.e., by drinking water only from bores rather than lakes, by boiling water, and by using a standard bottle measurement to prepare salt solutions for treating diarrhea.

In *Weya Women's Cooperative* (Fig. 26), Chigumira depicts farm women weaving baskets and sewing dresses. This painting had a written message attached to the back that told the story of "*Cooperative*: Women are beating *rapoks* [*pounding corn meal*] for beer and *sadza*. An old *ambuya* [grandmother] is sweeping grains which are getting away from the beating place. Now a woman is winding *rapoks*. They are putting them in sacks. They are helping each other to load the sacks in a Scotch cart. They shall carry them home."

In contrast to the UNICEF painting themes, *Spirit Medium of Chaminuka* (Fig. 27) portrays the importance of spirit mediums in the African community. A note attached to the back of the painting says:

> *When it is the rainy season people cook beer for spirit medium so that rain would be able to come. Now you can see Chaminuka's spirit medium (Svikiro) is crossing a river. He is accompanied by birds on his shoulders. His wife is carrying a clay pot full of beer . . . by Grace.*

Grace Chigumira told me that she attended St. Benedict Mission but

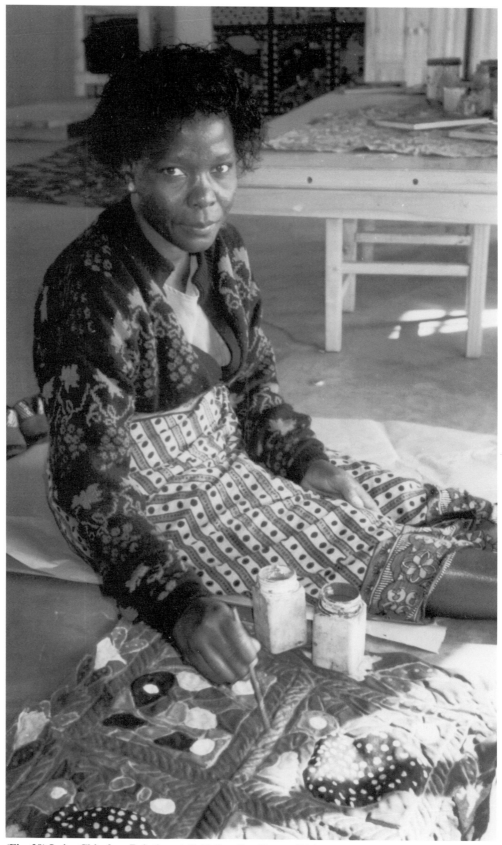

(Fig. 29) Loice Chirubuu Painting at Cold Comfort Farm, 1994.

did not complete her studies "because my father had no money for me to continue." However, she is proud that all her children attend school, and, from her earnings as an artist, she sends them clothes, soap, and sugar. She has remarried, and her husband works at the Cold Comfort Farm administration office. Since he is fortunate enough to be a co-op member, they have a room to live in on the farm.

Chigumira had just completed work on an impressive commission, the surface painting of a twelve-foot long, four-foot tall cupboard made at the Farm's Co-op Carpentry Shop. The requested painting theme is about a couple's relationship from courtship through marriage, and the birth of their first child (Fig. 28). I sense that in the future she will have many more cabinet commissions to paint!

Ilse Noy feels that Grace Chigumira and Loice Chirubuu are exceptionally creative, and their development would be stifled in Weya. "I'm planning to stimulate them further, to expose them to other techniques. The Weya workshop is very linked to creating repeated products that are sure sales, but these women are capable of doing more." Ilse also feels, "There is no rigid boundary between what is and isn't art."

(Fig. 30) *Sazda* **Painting on Blue Cloth.**

Loice Chirubuu and *Sadza* Painting

Loice (or Mai, meaning mother) Chirubuu attended Noy's 1988 workshop, and since then has been painting with *sadza* (Fig. 29), a resist technique that Ilse Noy developed after much experimentation. For a *sadza* solution, she mixed polenta or a very finely ground corn meal mixed with water. Chirubuu pours the *sadza* into a plastic squeeze-bottle that has a pointed nozzle and a small opening, and then creates her drawing, or resist outline, by squeezing the *sadza* solution onto a dark blue or black cloth (Fig. 30). When the *sadza* drawing dries, she can begin to fill in each shape with textile paint. She also buys six or seven textile colors from which she then mixes twenty or more colors stored in small jars. The *sadza* paintings are then folded, wrapped in tinfoil, placed in a baking dish, and baked in an oven at 100° Fahrenheit for thirty minutes. Afterwards, the paintings are washed and the *sadza* comes out, leaving in its place a soft black line.

When Chirubuu's husband died three years ago, Noy invited her to come and paint at Cold Comfort Farm. Her three children, all girls, live with her mother at Weya, but she returns frequently "to see if my mother is keeping them well, that they have enough to eat, and their clothes are washed."

Chirubuu says she will teach her children to paint, but her oldest, age seven, is just learning to draw. Since her paintings sell well, she no longer has to do farm work, but can cultivate a mixture of maize, ground nuts, beans, *rapok* for beer by "putting some workers in the field. Myself, I will be too busy doing *sadza* painting so I can get money to pay those people. At night I paint too. I don't have a husband, and I must work very hard to cover everything."

Loice Chirubuu's paintings are large, approximately four by five feet each. One story, *Drums* (Fig. 31), is about men beating

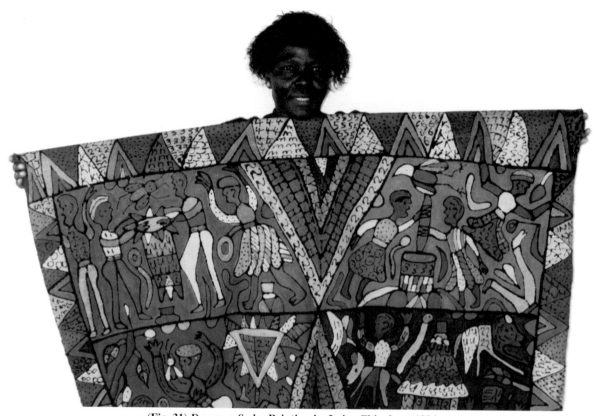

(Fig. 31) *Drums,* **a** *Sadza* **Painting by Loice Chirubuu, 1994.**

drums, cooking beer, and dancing; another man plays with a dog. The *sadza* paintings on display at the Amon Shonge Gallery include: *Turtle-Snake* (Fig. 32), which depicts a man and a woman pounding rice; *Dancing-Drumming* (Fig. 33), which shows a man and a woman kissing on the way to a dance; and *Design,* which presents a delightful mixture of patterns.

Other Sadza Paintings

At the Amon Shonge Gallery, I was attracted by two complex paintings by Weya artists I did not meet. Mary Chiliyo's *Village Life* Scene (Fig. 34) is a very dramatic and intricately detailed painting, approximately five feet wide and ten feet long. There are many elaborate episodes, including a story about AIDS. She writes:

> *The pregnant daughter-in-law is going to look after a herd of cattle and to cut a heap of firewood while the cattle will be grazing. On the other hand, John is suffering from AIDS and his brother and mother have taken him to the herbalist. At the place people were asked to play mboia and young kids to play nyoma, whilst standing on top of the living tortoise . . . and were ordered to pay ten dollars so that the ancestors will come and say something about the illness of John. His mother is clapping her hands whilst kneeling and begging the ancestors to take pity on the poor child . . . John passed away.*

Cornelia Nemangando's *sadza* painting, *Causing of Street Kids* (Fig. 35), is smaller but also dramatic in content. In this work, she clearly narrates the following episodes:

> *These are school children, but they are in the bush loving each other; the boy is reaching for the girl's waist; the girl is pregnant and running to the boyfriend, but the boyfriend is hitting her, saying, "get away"; we can see the girl has given birth to a baby boy; her mother is telling her to go away from the home; now the girl is in the bush*

(Fig. 33) *Dancing-Drumming*, a *Sadza* Painting, by Loice Chirubuu.

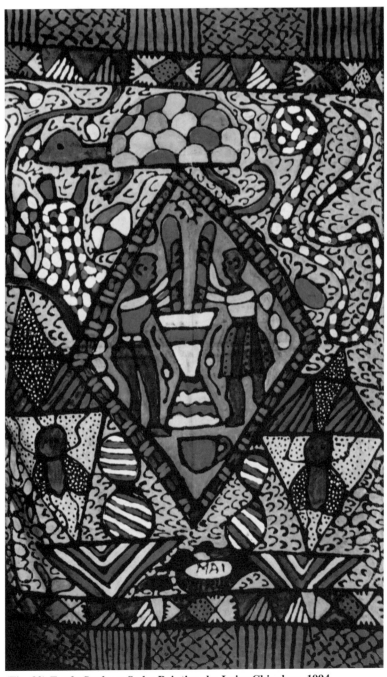

(Fig. 32) *Turtle-Snake*, a *Sadza* Painting, by Loice Chirubuu, 1994.

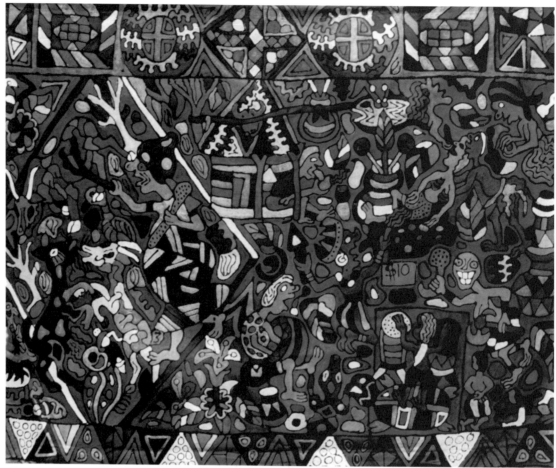

(Fig. 34) *Village Life* (Detail) by Mary Chiliyo, 1994.

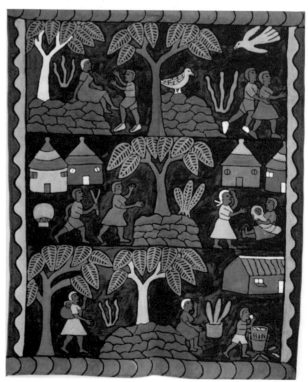

(Fig. 35) *Causing of Street Kids*, by Cornelia Nemangando, 1994.

with her child on her back. She is crying, thinking about her
life; and the child has grown up now and become a street
kid. He is eating food from the bin and his mother is crying.

Noy's work with African women is continually challenging and grati-
fying. The technical results are superb, as Noy consistently offers
new workshops to rural communities and high-density townships,
exploring a variety of media such as papier mâché, painted sculp-
ture, or textile sculptures. Whatever the medium, she encourages
the same depth of feeling by insisting, "now you do something that
is important about your life."

However, I was surprised to learn that there are two themes
that are not welcomed by commercial galleries. One concerns an
exploration of Black-White social relationships; the other is about
the war of liberation in which women participated. Noy states:

Whilst customers' wishes can have a stimulating influ-
ence on the women's art production, more often than not
the opposite is the case. For the women living in the poor
communal areas, life is not as pleasing and simple as the
customers would like their pictures to reflect. For instance,
any theme that touches on political topics is negatively
received. This is understandable from private buyers but
hardly acceptable from art galleries. If the women illus-
trate the different lives white and black Zimbabweans live,
the paintings are excluded from art exhibitions and not
taken for sale by market outlets. Paintings about the
Chimurenga [liberation war against apartheid and En-
glish colonial rule] are hardly accepted in the official
glorious version, not to mention the horrible personal
experiences the women endured during the war. Not one
of them has ever tried to show her experiences during the
war in her work.[4]

Compromise is a reality, since the economic need is so crucial. How-
ever, I wonder what would happen if "doing something important
about your life" also included the themes that are currently taboo
due to commercial restrictions. Is this kind of repression and self-
censorship healthy for their society?

While Zimbabwe is now governed by a mixed administration
of Blacks and Whites, the shadow of apartheid and class distinc-
tions is still evident in many subtle ways. For example, when Noy
speaks at various upper-class White women's quilting or craft guilds,
showing them examples of Weya women's art, their response is "look
how cute this is, or how clever." She feels these organizations "put
up self-imposed barriers or huge defenses of technical rules and
deadlines as security nets," to give meaning or importance to their
own work. Many have empty or superficial lives that are "buried in
a world which revolves around TV sitcoms and fashion magazines."
What else could their response be to art work that so clearly illus-
trates social injustices–past and present?

Endnotes

1. Betty LaDuke, *Compañeras: Women, Art, and Social Change in Latin America* (San Francisco: City Lights Publishing, 1985), pp. 1–6.
2. Ilse Noy, *Weya Women's Art* (Harare, Zimbabwe: Baobab Books, 1992).
3. Ibid., p. 21.
4. Ibid., p. 141.

Conclusion

After ten intense years of working at Cold Comfort Farm and at Weya, Noy and Anton are planning a one-year leave to clarify their personal and future goals. As a result of this decision, they have become advisors to new managers whom they have recently hired and are training, so that there will be project continuity.

Noy estimates that her workshops have directly influenced and benefitted the lives of over five hundred women, who have learned skills they can creatively develop instead of duplicating the same models. Through her interaction with African communities, Noy's views on life also underwent profound transformations, which she candidly shared with me.

When Noy first arrived in Zimbabwe, she wanted "to fill people with my life and to fill my life with theirs." Gradually she began to realize "we are very different and there are parts of their culture I will never understand . . . and it's better not to interfere. I have no ambition to change it." More important is Noy's growing acceptance of her own identity. "I can be a German and not feel guilty. To be able to live well together means a lot to me."

Noy reiterated her conviction that "the longer I'm here, the more I accept I do not belong here. Africans cry and they laugh for the same reasons I would. I saw my own limits and found it better not to assimilate. . . . It is not a question of respect, but of recognizing there are deep differences, and it is better to maintain differences."

Whatever Noy decides to do in the future, she can be proud that she has left a legacy of creative development that can serve as a role model for adaptation and modification by other nations and communities. Rather than staying on to risk becoming, in time, a rigid institution or power structure, Noy is leaving a strong foundation upon which others can continue to grow and reshape as needed. Meanwhile, she is eager to mature in new ways.

Noy is looking forward to developing her own art work. Ironically, though she identifies strongly with her German cultural heritage, she feels her art has had "a break . . . a separation from her European past. Now, all of a sudden what I do [mixed media weavings] looks strange to European eyes . . . looks African." Noy seemed pleased with this new perception of her art! I left Zimbabwe having witnessed an extraordinary personal and communal evolution . . . one that is still in progress.

7

Eritrea

ARTISTS/FIGHTERS
WITH NEW VISIONS

Asmara, the capital of Eritrea in northeastern Africa, is currently one of the safest, cleanest, most peaceful cities in a war-weary world. This peace, achieved May 25, 1991, came after a high toll of human suffering as Eritreans fought for thirty years for their independence from Ethiopian subjugation. This was one of the longest, most costly liberation struggles in Africa, led by the Eritrean People's Liberation Front (EPLF), a national organization in which almost everyone participated. Therefore, Zamede Tecke, director of the Department of Culture, told me, "We dislike war more than anyone in the world. This whole society, once it was liberated, had no need to see an army, police, or guns on its streets. This is my explanation of what you can see in the city people who can really appreciate peace."[1]

I came to Eritrea in July 1994, to meet with the EPLF artist-fighters, to learn how their creativity was nurtured and sustained during their long liberation struggle in which men and women participated as equals. As many as thirty to forty percent of the combatants were women. In the process of learning to fight, approximately twenty-eight, including five women, had the opportunity to train as artists. Unfortunately, only fourteen of this original group survived the war. Their images taught me much about Eritrea's land, people, and cultural diversity, as well as the impact of war upon the role of women. While some of their paintings document women's traditional baking of *injera* (an Eritrean staple, somewhat like a very large sourdough pancake), spinning cotton, mak-

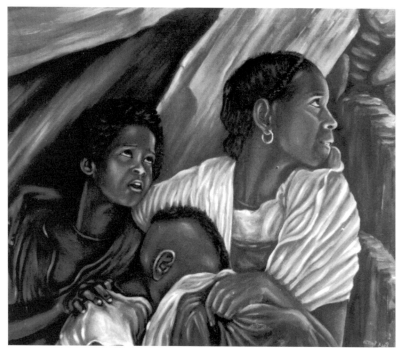

(Fig. 1) *Fear***, by Tzeghereda Yohannes, 36 x 48", 1987.**

ing baskets, or caring for children, new, non-passive role models of women as combatants and martyrs were beginning to emerge.

I learned much about the human side of this liberation struggle; how the Eritreans formed interpersonal relationships and how women gave birth in the war zone. There was also a Revolutionary School at Arareb that took care of orphans, the Camp of Challenge for the disabled, and Solumona Camp for hundreds of thousands of refugees and displaced people. By 1980, an art center opened at Arag, where the twenty-eight artists-fighters then lived for most of the war, and where their aesthetic creativity was nurtured in the intervals between battles. I was surprised that the artists were so young, as most were born around 1960 and joined the EPLF around 1977.

One woman artist-fighter, Abeba Habton, died in battle, while another left the art section for journalism, and a third, Tzeghereda Yohannes, now married to an Eritrean diplomat, lives in the nearby nation of Djibouti. I found her 1987 oil painting *Fear* (Fig. 1) in the National Art Museum archives, a powerful portrayal of a mother and her children hiding from the falling bombs. Even the agitated folds of their clothes echo their fear. However, my primary focus in this discussion is on two women artists who survived the war: Terhas Iyassu and Elsa Jacob.

In addition to painting, in the war zone, the production of traditional baskets, decorative bead and leather work, embroidery, and tapestries was also encouraged when supplies were available. Many of these craft items (Figs. 2 & 3) are now preserved in the display center of the National Union of Eritrean Women (NUEW) in Asmara (Fig. 4). They also have current programs for promoting craft skills, as there was much disruption of these basic activities during the war. I particularly liked the tall, elegant shape of the injera-serving basket, made from straw and overlaid with colorful yarn patterns (Fig. 3).

I found that all the artists-fighters were extremely close. Aside from their personal stories, their anecdotes about camels, "Matches," and Saturday-Tuesday nights were the most revealing, as they reinforce the human aspect of war. It was disappointing to learn that

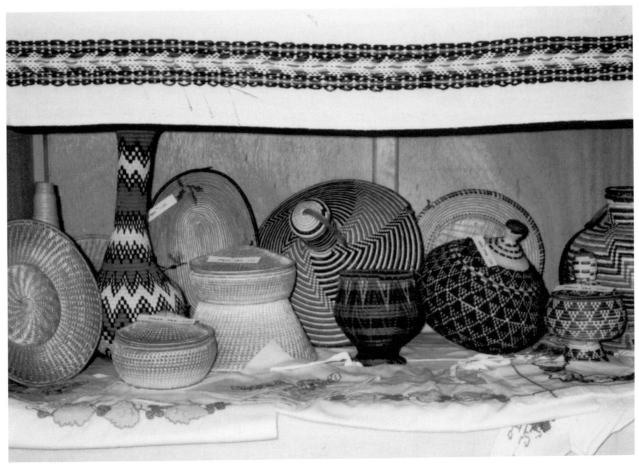

(Fig.2) Display at the National Union of Eritrean Women, Asmara Eritrea, 1994.

some of the stronger paintings that were reproduced in a 1987 catalogue were lost during a European exhibit tour, and that many art works were damaged, inaccessible, or not necessarily the best representations of the artists discussed.

Since liberation and the establishment of the Ministry of Information and Culture, artist-fighter Mikael Adonai, who heads the Fine Arts Section, promotes art through the selection of paintings that are reproduced as posters. They are prominently displayed on windows and walls throughout Eritrea for national holidays and celebrations as well as for Women's International Day, etc. Posters commemorating the martyrs of the liberation struggle are dominant such as *Fighter* (Fig. 5) by Terhas. (In Eritrea the first name is used rather than the father's name.) Mikael succinctly explains why:

> *I saw war at the age of fifteen. I'm confident enough I'll continue my career but will remember the past, always. My objective in art is to show people that WAR is the ugliest side of life. You can't erase those bad wounds easily. I have seen people bombarded, comrades dying, and I participated in many battles. If you become an artist, there at the front, I believe those memories should be reflected in your art. But the biggest challenge lies ahead, that is, how to express peace.*[2]

(Fig. 3) *Injera*-Serving Basket.

149

(Fig. 4) *Asmara,* **by Betty LaDuke, Pen and Ink, 11 x 14", 1995.**

Historical Review

Three years after liberation, Asmara (Fig.4) has been transformed from a city dominated by fear and physical neglect to a scrubbed-clean image of revived dignity. The streets are once again filled with the vibrant strides of its inhabitants, who now walk safely any time of the day or night. They are proud that in spite of indifference and neglect by the world community, Eritreans alone, with their fierce and united resistance to injustice and with a desire for nationhood, defeated the Russian-equipped Ethiopian forces recruited from a population of forty-two million.

In its recent history, Eritrea, a tiny nation of a little over three million with the strategic ports of Massawa and Assab on the Red Sea, experienced fifty years of colonization by Italy, from 1891 to 1941. When the British defeated the Italians during World War II, the big four superpowers England, the Soviet Union, the United States, and France could not reach an agreement on the status of Eritrea. Therefore, the question of Eritrea's desire for independence was brought to the United Nations, and in 1952 a compromise was arranged. A U.S.-sponsored resolution was passed, federating Eritrea with Ethiopia. This resolution benefitted the United States, which received communications and military bases near Asmara and along the strategic Red Sea. In turn, Ethiopia received substantial American military and development aid as well as political support for its expansionist policies.[3]

Ethiopia soon violated the conditions of federation, and resistance mounted with the clandestine Eritrean Liberation Movement,

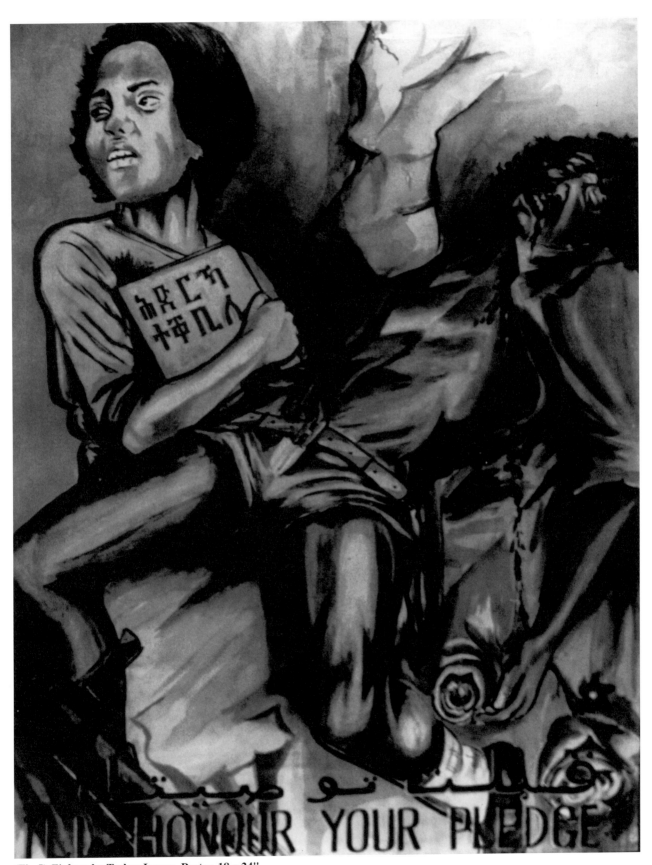

(Fig.5) *Fighter,* by Terhas Iyassu, Poster, 18 x 24".

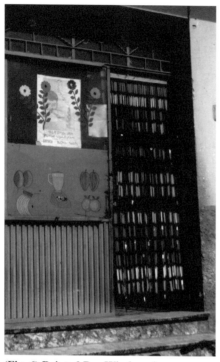

(Fig. 6) Painted Bar Window, Asmara, Eritrea, 1994.

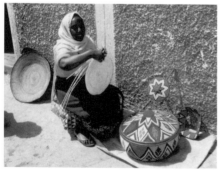

(Fig. 7) Making a basket, Asmara, Eritrea, 1994.

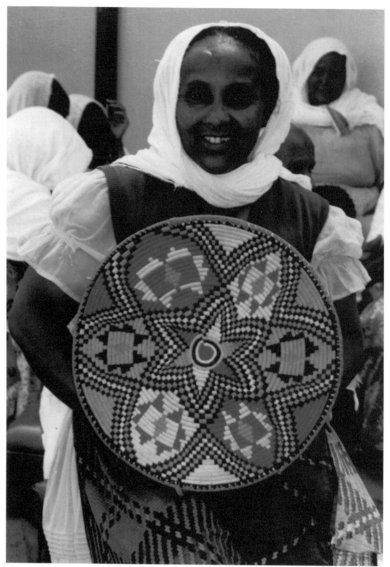

(Fig. 8) Basket by Fiseha Asfan, Asmara, Eritrea, 1994.

which organized for Eritrean independence. The armed struggle began shortly before the Ethiopian government officially annexed Eritrea in 1962.

Ethiopia had been governed by Emperor Haile Selassie since 1941, but in 1974 he was overthrown by a popular uprising. The Ethiopian military junta or Dergue then took over and forced the United States out, turning to the Soviet Union which, aided by Cuba, expanded and trained the Ethiopian Army to crush the Eritrean revolution.[4] Intensive land and air offenses against Eritrea were initiated.

Amazingly, the Eritreans had no international help, and fighting only with captured Soviet tanks and weapons, they gradually launched a series of eight major offenses. Finally, after long years of struggle, the port of Massawa was captured in 1991, and the Ethiopian siege of Asmara was broken. Victory and peace were achieved. Basil Davidson succinctly explains: "They were able to

win this victory over evil for many reasons of stubborn and in-telligent persistence, but above all . . . because they were able to forge among themselves a unity of companionship in struggle that proved invincible."[5]

I saw physical remnants of the war along the two major roads I traveled; those leading from Asmara to Massawa and from Asmara to Keren, Agordat, Barentu, and Tocombia in the Barka province. Rusted skeletal hulks of tanks, trucks, and military equipment were strewn along the roadside. They were upended and sharply silhou-etted at precarious angles against the rocky landscape, or partially hidden by the scrawny vegetation where shepherds with flocks of goats seek pasture and water. Farmers plowing this drought-prone land with oxen or camels are also reminded of the not-too-distant atrocities, as are the Kunama women with their baskets and babies walking to and from the local markets. Almost every family was affected by the war.

Asmara

As I leisurely strolled around Asmara, one particularly pleasurable observation was how men and women greeted each other, embrac-ing and sharing three kisses rotated from cheek to cheek. One fa-vorite Eritrean pastime is to sit and talk for hours in one of the innumerable bars that feature cappucino, tea, blended fruit drinks, and beer. Contributing to the cheerful atmosphere of Asmara are the uniquely painted window designs illustrating each shop's spe-cialty, be it food, clothing, hair styling, or the latest cassettes (Fig.6).

I was delighted to see women in the open doorways of their homes or seated outside, weaving elaborately shaped straw baskets embellished with colorful yarn designs. These baskets can enliven any home, as they make wonderful wall ornaments in addition to their practical use (Figs.7 & 8). The Eritrean's love of color is also evident in the ornate embroidery applied to women's traditional

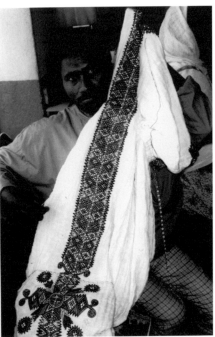

(Fig. 9) Embroidery of Traditional Dresses, Asmara, Eritrea, 1994.

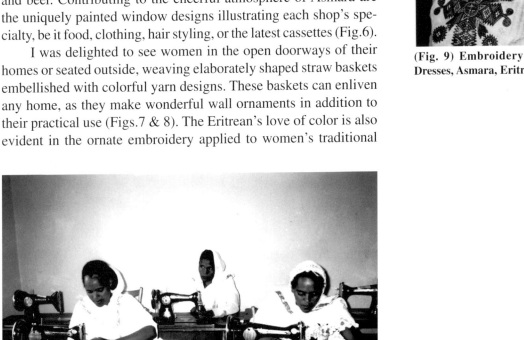

(Fig. 10) Solomuna Refugees Trained to use Sewing Machines by NUEW, Asmara, Eritrea, 1994.

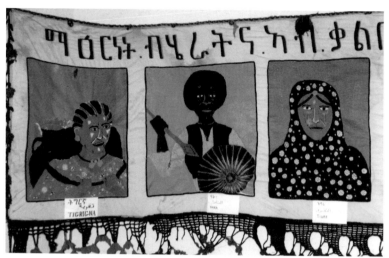

(Fig. 11)

(Figs.11,12,13) Embroidered
Portraits of Eritrea's National
Groups, by Zaid Berhane,
Asmara, Eritrea.

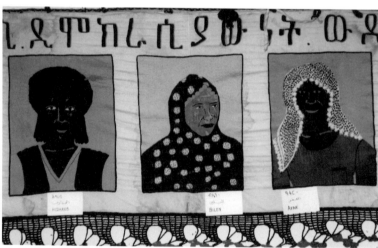

(Fig. 12)

(Fig. 13)

(Fig. 14) Zaid Berhaine with her Basket, Asmara, Eritrea, 1994.

white cotton dresses, which are made by men (Fig. 9). This form of embroidery as well as machine sewing have always been male occupations, but now women were being trained to use sewing machines for creating decorative embroidery through a NUEW program for former Solomuna refugees (Fig. 10).

I was really delighted to see a recent and extraordinary example of non-traditional embroidery featured at Eritrea's new National Art Museum, which had served as a prison during the war years. The embroidery, created by Zaid Berhaine, a former artist-fighter (Figs.11–13), consisted of a series of nine portraits exemplifying Eritrea's national diversity. Woldu Afeworki, an art teacher and fighter, made the drawings for the embroideries. It took Zaid over six months to complete this series exemplifying the Tigre, Tigrinya, Bilen, Afar, Beja, Saho, Baria, Baza, and Rashaida peoples. This impressive embroidery stretches more than twenty feet across the main wall of the Museum. Zaid has since continued to design and create other embroideries as well as baskets (Fig. 14).

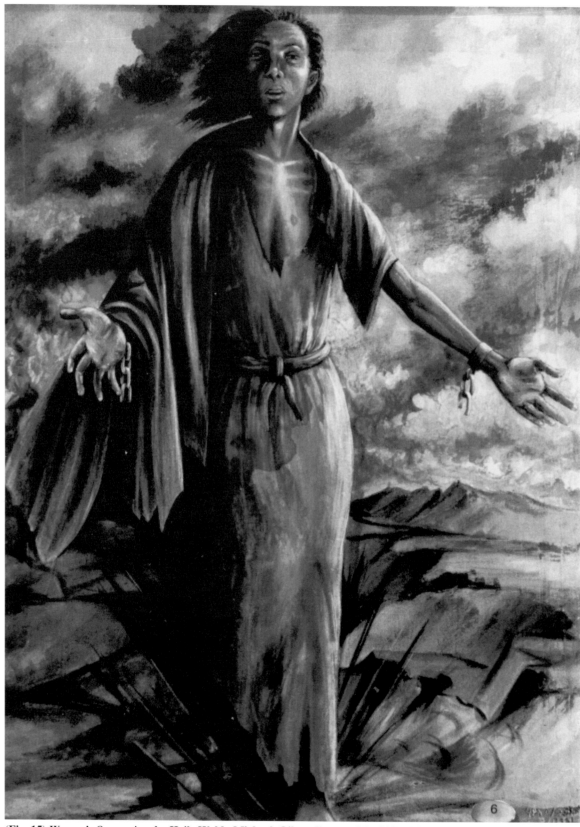

(Fig. 15) *Women's Oppression*, by Haile Wolde-Michael, Oil on Canvas, 36 x 30", 1981.

Haile Wolde-Micheal

The current small number of Eritrean artists would probably not have had the opportunity to develop their talent without the guidance of several dedicated artists-teachers who were also involved in the liberation struggle. They are Haile Wolde-Micheal, Woldu Afewerki, and Berhane Adonai (director of the School of Art, scheduled to open in Asmara, September 1994). Haile is probably the best known and most revered teacher. He was born in 1944 and the only one to have completed five years of study at the National Art School in Ethiopia. Woldu studied for three years, and Berhane is self-taught but influenced by an Italian painter who lived in Asmara. That these three art teachers became catalysts for promoting a generation of artists under the most unusual circumstances is an amazing story in itself.

(Fig. 16) *Handicrafts*, by Haile Wolde-Michael, Oil on Canvas, 26 x 36", 1981.

In the catalogue of Haile Wolde-Micheal's retrospective 1994 exhibit at the National Art Museum, the following comment describes his involvement with the People's Militia in 1977:

[He] came to the field in 1978. Commissioned to the then "Revolution School" in February, 1979, Haile's duties and responsibilities centered on: teaching fine arts; monitoring art students with advanced skills organized in clubs; and training EPLF army fighters (including the wounded) drawn from the battle-fronts and departments. In 1983, in line with the Front's Literacy Campaign Program, Haile had been charged with conducting extensive studies behind enemy lines. Unfortunately, Haile never came back to the base camp. In December 1983 . . . a land mine sealed his fate.[6]

Haile's teachings, as well as his own paintings, were an inspiration to his students. They varied in style from detailed realism to passionate expressionism. In *Handicrafts*, 1981 (Fig. 16), a woman is calmly absorbed in creating a large *injera* basket; as her hands are graphically portrayed shaping the straw. Both her face and hands are realistically shaded in warm brown tones, which contrast with her pale green blouse and the fertile landscape behind her.

In strong contrast to this sedate and realistic painting is Haile Wolde-Micheal's larger, expressionistically vibrant *Women's Oppression* (Fig. 15), also created in 1981. Painted with oil on canvas, it is symbolic in concept. Brush strokes of flaming warm tones dominate the woman's form as she rises from the midst of destruction and breaks free of the iron chains that mentally and physically bind her. This powerful painting seems more than a call to arms, i.e., to encourage women's participation in the liberation struggle. It also refers to the centuries of women's oppression under patriarchy exemplified by an Eritrean proverb that brutally illustrates women's traditional position: "Just as there is no donkey with horns, so there is no woman with brains."[7]

There are differences between the urban educated and rural farming communities in contrast to the nomadic peoples, who form the majority of Eritrea's population. The war of liberation affected most aspects of Eritrean culture. For the first time, young women in urban and rural communities became politicized; they left their parental homes before marriage and experienced a new, egalitarian culture that developed in the field. The newly established Health Centres informed women about nutrition and practices related to pregnancy. It must be noted here that the concept of "God's will" or "a religiously inspired fatalism combined with a limited medical knowledge offered Eritreans a life expectancy of thirty-eight years and a fifty percent infant mortality rate. The overwhelming majority were illiterate and among women illiteracy was ninety to ninety-five percent."[8] There was also a strong educational emphasis placed on the civilian community to abolish female circumcision and infibulation. How would all this consciousness-raising translate during peacetime?

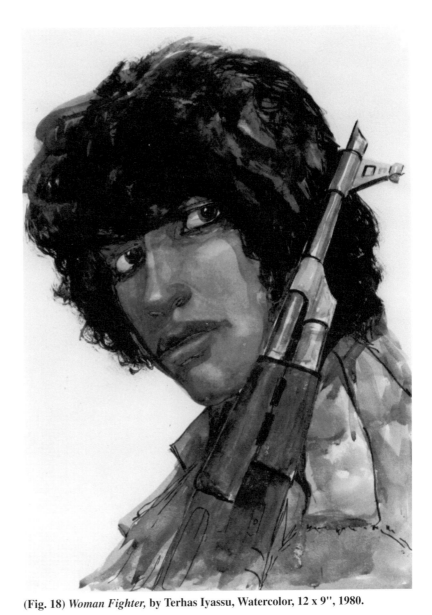

(Fig. 18) *Woman Fighter,* by Terhas Iyassu, Watercolor, 12 x 9", 1980.

(Fig.17) **Terhas Iyassu, Asmara, Eritrea, July 1994.**

Terhas Iyassu

When I met Terhas in Asmara, it was immediately apparent by her jewelry and bright magenta blouse that her physical involvement with the war was behind her (Fig. 17). I was fascinated by her process of development as an artist-fighter. She began as a child-informant in Massawa when, at age fourteen, she carried messages about Ethiopian naval and troop operations to the EPLF base five kilometers away. Sixteen years later, in 1990, she participated in the EPLF liberation of Massawa as an artist, recording history in her sketchpad. I gradually learned that the war and the battles in

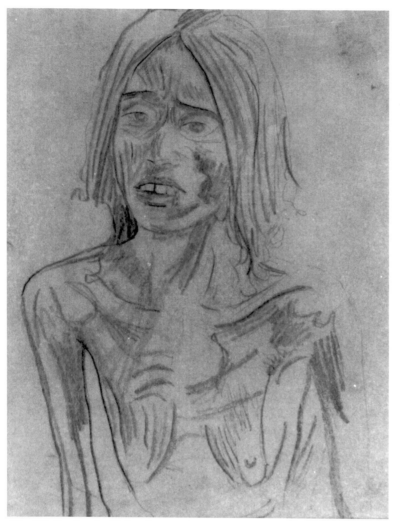

(Fig. 19) *Famine,* **by Terhas Iyassu, Pencil, 9 x 12", 1980s.**

which Terhas took part, the two children to whom she gave birth in the war zone, and her intense interest in drawing and painting were the key experiences of over half of her young life. Now that Eritrea is free, Terhas is facing a new challenge, how to express the reality of peace.

As Terhas described her experiences, I sensed her inner strength, reinforced by bonding with comrades who shared the same vision. Whenever we walked in Asmara and later when we journeyed together to Massawa, Terhas was greeted and embraced by her extended family of former fighters, as well as by her very special friend, Volvo!

Terhas was born in 1960 in Asmara, where her father was employed by the local government. She had three sisters and two brothers. One sister was also a fighter, another a nurse exiled in Saudi Arabia; one brother, an electrical engineering student, was suspected of being an EPLF collaborator, imprisoned, and tortured for nine months. All Eritrean parents feared for their children, as there were many midnight incidents, especially from 1975 to 1977, when the Ethiopian police, the Dergue, knocked on doors. Terhas' family all survived the war and have since been reunited, except her father, who died three years before liberation.

When Terhas completed the eighth grade, she moved to Massawa to live with her aunt so that she could join the EPLF. She was only fourteen, "just a child," and they told her, "School is food" and to "come back when you have eaten another quintal of grain." Meanwhile, she became a child-informant, as no one would suspect

she was carrying messages hidden in her shoes, hair, or clothes to the EPLF base at Inberemi. Approximately two years later, when the EPLF were surrounded by massive numbers of Ethiopian troops and airplanes, they strategically retreated from Massawa to a well-fortified and impenetrable base at Fah in the Sahel province. Terhas then joined them, and at Fah she met Elsa Jacob, who had arrived from Keren, and they trained together, first as fighters and then as artists. They have remained close friends and have become important figures in Eritrea's historical legacy, as they are the only two women artists-fighters (of five) who have continued to paint. They also share the dream of improving their skills to become the best artists they can possibly be.

Becoming an Artist-Fighter

How does one progress from standard military training, that is, from learning to use a gun to shoot and kill to drawing and painting within the same EPLF organization? Iyassu explained how a Department of Culture was formed within the EPLF in 1975 to plan activities in music, dance, drama, writing, and the fine arts. "In 1978 three teachers, Woldu Afeworki, Berhane Adonais and Tesfay Ghebremicael came to my unit and distributed papers and pencils to all who were interested in art. They asked us to draw something, anything, and then selected the thirteen best drawings," which included those by Terhas as well as those by Elsa, Tzegherede Yohannes and Mikael Mickael Adonais.

The Fine Arts section later expanded to include twenty-eight artists, the nucleus of Eritrea's contemporary art movement. Ironically, these young people would probably not have had the chance to develop their talents were it not for the war and the opportunity to attend the Fine Arts Centre at the Arag base after completing their military training. Some of these young people also became teachers and eventually offered short art courses to the brigades, so anyone interested had a chance to learn to paint.

Terhas described their studio as "an underground cave," adding: "We tried our best to learn the ABC's of art: drawing, painting, perspective, light, and shade. A soldier would become our model (Fig. 18). We arranged a still-life and made many pencil and water color sketches." They also sketched and painted from memory. Some of her quick sketches from the 1980s are *Famine* (when most of the donated food supplies for Eritrea were usurped while en route from Ethiopia and sold by entrepreneurs for personal gain) and *Woman Carrying Her Child for Resettlement*, a result of the constant Ethiopian bombing attacks (Figs. 19 & 20). With a few swift lines, she has captured the emotional impact of each experience.

During intervals of calm between offensives, the artists, mostly from urban areas, ventured to the countryside, carrying guns as well as pencils and water colors to do landscapes and portrait studies of the nomadic Sahels. Terhas then painted the proud *Tribal Chief* (Fig. 21) who joined forces with the EPLF.

(Fig. 20) *Woman Carrying Her Child for Resettlement,* by Terhas Iyassu, Pen and Ink, 12 x 9", 1980s.

Almost all the artists-fighters did at least one or more draw-ings or paintings with camels (Fig. 22). I soon understood why. They told me:

> *Camels are like fighters. They are like our brothers or sisters, carrying our food supplies all night long from one combat zone to another. They can go seven days without water or food, and they don't make noise or bray like don-keys. But camels can also be naughty. If there is food on the table and you turn your back, they can enter and eat all the bread, all the soup. This happened to us in Sahel.*

At Arag, art supplies were scarce but they learned to improvise, to make colors from local plants and outdated medicine. For an oil painting surface, a flour sack was cut open and prepared with a base of sugar and flour. "We had no other choices," I was told. But after 1983, they received some art supplies from Eritreans living in America and Europe.

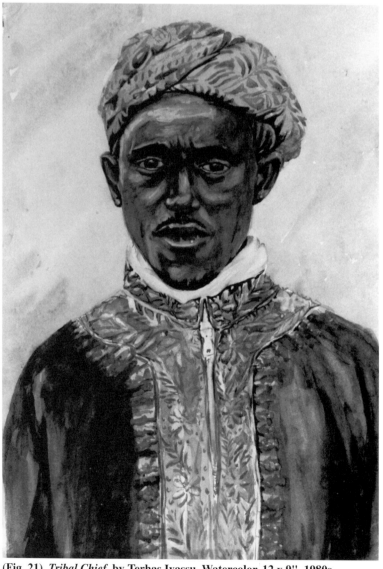

162

(Fig. 21) *Tribal Chief*, by Terhas Iyassu, Watercolor, 12 x 9", 1980s.

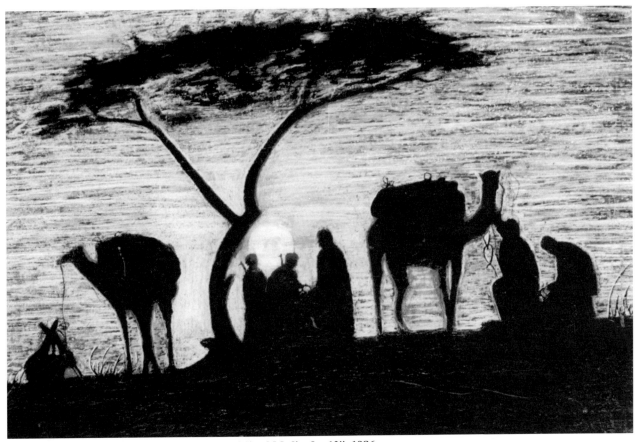

(Fig. 22) *Shepherds of Tigre*, **by Terhas Iyassu, Mixed Media, 9 x 12", 1986.**

Terhas also explained that "after the 1978 EPLF withdrawal from Massawa, there were eight major offensives against the Ethiopian troops, and we were all obliged to go to the front and fight. Sometimes one or two artists would be left behind to teach. Since there were intervals of calm for two or three months or longer between offenses, we produced art during this period, though we still considered ourselves as students."

Terhas recalled that their art work was used for promoting awareness of the EPLF in the countryside. After 1985, they tried to show their paintings to the highland village people.

> *Most of our paintings made very clear our suffering, and our hope, our longing for liberation. Most of our work was done in the simplest way, so nomads or farming people could grasp the messages of the paintings. They wonder how we came to make such kinds of work in the midst of war. They always express their admiration and give us encouragement to continue.*

When I asked Terhas if she saw any difference between male and female styles or images, she said, "No, but for the woman artist, women are the center of her work."

In 1986, a huge contest was held in the field for all the artists-fighters for the first time. An artist from the Sudan, Tadjadine, who had also participated as a fighter, was invited to judge the paint-

(Fig. 23) *Soldier Cooking*, **by Terhas Iyassu, Oil on Canvas, 30 x 42", 1980s.**

ings and offer the artists a critique. He asked them, "Why do you paint the fighters as big, strong people? They are very small and weak. They only have old weapons to use, captured from the enemy. . . . You should make the fighters small, but show them accomplishing more than it seems possible!" He then went on to say, "Most of you are married. Why not paint something about Love? Think about Liberation." Eventually these themes began to appear in the work of several artists.

Terhas' Family and Studio

Memories of war lingered long after the peace treaty was signed. "Peace can create a lot of opportunities for personal development," says Terhas, "but up to now I haven't been able to really express these feelings. I am hoping to change and paint such works."

Since her paintings were stored in her studio at home, I was invited to walk there with her from her office at the Ministry of Education, where she works in curriculum development. When we arrived, she opened the doorway, and I was surprised by all the bustling activities in various alcoves around the central courtyard. Some women were making *injera*, others were washing clothes, and children were playing. I was told seven families were now crowded into this house, where formerly only two had lived. After introductions, protocol required we drink tea before proceeding to

(Fig. 24) *Mother and Child*, by Terhas Iyassu, Oil on Canvas, 1987.

(Fig. 25) *Crying Child*, by Terhas Iyassu, Pen and Ink, 14 x 11".

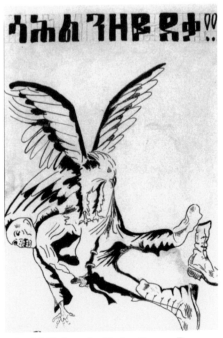

(Fig. 26) *Vulture*, by Terhas Iyassu, Pen and Ink, 14 x 11".

Terhas' small, crowded room, where she slept with her two daughters. She also painted in this room. When I asked about her husband, who is a journalist, she explained, "Due to economic hardships, we are not able to live together. I'm living with my parents. He lives with his parents. It is hard for us to start our own life. My husband comes two or three times a week to visit us. I'm confident these problems will be solved in the future."

In her room, oil paintings, water colors, and drawings fill the walls, and there were stacks of drawings and water colors on two small tables. Terhas' work was diverse; the gestural, transparent quality of her water color portraits is particularly haunting. On the wall next to her oil painting, *Soldier Cooking* (Fig. 23), was a smaller watercolor, *Fighter* (1992) (see Fig. 5), which had been made into

165

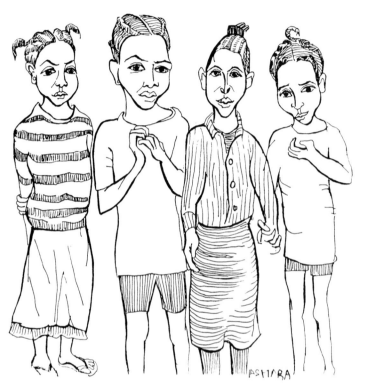

(Fig. 27) *Asmara Children,* **by Betty LaDuke, Pen and Ink.**

a poster and popularly displayed on store fronts throughout Asmara. The symbolic image is expressionistic in style but carefully composed to convey the political message, "I'll Honor Your Pledge," written in Arabic and English on the bottom. There are two figures, a dying combatant and his young wife who stands at his side. Her determined facial expression conveys the message that she is ready to commit her life to the struggle. Blood seeps down from the combatant's wound, but rises upward in the form of red roses, a symbol of peace and liberation.

In contrast to *Fighter*, another oil painting on the wall offers a different emotional context; *Mother and Child* (Fig. 24) seems somewhat stiff, like shocked observers of tragedy. This 1987 image is more opaque and realistic in style. The frightened mother holds her child against a background of desolation. The surrounding landscape reinforces this feeling as it seems barren and scarred from war. The horror of war is also echoed in two unfinished pen-and-ink sketches, one showing a crying child with a gun pointing at his head, and another shows a vulture swooping down upon the remains of an Ethiopian soldier (Figs. 25 & 26).

Before I could see more work, Terhas' sister, Olga, brought a small tray into the room. They invited me to share lunch with them. In the center of the *injera* was a mound of spicy meat sauce. After the traditional washing of hands, we proceeded to break off segments of the *injera* and use it to scoop up the delicious sauce.

(Fig. 28) *Shepherd Hiding From the Bombs*, by Terhas Iyassu, Mixed Media.

I was curious about the war experiences of Terhas' sister and brother, Teadro, and gradually they each began to share their painful stories. During my three weeks in Eritrea, I learned that such stories were not uncommon. Somehow this family and many, many others have survived the initial trauma of their wounds, and brothers and sisters have returned to live in their parental homes, as there is no other choice. However, their affection and support for one another and for their country is much in evidence.

Relationships and Children

During the early war years, men and women lived and fought together, but sexual relations were strictly forbidden. Since the war was protracted and approximately thirty to forty percent of the combatants were women, policy changed, as life had to take on some aspects of normalcy, or morale would have suffered.

I eagerly listened to details related to friendships, love, and trust in the midst of war. Danny Dafla, who learned to paint in his

brigade, and later married the musician-fighter Abrahet, in the war zone, provided many anecdotes:

> *In the period between battles, Tuesday night was considered Saturday night, a time for entertainment, singing, dancing, and drinking of suwa, a local beer. Sunday, celebrated on Wednesdays, was a day of rest and relaxation. These changes were made so as not to offend either Christians or Moslems as the militia was composed of Eritreans from ten different national groups and preference for any one was strictly avoided.*

Gradually, intimate relationships formed, and by 1981 there were mass marriages, but husbands and wives were not allowed to be together in the same regiment. Each brigade had its own maternity

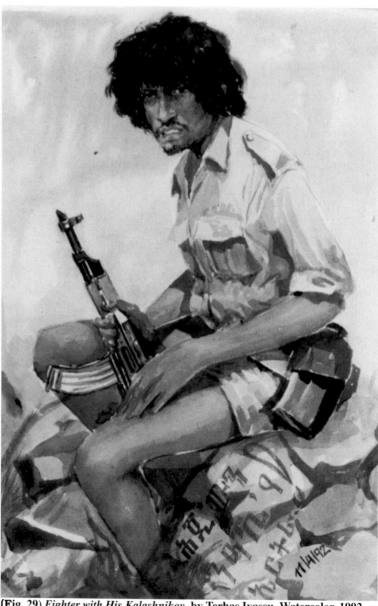

(Fig. 29) *Fighter with His Kalashnikov*, **by Terhas Iyassu, Watercolor, 1992.**

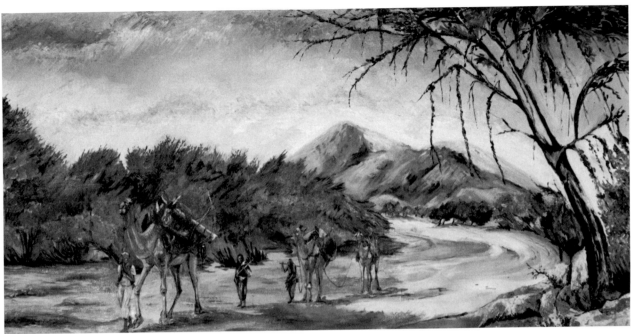

(Fig. 30) *Camel Caravan*, by Terhas Iyassu, Oil Painting, 24 x 36", 1994.

camp, and mothers took care of their children (Fig.27). But childcare duty rotated, as women were needed for building houses, paving roads, and repairing roads, especially after the rains.

During this period, Terhas also married and became pregnant. She said, "At that time I was not happy about raising a child, as we were living in caves experiencing bombardments, but the comrades who lived with me helped me." Children became the responsibility of all the men and women at the base. Terhas raised her child, Martha, born in 1980, for two years before returning to fight, "confident enough when I'm out of the base and at the front, fighting, that my comrades will take care of my children." Terhas had a second child, Janet, also a girl, born in 1986. As the war dragged on, Martha became old enough to attend the Revolution School where Terhas taught art.

"Matches" and Other Stories

Wonderfully vivid portraits emerged during our conversations about the war years. One such tale evolved about a woman nicknamed "Matches" because of her fiery temperament, which seemed to flare up like a match. "Once she saw a fighter going around almost naked. She gathered together fifteen scraps cut from worn-out clothes and then made him a shirt."

Danny also told me, "Fighters learned from girls how to patch and wash their own clothes." When it was men's turn to cook, women also offered them advice. "Any fighter will tell you women are the most active in the field. Also, when we capture any village, women rush out with food and water to greet us. Men have good intentions but are more reserved."

(Fig. 31) *Coffee with Volvo*, **by Betty LaDuke, Pen and Ink, 14 x 11", 1994.**

Massawa and Coffee with Volvo

I was really pleased that Terhas could accompany me to Massawa. With its endless sprawling twists and turns, the narrow rock-strewn road to Massawa is extraordinary, dropping from the cool Asmara plateau of more than seven thousand feet to the level of the Red Sea. Ribbons of rock rhythmically circled the mountains, forming terraces for planting grains, fruits, and vegetables. En route, clusters of rock and mud-plastered huts with thatched roofs were nestled precariously on hillsides between some of the larger towns. There were also skeletal remnants of rusted and burnt tanks, trucks, and long-nozzled artillery guns, indicating many battles and the occupation and isolation of the port of Massawa from the rest of Eritrea for most of the war.

When Terhas and I arrived, I was dazed by the intense sunlight and heat, which immediately wrapped around us like a blanket. Terhas was surprised by the dramatic improvements in Massawa, as there had been much rebuilding and painting since her last visit, i.e., shortly after the war, when not a single structure was left unmarred. Massawa was then a ghost-like city filled with memories of terror, pain, and death. Slowly the residents had begun to drift back (some on crutches, limbs missing), and the long process of reconstruction began. Once again children played, women baked *injera* in circular ovens near their doorways, or prepared coffee, sitting together outside, drinking and talking in the late afternoon. For most of the day, rickety ladders propped against rough walls held the weight of men carrying buckets of cement as they filled the

crevices between layers of rocks or bricks, gradually reclaiming their once elegant and beautiful city. For two days Terhas and I wandered together with our sketchpads, recording our impressions as children gathered around us to observe our efforts.

Perhaps one of the most poignant experiences for me was our visit with Terhas' friend, Almas Kidane (Fig.31). She was a big woman renamed "Volvo" (like the sturdy, dependable Swedish car), renowned for her ample physique as well as for her spirit of resistance. She prepared coffee for us in a room behind her shop, which contained shelves filled with an assortment of soaps, packages of biscuits and pasta, and some canned items. First she roasted the raw coffee beans in a long-handled pan held over a small charcoal stove. The aroma was enticing. Then, Volvo poured water over the ground beans, which slowly settled. Soon she graciously filled our little cups with this dark sweetened brew, which we were obliged to sip slowly.

Terhas told me how Volvo's shop had formerly been a bar frequented by Ethiopian soldiers. All the residents had admired her, and she was known for "not taking orders" and for "fighting like a

(Fig. 32) *Ethiopian Lady*, by Terhas Iyassu, Oil on Canvas, 24 x 18" 1995.

man." She ignored the soldiers' request to play Amharic or Ethiopian music. Finally, in 1988 she was accused of secretly collaborating with the EPLF and was imprisoned. Her father was a fighter with the EPLF, and Volvo had been helpful during Terhas' early informant career. For one year and eight months, Volvo never saw daylight. She was constantly tortured, experiencing beatings on the soles of her feet and other atrocities "too terrible to explain," especially when she was moved to the infamous Mariam Gimbe prison in Asmara, which boasted few survivors. Finally, her wealthy uncle was able to bribe the Ethiopian officials, and she was released.

War Is Not Always Grim

During the war years, Terhas' skills were needed at the Revolution School at Arareb. There were over seven thousand orphans, and she taught art to the children and prepared teaching aids and curriculum materials in addition to taking care of her own children. During this time, she developed the necessary skills for her current job at the Ministry of Education in Asmara, where she illustrates elementary and secondary textbooks.

It is sometimes easier to learn from others about a fighter's combat experiences. Once again, Danny, who has also continued to paint and is in charge of the Archaeology Section of the National Art Museum since liberation, told me, "Terhas was also involved in some of the final battles of the war. At Massawa she made rapid sketches in the war zone, but people were fleeing, and she had to complete her images later from memory. In some of the final battles in the provinces of Decamara, Toro, and Segeneti between 1990 and 1991, there was hand-to-hand combat. There were four to five months of continuous combat, sometimes with five to seven days of rest in between."

Danny also wanted me to know, "War is not always grim or miserable. There is so much love. Every outsider was impressed how much life there is in the field. No one had belongings, maybe one change of clothes even the women. So you live to the fullest each day."

I could understand that, when over half of one's life has been in a war zone, memories could persist and that paintings about love and peace would only emerge slowly. In Terhas' mixed media portrait of a shepherd she completed in the 1980s, we can see the fear on his face as he hides from the bombs (Fig. 28). Even after liberation in 1992, Iyassu painted a portrait of a fighter holding his Kalashnikov, a Russian rifle (Fig. 29).

The Kalashnikov, according to Danny, "is the best rifle in the world," and there is a simile related to every part of this weapon. For example, the gun sighting is compared to the "fighter on the front"; the gun barrel is "the road to victory"; the filter for gas is like the "filter of the revolutionary struggle, to avoid the bad things and only take the good"; and the wooden rifle butt requires that it be "held firm against the shoulder, to be firm like the masses. You have to rely on their support in order to shoot properly."

In contrast to her earlier work, in 1994 Terhas returned to her camel theme. In the oil painting *Camel Caravan* (Fig. 30) she portrays a calm and peaceful journey.

When I asked Terhas about her professional goals, she stated, "We artists need help from the outside. We need scholarships so we can receive training and improve our skills." Her personal dream is "to attend an art academy and make good paintings!"

Terhas' portraits reveal the soul of her subjects, whether they carry a Kalashnikov or wear the traditional ornamentation of their cultural heritage, as in her 1995 drawing *Ethiopian Lady* (Fig. 32). When I asked Terhas why she created a portrait of an Ethiopian, her enemy for so many years, she replied, "because I love her style of ornamentation. Now I don't see her as an enemy, because we have to promote regional unity and art is universal."

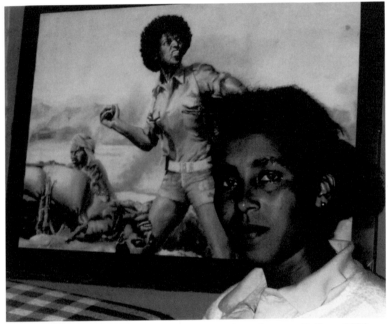

(Fig. 33) Elsa Jacob with her Poster, *Woman Hero*, Asmara, Eritrea, 1994.

Elsa Jacob

Elsa (Fig. 33) told me she had just completed the tenth grade in the Keren Secondary School when she made the decision to join the EPLF. "I was very angry, as I was very, very interested in my academic studies." But the Keren school facilities were inadequate. "There were no laboratories, books, or supplies, and I tried to leave Keren to go to Asmara for my studies." But at this time she also witnessed "much suffering . . . women and children cruelly killed by Ethiopian soldiers, villages set on fire . . . and I felt, Why do I try to learn under these conditions? I need to try to find a better solution."

Before Elsa joined the EPLF, they "tried to convince me to remain in Keren, to continue my work with the Eritrean Youth As-

sociation, but I decided to be a full-time fighter." This was a diffi-
cult decision, as she was the oldest of four daughters, and her father
had died the year before, in 1976. Ironically, he had fought in the
war as an Ethiopian soldier, "always against my will," he told his
family, but this was his means of supporting them, and not an un-
usual occurrence. Elsa felt, "He did not die a happy man."

Elsa was sent to the military camp near Fah in the Sahel
province for approximately six months of training. This experi-
ence, from her urban perspective, was filled with "too much
hardship, as you even sleep on rocks." But, she added, "I was
satisfied with my decision."

During this period, the EPLF was trying to organize an Art
Section. The idea evolved spontaneously among the fighters and
was later promoted when the EPLF realized that art can be "a weapon
to help in the struggle for liberation."

At Fah, Elsa and Terhas became close friends, and both were
shocked when their common artist-friend was killed in battle in
1981 at a time "when she was just beginning to learn water colors."

"Death," Elsa told me, "that is the hardest thing to bear, when
your colleagues and friends suddenly disappear . . . they are killed.
You feel you can't smile ever again, but nature makes it happen."
She described the cameraderie among the fighters as "good culture
as everyone tries to help anyone, even if you don't know him or
her. You give your life for each other, because we are fighters. If
you see anyone without a shirt, and you have two, you give one, or
you give some bread. You share everything."

As everyone's drawing and water color skills developed in
the Araq base Art Section, they were immediately given the task of
illustrating military manuals that showed equipment such as tanks
and trucks. This was important work, but intermittently they also
had a chance to paint with oils during short courses organized by
Haile, who was also illustrating manuals. Elsa said, "We called Haile
to correct our drawings or paintings, and then we tried to help him
with his work. In 1979, I did the first oil painting with which I was
satisfied . . . there was a very smiling woman harvesting corn with
a child on her back, surrounded by green fields and flowers." Un-
fortunately, this painting was lost . . . but Elsa had the inner need to
see beauty in other events, perhaps as a survival mechanism against
the brutality of war.

During most of the war years, Elsa lived and fought in the
desert region of the Sahel, but she had two opportunities to visit
Barka province. There she made sketches that later inspired paint-
ings such as *Smiling Face from Barka*, a tempera paint on canvas
(Fig. 34). For the first time, she joyfully experienced the cultural
traditions of semi-nomadic people. Elsa felt they had "beautiful
teeth and were good smiling people." They were always hopeful
even though they had troubles. "War," she told me, "is not only a
time of hardship, but you also have time to be happy and to have a
peaceful mind." She was always "hopeful, one day there will be no
more war."

(Fig. 34) *Smiling Face from Barka*, by Elsa Jacob, Oil on Board, 30 x 36", 1980s.

(Fig. 35) *Fish*, by Elsa Jacob, Oil on Board, 30 x 36", 1987.

(Fig. 36) *Woman Hero* **(Photograph from a Reproduction), by Elsa Jacob, 18 x 24", 1984.**

Another painting, *Fish* (Fig. 35), expresses Jacob's interest in the Denkalia coastal region. She was fascinated when friends told her how the women kept the fish they caught on a string around their waists while they looked for coral, shells, and pearls. This painting is a romanticized vision of young people holding fishing lines instead of guns.

In 1979, Elsa was enjoined in her first battle (in the fifth offensive); she was only seventeen. The battle place was in Karora, near Arag, and she was told not to go, but she insisted. "The Ethiopian solders pushed us against the hills, and then we had to retreat into the mountains for ten kilometers. We were surrounded by too many Ethiopian solders and tanks, and we had to fight our way out of that. The battle took three days. I was the only woman in our group."

Elsa did not want to talk too much about the sixth offensive, which lasted five months. She said, "I went to help fighters, to bring them food and water, to carry the wounded. There was very heavy fighting and loss of life."

The *Woman Hero* (Fig. 36), a dynamic oil painted in 1984, was made into a poster (unfortunately, I was not able to see the original). It was painted from the memory of her participation in the sixth offensive. The dominant figure of a woman fighter (whose face is covered with thick drops of sweat) stands over the body of a slain Ethiopian soldier. Elsa told me that she had thought about this image for two years and had made many sketches before she could

(Fig. 37) *In the Trenches*, by Elsa Jacob, Oil on Canvas, 24 x 36", 1986.

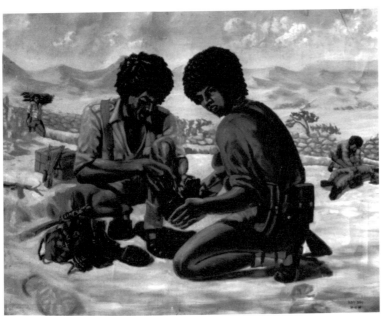

(Fig. 38) *Making Cartridge Containers*, by Elsa Jacob, Oil on Canvas, 30 x 36", 1988.

finally paint it. Though the woman with a grenade and rifle is portrayed sweating profusely, maybe she is afraid, but she is not weak. She "is proud that she has contributed to the battle." This view of war and hand-to-hand combat is usually associated with men. There are also many posters showing women as martyrs dying on the battlefield rather than accepting a future of subjugation for the sake of their children. There seem to be fewer images of women as aggressive fighters.

In the Trenches (Fig. 37) captures a restful moment in 1986, as combatants listen to a woman fighter play the *kirar*, a traditional guitar. In *Making Cartridge Containers* (Fig. 38), painted in 1988,

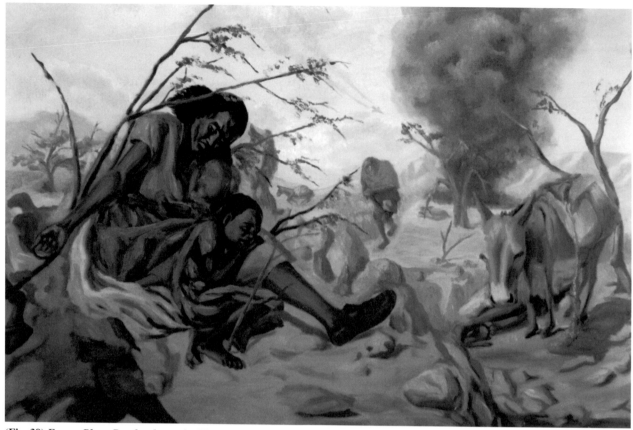

(Fig. 39) *Enemy Plane Bombardment*, by Elsa Jacob, Oil on Canvas, 30 x 36", 1990.

two fighters are preparing leather to make shoulder bags for holding cartridges. The incomplete painting *Enemy Plane Bombardment* (Fig. 39), begun in 1990, evinces loose, suggestive strokes, portraying a mother and her children huddling together beside their donkeys while an overhead plane releases its terror.

During the war, Elsa felt that she wanted to "focus only on art" and decided not to marry or to have children. In between battles and painting, "I was also teaching art in the field to interested fighters, and sometimes I doubted I was doing it in a proper way, but I tried my best." She readily admits, "Something inside me tells me I'm not an artist in the fullest sense," but her present goal is to have the opportunity to study abroad at an art academy.

Toward the end of the war, Elsa spent one month in Afabet, also in Sahel province, where she was guarding thousands of prisoners of war. After liberation, Elsa returned to Asmara to live with her mother and three sisters and was able to attend the university for a year, assigned to study languages and literature. However, she is now married to a former fighter, who works as an administrator in the local government. They have an eighteen-month-old son, and Elsa has had little time to paint or to study, as she spent the last seven months in Addis Ababa, Ethiopia, where medical specialists were able to successfully operate on her son's malformed foot. Unfortunately, Jacob and her husband each live in parental homes and visit each other regularly, as there is no housing available.

I was pleased when Elsa invited me to her home to meet her mother, sisters, and little son. Once again I witnessed much familial love and cohesiveness, and a concern for maintaining traditions. Drinking coffee and eating *injera* were part of the protocol. In addition to the powerful poster *The Woman Hero,* framed in one corner of the room, I also saw a recent portrait of her father Jakob (Fig. 40) painted from a photograph, and one of her son, Tesfaledet Mengstab (Fig. 41). The father's features are lean and stern; his eyes focused straight ahead. In contrast, her son's round baby face and dark, bright eyes look upward. A sky-blue background and a garland of flowers surround him. "Our country and our children are like flower seeds," she told me, "and we have to find a way for a bright future, a better way of living, education, and opportunities for development." Each of these three paintings symbolizes key decisions in Elsa's life, beginning with her father, whose conflicted pathway she chose not to follow. *Woman Hero* can be seen as a representative summary of her war experiences, while *My Son* confirms for her that his generation will grow up in peace and freedom. My photograph of Elsa holding her son beside her painting of him (Fig.42) seems a reaffirmation of her commitment.

When I gently chided Elsa about the absence of camel paintings in her collection, she then admitted that one was in progress, but it was in her husband's house, where she has more room to paint. She told me, "My mother is riding the camel." She went on to describe how her mother had used a camel, riding for two days to find her

(Fig. 41) *My Son*, by Elsa Jacob, Oil on Canvas, 24 x 16", 1993.

(Fig. 40) *My Father, Jakob,* by Elsa Jacob, Oil on Board, 18 x 12", 1992.

179

daughter shortly before liberation, aware that Elsa was based in the nearby town of Agordat. Elsa was then given permission to leave her work and visit with her mother for three weeks, as it had been more than thirteen years since they had seen each other.

It seems Elsa's goal to be a "professional artist and a skilled art teacher" will have to evolve through practical experience as she has been assigned by the government to teach at the Asmara Art School, which is due to open soon. The school's primary objectives, initially, will be to develop a core of elementary and secondary art teachers and an art program, the first ever in their educational system. Elsa has also been made a board member of *Mossana*, the official magazine of the National Union of Eritrean Women. Since liberation even though the Eritrean government is struggling economically, facing severe housing shortages and the inability to offer higher salaries to government administrators or to street cleaners, education and art education are priorities. Elsa's child will not have to go to war to become a painter.

Images of Women

Modern Eritrean painting is lean stylistically, and images of women have had to conform to the religious codes of churches, monasteries, and mosques. For centuries, the Virgin Mary was the supreme feminine role model for sexual purity, patience, and self-sacrifice. She is now being challenged by the corporeal presence of the militant woman and martyr, her hair in an afro and her dress, khaki shorts and shirt just like a man. In an exhibition catalog, sponsored by the EPLF, the following comment offers a clue to the reason for the lack of modern painting in Eritrea prior to the war years:

> In general, the paintings and other art works produced by the successive colonizers, including the Ethiopians, have portrayed the prominence and superiority of their respective cultures and power while undermining ours. Because of such political, cultural, and economic oppression, it was not possible to develop indigenous modern painters in substantial numbers and quality. Thus their paintings by and large did not encourage our society to appreciate art and develop critique.[9]

For the past thirty years of the liberation struggle, painting became a tool for raising consciousness about all aspects of life. However, it is still hard for female and male artists-fighters to confront the brutality of war in images that portray women as the active leaders or heroines that many of them were. According to Danny Dafla, "Some women even led battalions of men into battle."

Elsa is the only artist I'm aware of who has thematically gone beyond the slain woman-soldier; she actually portrays the woman-fighter with the male object of her destruction, an Ethiopian soldier, beneath her legs. Her painting *The Woman Hero* seems a modern metaphor for the biblical theme of Judith, an Israeli woman who slays the arrogant Greek general Holofernes. Elsa's work is reminiscent of Artemesia Gentileschi's non-squeamish Renaissance in-

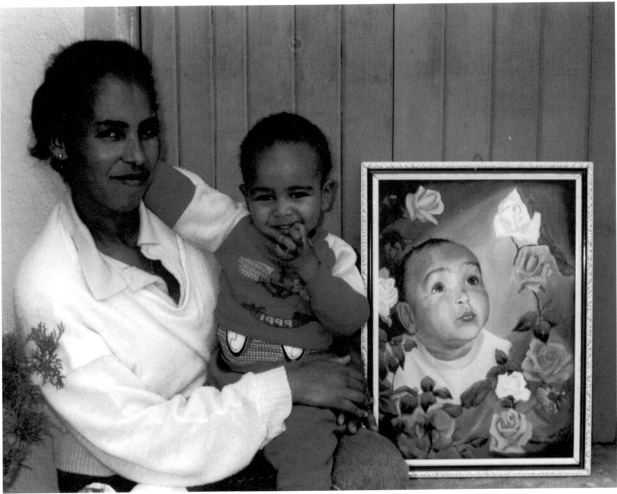

(Fig. 42) Elsa Jacob, Her Son, and Her Painting *My Son*, **1994.**

terpretation of this theme, as Judith holds Holofernes' head, which she has just severed with her sword.

Since life emerges from women's bodies (though Eritrea's past infant mortality and maternity death rates are appalling), to portray women as soldiers in the act of destroying life may seem quite ironic, even antithetical, for these artists-fighters. I wondered if strong expressions of women's leadership could also be explored, as well as the gentle human acts of socialization exemplified by Elsa's *In the Trenches*.

Social realism, the style adapted from the period of Russian cultural influence at the National Art School of Ethiopia from 1974-1991, was very limiting. It is regrettable that the Cubans, who also trained Ethiopian soldiers, did not share their diverse experimental styles of contemporary painting,[10] offering to train artists instead of soldiers. More options and explorations are needed; e.g., cubism, abstract expressionism, and surrealism, as well as incorporating local decorative folk art motifs. Women artists also need to become informed about other women artists in Africa[11] and abroad.

Another major hindrance is the current shortage of art supplies. It was disheartening to discover that the library of the pro-

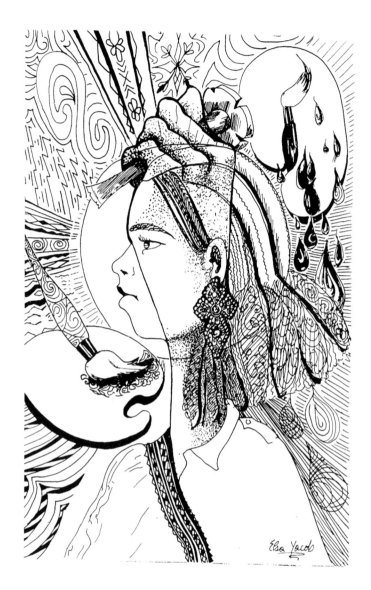

(Fig. 43) *Self Portrait*, by Elsa Jacob, 11 x 14", Pen and Ink, 1995.

posed art school currently has only thirty books on its shelves, which severely limits the opportunities for student growth. However, some male artists have traveled abroad with Eritrean exhibits for fund raising purposes and have visited museums and galleries, expanding their aesthetic horizons.

I found some parallels between Eritrea's and Nicaragua's recent history. Nicaragua's artists, especially in the 1970s, also experienced a long period of war, and they promoted the arts for consciousness raising and national unity in the struggle to overthrow the corrupt Somoza dictatorship. During the war, women were also combatants, leading men in battle, yet the murals portray only Sandinista men as leaders with flags unfurling, as women stand by to welcome them home with children at their breasts. Will this reversal of women to their former traditional roles in art and life also become the norm in Eritrea, or will women remain visible as "women heroes" and achieve positions of leadership in the peacetime government?

Terhas' expressionistic watercolor portraits, which capture so succinctly the inner souls of her models are admirable. So too is Elsa's terrifying painting of *Woman Hero*, which contrasts so dramatically with her loving, idealistic portrayal of her son. These two women have been through an incredible ordeal, but, for the most part I believe that they have illustrated only a small portion of some deeply buried memories that need time, processing, and nurturing

(Fig. 44) *Grinding Corn*, by Terhas Iyassu, 18 x 24", Pen and Ink, 1995.

(Fig. 45) *Coffee*, by Elsa Jacob, 18 x 24", 1995.

to surface and to expand into more diverse creative styles. The results might well be shocking. One wonders what the experience of travel abroad might do to facilitate this outcome.

These two women, both modest, have left us an unusual personal record of their war experiences. My hope is that they will receive the encouragement and support to further explore the depths of their feelings as women-artists-fighters, now residents of Asmara, one of the world's most peaceful cities.

New Visions

In the summer of 1995, I had a second opportunity to visit Eritrea when I was invited by the Eritrean Ministry of Culture and Education and the United States Information Service to present a three-week art workshop. This event was planned for teachers of elementary and secondary schools, Asmara School of Art faculty, and former artists-fighters. Among the forty-two participants, whose ages varied from twenty-two to fifty-two, were Elsa Jacob and Terhas Iyassu!

This was an extraordinary challenge as, during thirty years of teaching at Southern Oregon State College, my students had never experienced war for half of their lives and more. Therefore, I wondered how I could aesthetically motivate Eritreans and encourage them to reflect not only upon their past, but their present hopes and new aspirations since their hard-earned peace had been achieved.

To stimulate their imaginations as well as promote technical skills, I gave many slide presentations. I introduced workshop participants to the monumental drawings, prints, and sculptures of the African-American artists Charles White and Elizabeth Catlett, my first artist-teachers. I also included diverse works of many other artists from the United States, Latin America, and Europe.

I decided to include examples of my own large acrylic paintings, inspired by ten years of travel to Africa. The paintings included my mythical interpretations of women harvesting millet, vendors selling their goods at market, children herding animals, and people of all ages involved in processions and celebrations. The paintings contained a rhythmic integration of all life forms which intrigued the Eritreans.

In addition, I presented examples of class projects by my students in Oregon. These were pencil or pen-and-ink Symbolic Self-Portraits in which the students created imaginative interpretations of their personal relationships, career goals, and recreational activities. The Eritreans particularly enjoyed these, and after some preliminary projects, Symbolic Self-Portraits became one of the favored workshop themes.

I was excited to see the participants became quickly motivated and enjoyed the wonderful outpouring of images that followed. Although much of the artwork incorporated feelings of anger, sadness and pain, there was also many New Visions, reflecting pleasure in common traditional experiences, expressed in images such as *The Bride, Grandfather, Jewelry, Coffee, Camels, Eritrean Pieta,*

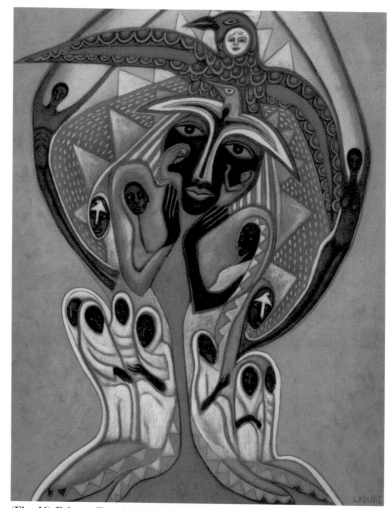

(Fig. 46) *Eritrea: Tree Of Life*, **by Betty LaDuke, Oil on Canvas, 1996.**

and *Love*. I learned much from each of my students about their past and admired their courage to move forward.

In Elsa Jacob's self-portrait, *Woman Artist* (Fig. 43), she holds a paintbrush instead of a rifle and portrays pride in her new identity as artist instead of an artist-fighter. In another drawing, *Coffee* (Fig. 45), Elsa symbolically shows a woman pouring freshly roasted coffee from a clay pot into two small glasses, while the smoke from the charcoal fire curls around her.

Terhas Iyassu focused on women's survival activities, such as *Grinding Corn* (Fig. 44) and *Basket Making*. She explained that the cultural and political symbols in *Pounding Corn* reflect the need for Eritea's multiple nationalities to unify as one nation.

"The woman's hair style is divided, representing Tigre on one side and Tigrinia on the other," said Terhas. "In each of the woman's eyes I placed the huts in which Tigre and Tigrinia live. Within one earring is a drawing of a child because expressing a mother's love is always important to me."

The workshop concluded with a major exhibit at the United States Information Service in Asmara, featuring ninety-six drawings and acrylic paintings. The United States Ambassador, Robert

Houdak, attended the opening celebration, as did representatives of the Eritrean news and television services. This event was a joyous workshop culmination, both for myself and the students, which I hoped would have ongoing benefits.

When I returned to Oregon, I was excited about sharing some of the results from the Eritrean workshop. I had purchased five large drawings, made clear photocopies of their smaller pen-and-ink drawings, and taken many photographs, all of which I now displayed at the college art gallery. The response was enthusiastic. Not only did the students admire the Eritreans' technical skills, but they were glad to learn about the human experiences the drawings revealed. The work of the Eritrean artists was an inspiration for my own work as well as many of my students. While surviving through thirty years of war is far from reality for most of us in Southern Oregon, somehow Eritrea—now one of the safest, cleanest, most peaceful cities in a war-weary world—would never seem far away again, as many of us would hold their experiences in our hearts and in our minds.

Eritrea: Tree of Life

After ten years of travel to Africa, I realize I have experienced just a small part of this complex and culturally rich continent. But, if any one painting could summarize some of my basic feelings about Africa, it is *Eritrea: Tree of Life* (Fig. 46). The mother is the *Tree of Life*, bearing the pain and suffering of her children, a cruel history of slave traffic, colonialism, and exploitation of the people, the earth, and the resources that nourish life. However, rising from her body are branches filled with new life, male and female. Their strong arms reach out to one another, as only men and women working together as equal partners can make the necessary changes to construct a better future for all our children in the generations to come.

Endnotes

1. Interview with Zamede Tecke, Director of the Department of Information and Culture, Asmara, Eritrea, July 1994.
2. Interview with Micheal Adonais, an artist and Director of the Fine Arts Section of the Department of Culture within the Ministry of Information and Culture. All interviews with artist-fighters took place in Asmara or Massawa, Eritrea, July 1994.
3. Robert Papstein, *Eritrea, Revolution at Dusk* (Trenton, N.J.: Red Sea Press, 1991), p. 6.
4. Ibid., p. 7.
5. Abeba Tesfagiorgis, *A Painful Season A Stubborn Hope* (Trenton, N.J.: Red Sea Press, 1993), Foreword by Basil Davidson.
6. An Art Exhibit by the Famous Martyr Haile Wolde-Micheal (catalogue), sponsored by the Ministry of Information and Culture, Asmara, Eritrea, 1994, p. 4.
7. Papstein, p. 15.
8. Ibid., p. 21.
9. An Exhibition of Art Works by Eritrean Fighters (catalogue), National Guidance Department, EPLF, Asmara, Eritrea, 1990, p. 40.
10. Betty LaDuke, *Compañeras: Women, Art, and Social Change in Latin America* (San Francisco, Calif.: City Lights, 1985), pp. 57-75.
11. Betty LaDuke, *Africa Through the Eyes of Women Artists* (Trenton, N.J.: Africa World Press, 1990).